D1515149

On High

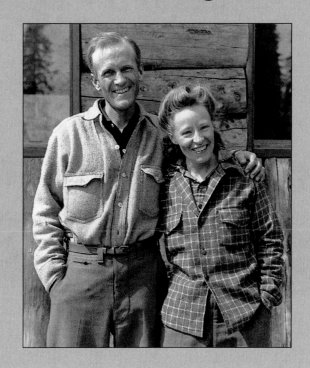

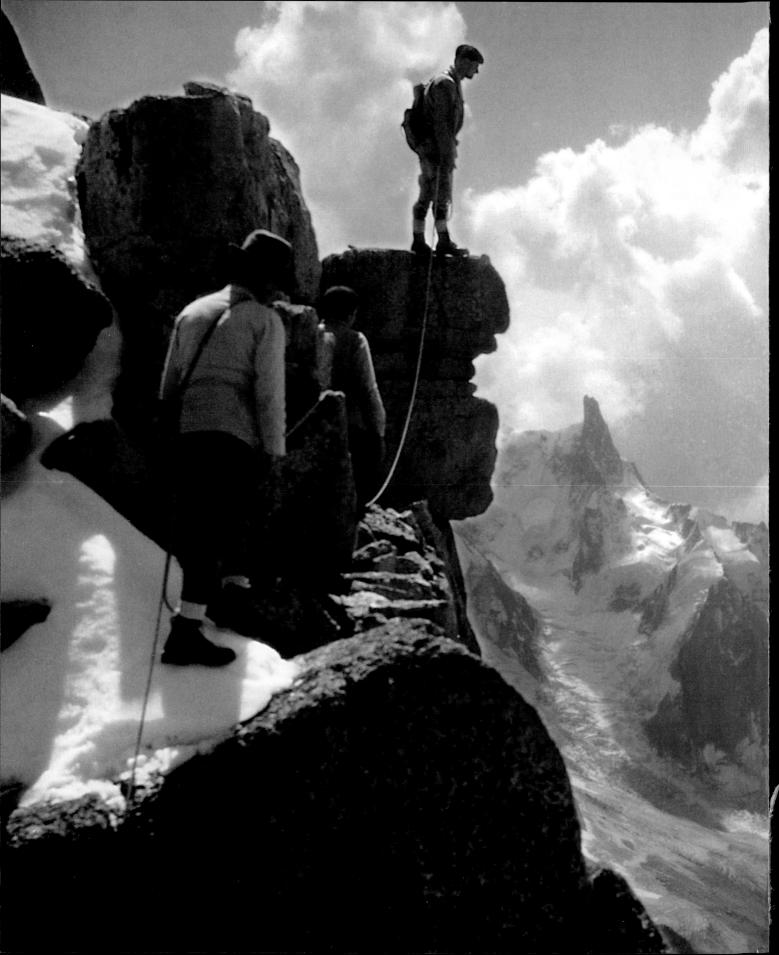

ON HIGH

THE ADVENTURES OF LEGENDARY

MOUNTAINEER, PHOTOGRAPHER,

AND SCIENTIST BRAD WASHBURN

BRAD WASHBURN WITH DONALD SMITH

NATIONAL GEOGRAPHIC

DEDICATION

To Barbara, my constant companion through all these years of thrilling exploration

Brad Washburn

TABLE OF CONTENTS

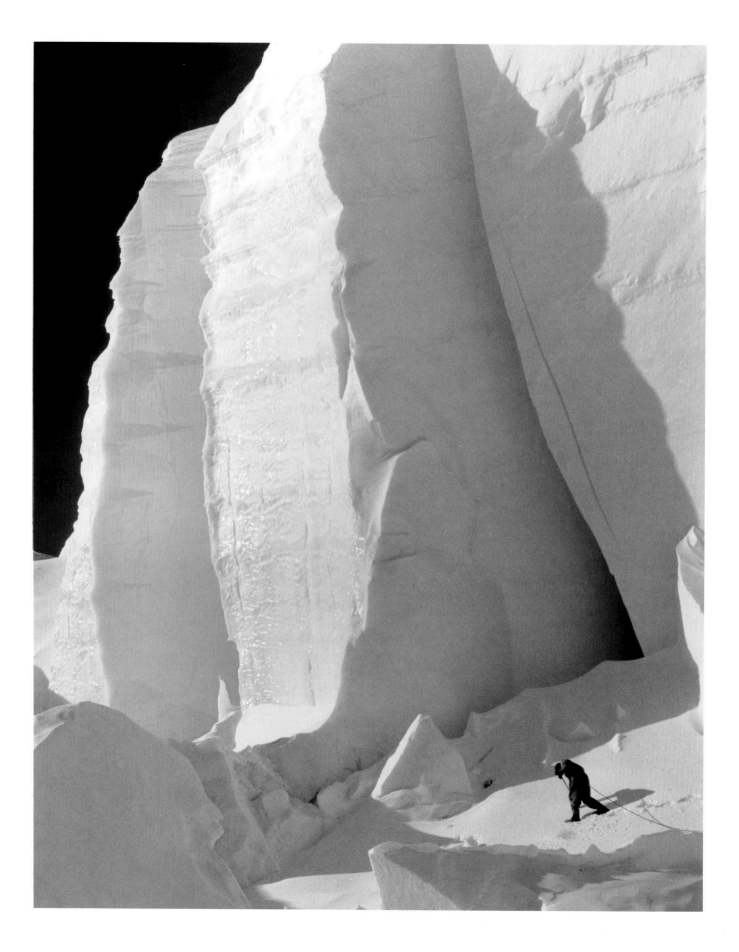

GIANT ICE CLIFFS NEAR SILVERTHRONE PASS, ALASKA, 1945

Prologue

This was no trail food. First to arrive at the tables were slivers of smoked salmon with crème fraîche and caviar on the side. Then the kitchen sent out tender hunks of filet mignon anointed with Cabernet sauce, plus several interesting side dishes, and for dessert, chocolate ginger blackout cake and petit fours. Everything was being presented with as much flourish as humanly possible by the wait staff of the Essex House Hotel, which overlooks Manhattan's Central Park from about the altitude of a low-flying cloud.

Among the black-tie and ballroom-gowned diners sipping champagne under the Grand Salon's crystal chandeliers on the evening of October 21, 2001, were some of the most accomplished adventurers, explorers, and professional mountaineers who ever roamed the Earth. They either belonged to or were guests of an exclusive, nearly century-old institution called the Explorers Club, whose membership roster reads like an international Who's Who of geographic overachievers. On this night the dinner crowd included National Aeronautics and Space Administration chief Daniel S. Goldin, deep-sea pioneer Sylvia Earle, mountain climbers Ed Viesturs and Krzystof Wielicki, and Peter Hillary, son of Mount Everest summiteer Sir Edmund. The old knight himself had sent regrets that he couldn't make the trip from New Zealand due to fragile health.

The purpose of the gathering, other than to have a bit of fun while reminiscing about lonely nights in the wilderness with only butane lanterns and lumps of cold pemmican, was to single out certain members of their tribe for special honor. It was the club's annual Lowell Thomas Award Dinner, an event named for the famed broadcaster of adventure in remote lands.

Listening attentively to opening speeches from one of the tables near the front was a smallish tuxedoed figure with intense eyes, sparse white hair, and the creased face of a person of great age. He might easily have been overlooked in such a large room. Not one in a hundred passersby outside along West 59th Street would have recognized his face or his name. But when TV personality Charlie Rose, the evening's master of ceremonies, invited him up to the podium to receive his award, this gathering of trekker cognoscenti knew exactly who he was.

I first met with Bradford Washburn to talk about his forthcoming biography—the book you now hold in your hands—at the Museum of Science, the well-known Boston landmark that he directed for decades and brought to national prominence.

We had crossed paths several times before, I as executive coproducer of National Geographic-National Public Radio's *Radio Expeditions,* and he as the closest a person can come to being a living legend at the National Geographic Society.

Two years earlier I had interviewed him and his wife, Barbara, for a special *Radio Expeditions* series entitled *The Geographic Century,* which reprised great moments of exploration and discovery during the 20th century. As I and my NPR and National Geographic colleagues were making difficult choices about people and events to include, we had a big debate about mountaineers. Some of us wondered whether they fit under the same tent as Robert Peary chasing after the North Pole, Roy Chapman Andrews roaming the Gobi in search of dinosaurs, Hiram Bingham stumbling onto Machu Picchu. Wasn't mountaineering more sport than science? More akin to say, recreational scuba diving than to underwater archaeology?

Each side had its passionate advocates and elaborate arguments. We never did settle it. In Washburn's case, we didn't have to. The fact is that he bridges the divide between high adventure and high scientific purpose. That he would be a part of our tribute to those bold individuals who went where none had gone before was a foregone conclusion. Deciding which of his many deeds to zero in on was the challenge. He wound up advising us in our segment on that ultimate goal of exploration, mapmaking, and making a prominent appearance in the series finale: His voice brought down the curtain. But there was so much more to say about Washburn's contributions to scientific exploration than we could possibly cover within the time constraints we had.

When George Mallory was asked why he wanted to go up Mount Everest, he famously answered: "Because it is there." Washburn's answer to why he climbed mountains was even blunter—and unflinchingly honest: "I did it because it was just plain fun." However, beginning with his earliest expeditions in Alaska, he never climbed a peak without a scientific mission. It might have been to study the movement of glaciers or the possible effects of cosmic rays on humans, to collect geologic samples, or simply to make a map of the place. On many of these outings, such as his 1935 foray into unexplored Yukon Territory, Washburn became part of that robust group who during the 20th century actually did fill in the last blank spaces on the globe.

And so the Washburn legacy makes a wide straddle, even before the subject of his pioneering aerial photography comes up. Or his role as creator/fundraiser/administrator of one of the world's premiere scientific museums. Or perhaps the most riveting aspect of his life: the marvel of a love between two human beings that survived a close encounter with death and continued to endure for more years than many of those assembled that night at the Essex hotel had been alive.

How do such people come to be? In learning Brad Washburn's story, I took a rather exciting journey down a spiraling tunnel of time.

———

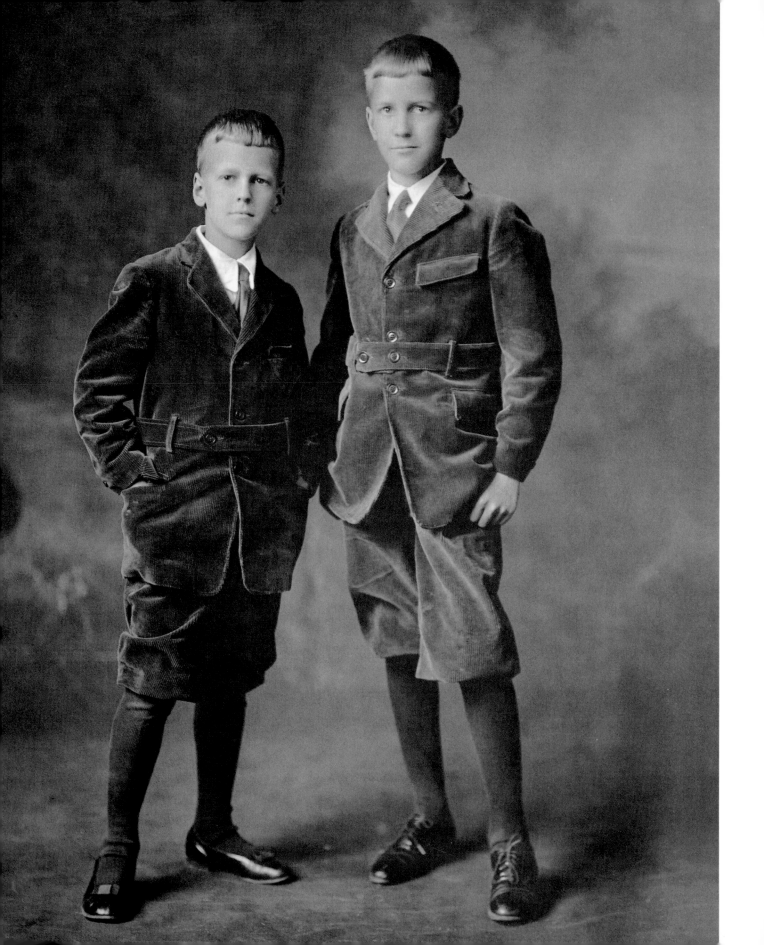

FIRST CAMPS

1910-1925

It had guarded its fierce secret well, hiding all morning behind a gently rising snow slope almost halfway up 15,330-foot Mount Fairweather—the highest peak in Alaska's coastal range. The lead climber was the first to see it in the distance: 400 feet of ice-covered cliff shooting straight up into the air. Blocking their path. As he later described it:

Rock cliffs rose nearly vertically for a good 2,000 feet off to our right. To our left a glacier a half-mile wide flowed out of a snow-covered valley. The glacier ran right in front, between us and the cliff, one of the grandest icefalls that I have ever seen. Pinnacles of blue and green ice capped with white snow, great walls and blocks of ice, towers of ice: All came tumbling out of that valley in one endless cascade that flowed past us and out of sight beyond a nearby shoulder of snow.

To get any farther, that seething cascade of ice would have to be crossed. Two other climbers came up beside me.

Only the distinctive rattle of ice falling somewhere in the distance broke the stillness as 20-year-old Brad Washburn made a quick assessment. The glacier's surface was scored at intervals by crevasses, some so deep that their bottoms weren't visible. With rope, skill, and a little luck,

Brad and his younger brother, Sherwood—"Sherry"—pose in June 1921 for a family portrait in Cambridge, Massachusetts. As adolescents, they would do some serious mountaineering together.

the climbers should be able to pass safely over this obstacle. They knew how to handle cracks in the ice. But what would they do about the wall?

The tawny-haired, boulder-chinned Harvard University sophomore and two others had been reconnoitering the next leg up the mountain for their party—in all, six young mountaineers from the Boston area. It was July 21, 1930, and they were nearing the end of a painstakingly planned quest to become the first humans to set foot on the summit of the redoubtable mountain.

His teammates knew that if anyone could figure out a way to continue, it would be the one who had put the expedition together. Despite his young age, Washburn was already a player in the competitive world of serious mountaineering. He was a celebrity on two continents. Admiring media coverage recently had included full-page picture spreads about his exploits in the *New York Herald Tribune* and *Paris Match*. He had made several impressive first ascents in the French Alps, the very birthplace of mountaineering, and had written two books on the subject, plus a trail guide. His tanned face and Prince Valiant mop of sun-blanched hair appeared on posters circulated far and wide by his top-of-the-line Boston booking agency for public lectures, which he illustrated with his own photographs and movies.

But now, Washburn stared at the sight before him in uncharacteristic silence. Turning back was not an attractive option. A lot was riding on this trip.

IT WAS A CHALLENGING TIME to be coming of age in America, and not just for mountain climbers. The country was still feeling aftershocks of events the previous fall on Wall Street. The crash of 1929 had wiped out a good part of the Washburn family's financial cushion. The money that young Brad was earning on the lecture circuit suddenly had become important. He had especially high expectations for the Fairweather climb: He was shooting quantities of film to show to audiences, and another book was in the offing.

People read more in those days, a time when electric refrigerators were considered high technology. The evening papers were following Babe Ruth's pursuit of a home-run record and the FBI's efforts to collar Al Capone. Washburn's Harvard classmates were reading the novels of Ernest Hemingway and Dashiell Hammett, listening to phonograph recordings of Bessie Smith and Hoagy Carmichael, and watching the comedy of the Marx Brothers on the larger-than-life, still fresh miracle of the Silver Screen.

Trouble was brewing in Europe, the site of some of Washburn's well-publicized pre-Alaska climbing feats. An ascendant German politician had been released from prison, where he'd written an autobiography, *Mein Kampf,* calling for a return to past militaristic glories. But in 1930 such omens seemed far away from Massachusetts and collegiate Cambridge, a sheltered world where bulky, knitted pullover sweaters and big ties were the uniform of the day. Baggy trousers and fedoras also were favored

AT ONTEORA, the family summer home in the Catskill Mountains, Edith Washburn admires her first son and second child, Henry Bradford Washburn, Jr.

among Washburn's crowd except at campus social-hall dances, where Harvard men wore tuxedos. At neighboring Radcliffe College, women were gravitating toward the fashionably casual look as well. After years of corsets, petticoats, and a strange invention called the "hobble dress," hemlines were headed for the knees. The boyish style was in vogue, as were sleek hairdos, sometimes tucked under clingy cloche hats worn rakishly at eye level.

Of more immediate interest to young men like Washburn were the stirring events that historians later would call the second great age of exploration. The first age had involved crossing oceans and discovering continents. Now the remaining blanks on the globe were being filled in. The North and South Poles had been reached. Yale history professor Hiram Bingham had found a spectacular Inca ruin on a ridge in the Peruvian Andes that he called Machu Picchu, after a nearby peak. Charles "Lucky" Lindbergh had recently advanced the science and craft of aviation by soloing from New York to Paris. And a young U.S. Navy lieutenant named Richard Byrd was rousing two American passions at once, aviation and exploration, by building in the remoteness of Antarctica a community that he called "Little America."

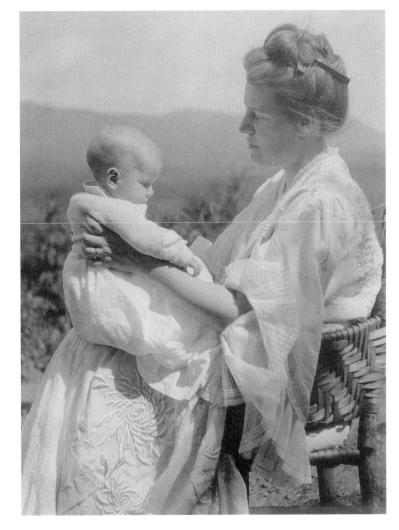

Brad Washburn was caught up in this spirit of adventure. He, himself, was interested in flying and was seriously considering getting his own pilot's license. In 1930, only two years after young Amelia Earhart had become the first woman to cross the Atlantic by air, who knew where time spent in airplanes might lead?

But before any of that would happen —the book, the lectures, and all the rest— he had a problem to sort out: What to do about 400 vertical feet of ice-covered stone.

WHEN FACED WITH DEFEAT, Brad's father always had advised accepting it and moving on. Two years earlier, when Brad was upset because his small size was frustrating his efforts in his school's football program, the elder Washburn penned the following advice:

Dear Braddie,

Do not be disappointed if you do not achieve all your ambitions in foot ball. Do your best and then take the consequences. And there are plenty of interests in the world apart from foot ball. I take solid satisfaction in thinking you are getting ready for the skiing. It makes the coming of winter look attractive. Your marks in math delight my soul, for math lies at the bottom of much of the clear thinking in the world. Why not try for a prize in it?
Best of love. Father

THIS BRILLIANT PIECE of attention-shifting was written on the letterhead of the Episcopal Theological School in Cambridge, where Henry Washburn was dean. A man of short stature, with dark curly hair, a prominent nose, and a friendly, outgoing personality, he was from a long line of successful Yankee entrepreneurs, politicians, and patriots. His direct ancestor, William Bradford, had been a prominent leader of the Pilgrims, those staunch British religious dissenters who had crossed the Atlantic in 1620 aboard the *Mayflower* and established one of the first English colonies in the New World, calling it New Plymouth. Their Mayflower Compact, signed by all while still aboard the ship, provided for their own local self-government, more or less independent of the British crown. Bradford's patient though firm leadership helped the colony to prosper.

Another ancestor, Ichabod Washburn, had pioneered in America the technique of extruding wire by mechanical means, thus helping found the country's wire-goods industry: hooks, screw eyes, strainers, frames for hoop skirts, and the like. Ichabod's grandson, Charles Francis Washburn—Henry's father—was successfully carrying on the family trade when Henry came along. Among the company's most popular 19th-century products was barbed wire, for which the company held exclusive patents. By the time Charles Francis Washburn died in 1893, the firm had played a major role in turning a good part of the Wild West into rangeland.

When Henry Washburn's generation came of age, leadership of the wire-goods business passed into the hands of his two brothers, Reginald and Charles Grenfill Washburn. Charles, in addition, became a prominent politician. But Brad's father, a Harvard man who also studied at Oxford University and the University of Berlin, chose a different career path—the Episcopal Church.

Harvesting souls paid not nearly so handsomely as making wire. Brad's future parents did have means, but most of it came from his mother's inheritance from a previous husband: Samuel Colgate, a scion of the soap-company family. The turn-of-the-century Colgate clan didn't rank among the country's super-rich—the Carnegies, Mellons, and Vanderbilts. However, Samuel's father was well-heeled enough to have endowed Colgate University.

Sam Colgate, like Henry Washburn, was a minister. Henry became friends with him, his bride Edith Colgate, and their baby daughter, Mabel, in 1895 during a sojourn

in Berlin, where the two men were doing postgraduate work in theology. Samuel died in 1902 of typhoid fever, and six years later Edith married her old friend from Berlin. Henry Bradford Washburn, Jr., arrived at Boston's New England Baptist Hospital at 8 a.m. on June 7, 1910. His brother Sherwood—Sherry—came along a year and a half afterward.

Edith was a gentle, loving, and nurturing soul. It may have been she who first stirred Brad's interest in adventure through the stories she read to him when he was small. One book, a fifth-birthday present, was *The Snow Baby,* written by Josephine Peary, wife of Arctic traveler Robert Peary. It is a bracing account of the birth and early life of the Pearys' daughter Mary, the first white child known to have been born in the Arctic. *The Snow Baby* was long remembered by the grown-up Washburn as one of his important early exposures to the idea of geographic exploration.

Brad had his first look at the Grand Canyon when he was six. That year his father underwent surgery for diverticulitis, an extremely painful, life-threatening malady of the intestines. The doctor advised Henry, by then a 47-year-old professor of church history at the theological school he would later head, that a lengthy recuperation period would be in order. Edith, who already had lost one husband prematurely to disease, willingly dipped into her Colgate bequest to help finance a year-long sojourn at the San Ysidro Ranch, a luxurious 500-acre resort overlooking the Pacific Ocean near Santa Barbara, California. On their way West by train, the family stopped off at the famous giant gorge carved out of the Arizona earth by the Colorado River. "I don't remember much about it," Brad said years later, "except for an impression of broad spaces and vivid colors, and watching my sister, Mabel, climb aboard a mule and set off for a trip down the Bright Angel Trail, a place I would later come to know intimately."

When they returned from San Ysidro, the family temporarily relocated from Cambridge to New York City, where Henry had been given a new job. The Episcopal Church appointed him secretary of its War Commission, a board that selected chaplains to serve with the United States Army in Europe during World War I. The Washburns lived at 450 West End Avenue in those days, not far from the home of Brad's Uncle Gilbert Colgate, who was in the process of expanding his soap company into the consumer-product empire it is today. Henry's office was at 14 Wall Street, in the heart of the Financial District. Brad vividly remembered him urging Edith to come with the boys to the neighborhood on November 11, 1918, to see the huge ticker tape parade that marked the end of the fighting.

After Armistice Day the Washburns moved back to Cambridge. Henry took up his work at the theological school again, and they continued a family tradition that, except for their year in California, had been in effect since the year Brad was born: They spent the summer in the Catskill Mountains.

One of the benefits Henry enjoyed as a professor was lengthy summer vacations.

The family had a first-class place to stay. Edith had retained from her first marriage a summer cottage near the tiny village of East Jewett, an area favored by many of the upper middle class and well-to-do of Boston and New York for seasonal getaways. She and her new family often were joined by Edith's three sisters and their families, who had their own houses in the area. "We spent long summer days of our early childhood rambling along woodland paths, swimming, and fishing," Brad fondly recalled.

Brad also spent time fishing in the Hudson River off the end of the 79th Street

dock in New York City. Some of the tricks he learned there found their way into print. In 1919, when he was nine years old, he wrote "Fishing: What a Boy Thinks," for an Episcopal periodical called the *Churchman*. In that first outing as a published writer, Brad offered the following tip: "Solder a bell onto the end of a strong piece of wire, on the other end a screw. Fasten this on the dock by means of the screw. Have about a hundred feet of line with about three hooks on the end of the line with a sinker. Tie the loose end of the line to the wire and throw the line into the water. When the fish bite the bell will ring."

The Catskills provided young Brad with his earliest exposures to the outdoor life. But the real geography of his future was decided during the summer of 1921, the year he turned 11. That year his parents discovered a new location for their annual summer retreats—Squam Lake in nearby New Hampshire.

Washburn later would say:

I LOVED THE CATSKILLS. But they were somewhat spoiled for me because of a curse under which I lived. Right around the beginning of summer every year I came down with hay fever. Mother's vacation cottage was in the middle of some very large fields, which made the symptoms even worse. I had it all: congestion, runny nose, itchy eyes. From a good part of the time when I got out of school until it was almost time to go back, I would just be miserable.

I had no way of knowing what a nice surprise I was in for the first summer we spent away from the Catskills. It seemed a miracle at the time. As time has gone by, I've come to think maybe it really was.

THE "MIRACLE" OCCURRED in 1921, the first summer the Washburn's spent on Squam Lake. The lake is the second largest inland body of water in the state. It's also one of the most idyllic places in New England, if not the world, with gentle mountains all around, hiking trails, crystal streams, and prime freshwater fishing. The 1980 movie *On Golden Pond* was made there.

"I had a lot of fun and made some lifelong friends there," Brad recalled. "I remember that we designed and built a boat from scratch and somehow got a motor for it. The vibration of that big engine shook off the entire rear end of the boat, and I suddenly found myself up to my neck in water."

But that wasn't the experience that altered his future.

The family had chosen this location partly in hopes that Brad would find some relief from his allergies. The lakes region for years had been a big draw for city people from New York, Boston, Philadelphia, and even into Virginia. It became so popular toward the end of the 19th century that special train lines were put in. At the larger lake to the south of Squam, Winnipesaukee, people stayed in Victorian-era hotels that were scattered all along the shores: imposing old wooden structures built in the grand style. But the region also had dozens of summer camps for kids and families. One of these was the very rustic Rockywold Camp.

Rockywold and its neighbor, Deephaven, were owned and operated by two women of means who believed in the healing powers of nature and the benefits of simple and wholesome family life away from the distractions of the city. Rockywold's Mary Alice Armstrong was the widow of a socially conscious Union general in the Civil War who had founded eastern Virginia's Hampton Institute, one of the first colleges for blacks. Mrs. Armstrong herself had taught at Hampton before buying the 27 acres for Rockywold in 1901.

Families stayed in one-room cottages whose design was based on traditional "fishing huts." Made of coarsely sawed wood with shingled roofs, they generally weren't much more elaborate than large tents—in fact many of the original shelters at Deephaven were tents. No two cottages looked quite alike. They had from one to five bedrooms and were priced accordingly. Guests might stay from a weekend to the whole summer. The cottages all had running water and insulated iceboxes, but no flush toilets, just outhouses. Kerosene lanterns provided lighting. Two icehouses, one in each camp, held 200 tons of ice cut from the lake the previous winter. Each of the cottages had a fireplace where kids could toast marshmallows. However, except for the occasional lakeside communal fish roast, the residents did little cooking. Meals were provided in a large central building that served as Rockywold's dining room. Often, guests would canoe out to any one of Squam Lake's many islands for picnic lunches or suppers. On fair days there was hiking, swimming, canoeing, and sailing. Tennis courts were available, as well as a small stage for lectures and movies. At night

"HOTEL" topping 2,100-foot Mount Morgan was built in 1925 by the Squam Mountain Club, a group of teenagers led by Brad. Today, almost 80 years later, he still proudly considers it his "first experience leading a project."

Childhood

Brad's mother, Edith, and father, Henry Bradford Washburn

Brad gives his infant brother, Sherry, a kiss.

At Onteora, in the Catskills, Uncle Bob holds
Brad and Sherry.

Brad and Sherry climbing their first mountain,
Cambridge, 1914

Brad at Onteora

Brad sports a Bavarian outfit for the annual costume party at Onteora.

Brad takes the 1922 Watersports Cups at Rockywold Camp, Squam Lake, New Hampshire.

Brad, Sherry, and their father, Rockywold Camp, New Hampshire

families would gather for games of charades, square dances, and talent shows.

Henry Washburn especially liked the moral and religious underpinnings of Mrs. Armstrong's operating philosophy for Rockywold. Most of the campers attended a weekly service on Church Island, and every Sunday evening a vespers service was conducted at Flagstaff Point on the lake. Alcoholic beverages were discouraged. However, like William Shakespeare's Prospero in *The Tempest*, Mrs. Armstrong ruled her woodland kingdom with a cunning, all-but-unseen hand. She used to say: "There are no rules at Rockywold. But if you disobey them, you may not be asked back."

This package of nature balm and family values attracted a loyal community of repeat summer guests from the worlds of business, academia, and the arts. Brad and Sherry had many adventures there, and Brad did indeed find that his hay fever was greatly mitigated. But he also discovered an even more amazing thing: Above certain altitudes, hay fever doesn't exist at all.

IT WAS THE MIDDLE of July, several weeks after my 11th birthday. One of my mother's brothers' sons, Sherman Hall, who was a student at Yale, had driven up from New Haven with his brother Fritz and two classmates to spend a long weekend with us on the lake. Sherm suggested that we take a couple of days and climb Mount Washington, 70 miles to the north. We enthusiastically agreed. Sherry and I had rambled up some of the peaks in the Catskills, and in the weeks since we'd arrived at Squam Lake we'd gone to the top of several good-size nearby hills there. But I'd never climbed a serious mountain anywhere.

I'd heard that Mount Washington was a challenge. It's the highest point in New England: 6,288 feet. On clear days you can see the Atlantic Ocean 60 miles away. But on good or bad days it can be treacherous. The ascent from Pinkham Notch begins on a trail that climbs through steep Tuckerman Ravine, taking you up roughly 4,300 feet in just over four miles, a good part of it above the tree line and exposed to the mountain's notoriously tricky weather. Almost every year someone is severely injured or even dies on Washington's slopes.

I was having my usual hard time with the hay fever on the morning we started up the Tuckerman Ravine Trail. One of the most annoying effects of that miserable disease is that after a few days of dripping and sneezing, your nose begins to get raw from blowing. It was another one of those times, leaking and blowing.

Up we went, passing close to a spectacular 80-foot waterfall on the Cutler River called the Crystal Cascade. The ground rose moderately in the pine forest as we went past tiny Hermit Lake at 3,800 feet. Then it got very steep. We scrambled up lichen-covered boulders past nearby Lion Head, a craggy, dizzyingly high cliff off to our right, then up the steep "Spring Gully," just to the right of Tuckerman Ravine's famed headwall.

As we continued climbing, I was enjoying the scenery and the exercise, and suddenly I was amazed to notice that I wasn't sneezing anymore. My eyes weren't itching either. Just like that.

We spent the night of July 21, 1921, at the Summit House, a big old hotel right on the top—it has long since burned down. For the first time in weeks I woke up in the morning with

a clear head and a dry nose. I've often joked that if it hadn't been for hay fever, I never would have taken up mountain climbing. I'd have done other things instead. Maybe. But it was quite apparent on that beautiful New Hampshire morning that there was some kind of magic at work up there on high. Something about that bright, windblown place above the clouds was speaking to my soul as well as my body.

I was seriously infected.

BRAD AND SHERRY attended moderately expensive private schools throughout their early boyhoods: in Cambridge, Buckingham School and later Browne & Nichols School; and, during their sojourn in New York City, the Collegiate School. As the boys approached high school, their parents aspired to send them to Groton, a college preparatory school located in the town of the same name 40 miles west of Boston. Groton catered to the most socially and financially elite families of Yankee society. It also served as a prime feeder for the Ivy League, particularly the hallowed trio of Harvard, Yale, and Princeton.

It was extremely expensive, more than the Washburns could afford even with what remained of Edith's Colgate funds, especially since they had two sons to educate. But the boys' Uncle Charles, the wire-goods magnate, had encouraged his nephews to aim for it. He had sent his own son to Groton and was one of its trustees. When the time came for Brad and Sherry, Charles was willing to pay the bill.

UNCLE CHARLIE was a sometimes aloof but very generous man. Every Christmas he would give Sherry and me a $10 bill, which in the 1920s was a substantial gift for a boy, roughly equivalent to $100 today.

In addition to being financially well-off as a result of his successful business career, he was a person of note in the Republican Party, which I'm sure didn't hurt his nephews' chances with the Groton admissions board either. He was one of seven Washburns to have served on Capitol Hill since 1851, representing Worcester in the U.S. House of Representatives during the 59th through 61st Congresses, 1906-1911. He'd also been a delegate to the GOP National Convention in 1904 that gave the presidential nomination to his close friend and former Harvard classmate Theodore Roosevelt.

When an unexpected vacancy at Groton occurred in December 1922, Uncle Charles forwarded the tuition, and I was in. But all was not immediately well. The sudden switch to an exclusive, academically demanding boarding school in the middle of the school year was a shock on several counts. In a way it was a demotion. As the senior of two brothers living with my older half-sister, Mabel, under the doting supervision of two devoted parents, I was used to being the center of attention. Now suddenly I was just a face in a crowd; and this crowd was a fast one. Among the other boys bunking in the Groton dorms that year were future Treasury Secretary C. Douglas Dillon, and Elliott Roosevelt, son of wealthy New York lawyer and future President Franklin Delano Roosevelt.

There were three or four of us kids who knew that we were different from the other kids because we weren't from the big New York schools, and our parents weren't very wealthy and important. We had a little visceral feeling that we didn't really fit in with the other youngsters.

I was overwhelmed and finished the school year with failing marks. In order to remain at Groton, I would have to start the first year over again the following fall.

As usual, my parents rallied behind me. I've said repeatedly that if I were to be reborn I would like to have exactly the same two parents. They were loving, thoughtful, and always eager to have us do our best. That June, to mark my 13th birthday, just before leaving for our third summer at Rockywold, we all went to Revere Beach, a popular public bathing spot five miles north of Boston on Massachusetts Bay. It had carousels, fanciful dancing halls, and one attraction that especially caught my attention: aerial sightseeing spins over Boston Harbor in a small, brightly colored biplane. My mother went up with me on my first flying experience that day.

It was just around this same time, when I was in my early teens, that I began dabbling in another technology that also would play a big role in my future. I had owned a Kodak Brownie box camera since I was ten. I'd used it to take snapshots around home and on summer vacations in the Catskills, and later at Squam Lake and in the White Mountains. At a retail price circa 1920 of a dollar apiece, the Brownie had its limitations. It was the result of Eastman Kodak founder George Eastman's idea that what the world needed was a simple, inexpensive camera that would hook people—particularly children—into photography. Actually the outfit could produce reasonably sharp pictures, especially if you took the operating manual's advice and didn't breathe while releasing the shutter.

A frustrating part of the Brownie experience, for me at least, was the long wait for exposed rolls of film to be processed into real photographic prints. I soon discovered that I could skip this test of endurance by developing and printing the pictures myself. And that led to another discovery: By doing my own processing, and varying exposure times while printing, I could control the appearance of my shots in a way not otherwise possible with the one-look-fits-all scheme of the Brownie.

When I arrived at Groton, I found that I was the only boy involved in photography to that degree. At first this realization added to my uncomfortable feeling of apartness. But I was pleased to find that, in addition to having high academic standards, the school had a tradition of encouraging individual interests outside the classroom. In the basement of the school's main building I was allowed to build a little private darkroom where I could experiment with chemicals, time, and light to my heart's content.

Resolved to make up for having to repeat my first year, I performed well enough throughout the rest of my time at Groton to graduate cum laude, with a respectable "B" average. I did well in sports, including baseball and football, although my small size was a handicap in the latter.

I was *unanimously* elected
Baseball captain!!!
yay
Love
Brad.

GROTON, 1924: Brad found the demanding curriculum of the famous Massachusetts boarding school a challenge, but, as with all challenges that would confront him in life, he rose to it admirably, graduating cum laude.

It was at Groton that my lifelong interest in Mount Everest was really kindled. British Army Capt. John Noel, who'd been part of the 1924 Mount Everest Expedition that had resulted in the deaths of George Leigh Mallory and Andrew Comyn Irvine, stopped by the school to deliver his account of that tragedy two years after it had happened. I reported for our class newspaper: "The talk was accompanied by motion-pictures and some beautifully colored slides. Captain Noel told how the expedition started from sea level and proceeded through luxuriant tropical growth until they crossed the high range of the Himalayas and then descended into the Tibetan plains.... On reaching the base of the mountain it became necessary to make a chain of seven camps or depots, a system known as the 'Polar method.' The first attempt was made without oxygen by [Theodore] Somerville and [Edward] Norton, who could only continue to about 28,000 feet. But Mallory and Irvine, who then tried the final ascent with oxygen, were last seen 600 feet from the top, and it is believed that they may have reached their goal, but were frozen on the descent. Captain Noel gave us a vivid picture of both the beauty and hardships of an Everest expedition...."

Groton and I were on such good terms when we parted that I left the school a gift that can be seen today overlooking the baronial, 180-seat oak-paneled hall that still serves as the main classroom: a set of five stained-glass windows designed by me and assembled in the attic of "Hundred House," the main school building.

Throughout school, Sherry always made much better grades than I did. I would get 80s and he'd get 90s. But I don't regret not making straight A's. Somebody asked me once why I didn't do better in school. I said that I was busy doing a lot of other things.

INDEED, AS HE LABORED those early years at Groton to overcome his benighted academic start, matters even weightier than Latin and trigonometry were occupying Brad Washburn's mind.

They had to do with rocks. And though he never could have dreamed it at the time, they were all pointing him toward Alaska.

His FIRST time leading a hike, 15-year-old Brad (second right) guides friends up Mount Morgan, where they built their summit hotel overlooking Squam Lake.

———

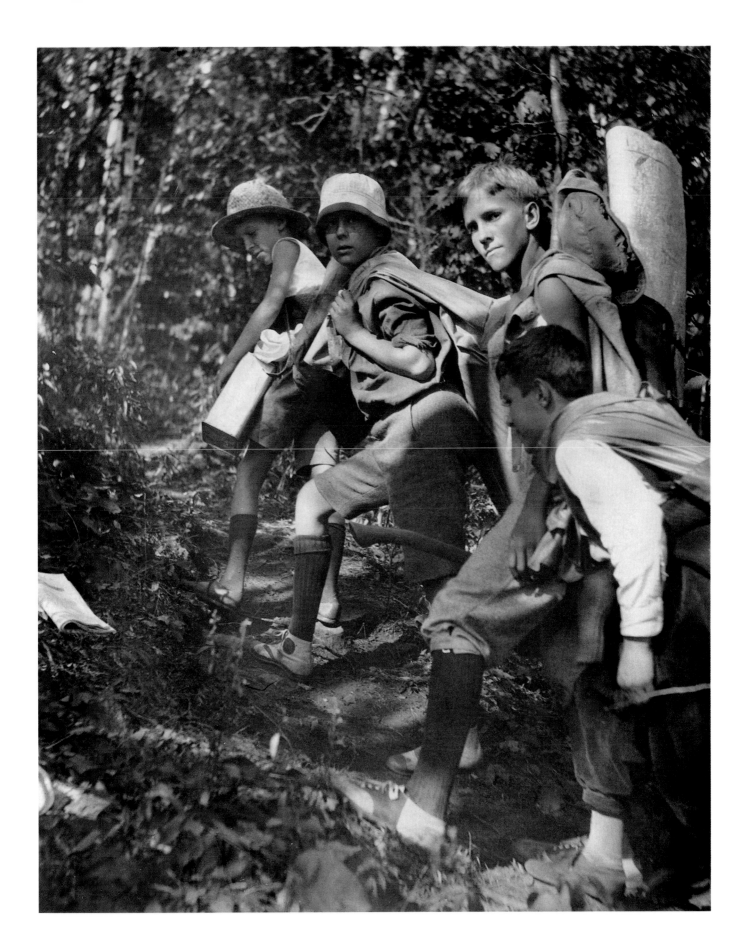

GRAND CANYON, ARIZONA, CIRCA 1972

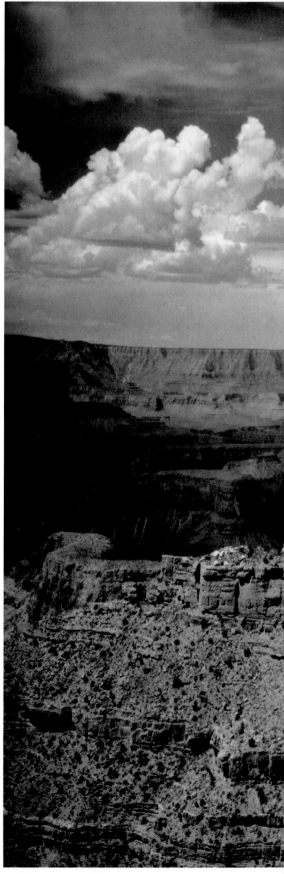

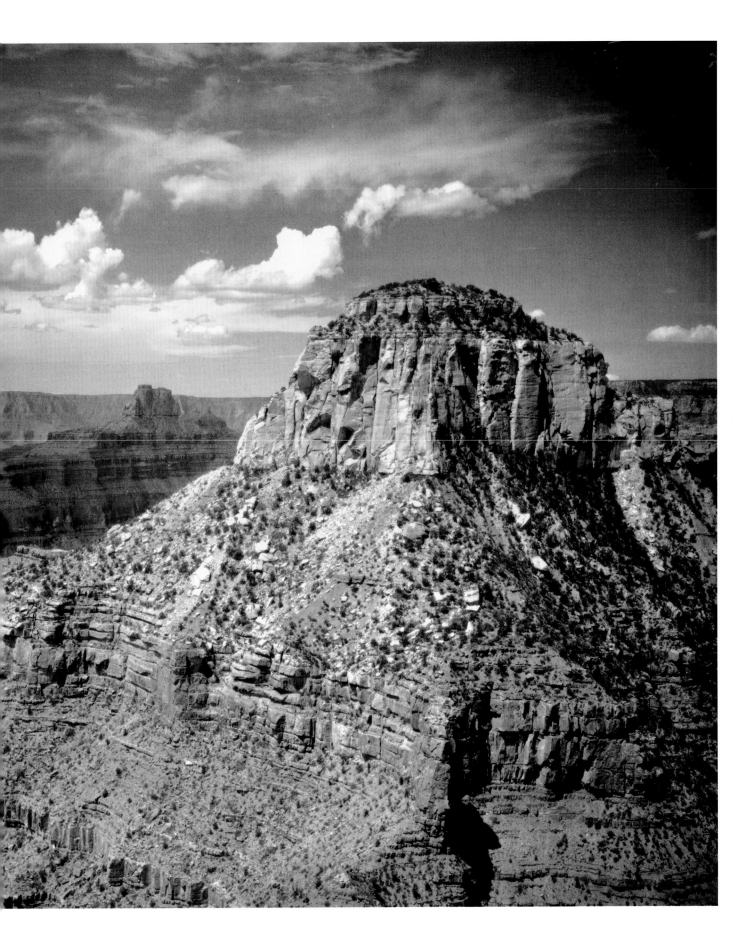

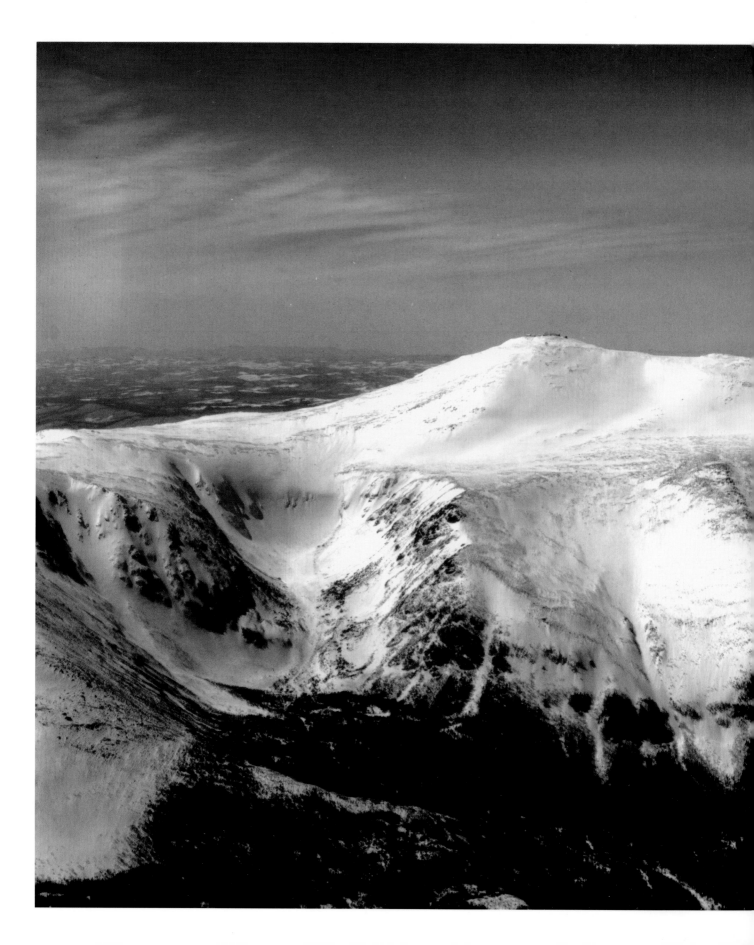

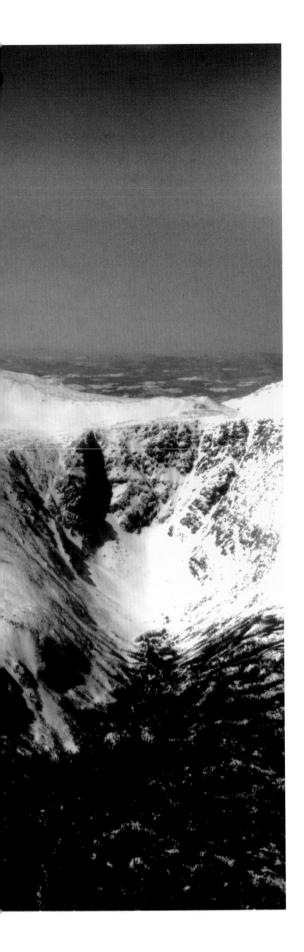

SUMMIT OF MOUNT WASHINGTON, OVERLOOKING TUCKERMAN
AND HUNTINGTON RAVINES, 1938

NORTH RIDGE AND SUMMIT OF MOUNT FAIRWEATHER, ALASKA, 1978

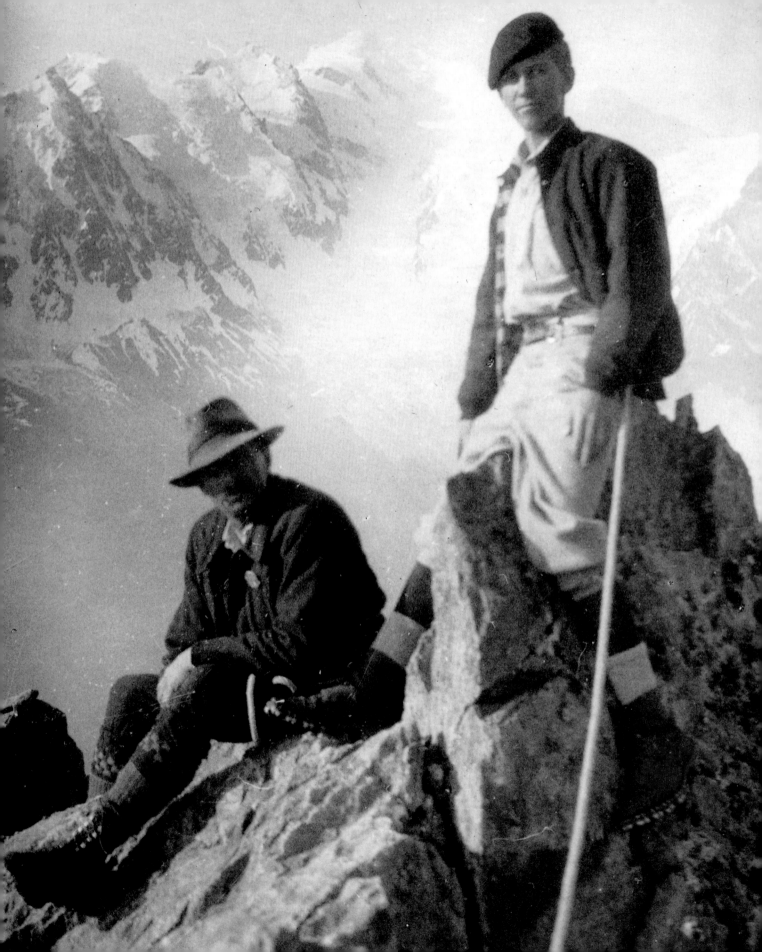

ASCENTS

1926-1930

A thick layer of snow freshly carpeted Mount Washington on New Year's morning 1926. Clouds hovering overhead hinted of more on the way. The seven climbers tramping through three and four feet of accumulation at the base of the mountain knocked off clumps of powder from tree branches as they passed by Hermit Lake, which was locked in solid ice. They'd been advised that Tuckerman Ravine, the preferred route from Pinkham Notch, was impassable. They would have to go up by a more difficult trail.

Fifteen-year-old Brad Washburn was thinking that if the ascent worked out, it might make a good tale to add to his growing repertoire of adventure yarns. But the weather was ominous. The higher he and his friends went, the darker the sky became. Finally, reaching the headwall—the rock face where the most difficult part of the ascent would begin—Washburn paused to squeeze off a few snapshots with a new camera. He'd gotten it only days earlier as a Christmas present to replace his Kodak Brownie. The more advanced Kodak Vest Pocket Autographic Special offered a choice of two shutter speeds. Still, he wondered if there would be enough light.

Then up the climbers went.

LONG THE DOMAIN of serious mountaineers, the Alps honed Washburn's climbing skills and earned him a reputation as a climbing wunderkind. In this 1926 shot, he poses with his guide, Alfred Balmat.

Due to the weather, they struck away from the Tuckerman Trail. Washburn wrote:

WE CLIMBED UP the steep slope of the Lion Head which, although a massive crag in summer, is a very steep, snow-drifted slope at this time of the year. Luckily, a previous party had broken out the trail all the way to the top. Many dizzying moments were felt (at any rate by me) as we gained altitude. Reaching the top of the Lion Head we proceeded in the direction of Mount Washington's "cone" over the snow-covered rocks. Four and one-half hours after leaving Pinkham Notch (and I with a frozen cheek) we reached the summit. Everything was frost feathers and ice. There was no view, as we were in the clouds, and a swift wind swept by, but I shall not forget the thrill of standing on the summit of the highest peak in the Northeast in winter. A truly alpine world.

MOUNT WASHINGTON, 1928: Brad (right) and Sherry take a break on the slopes of the Northeast's highest peak, which rises 6,288 feet in the White Mountains.

WASHBURN'S 600-WORD ACCOUNT of that mini-adventure is one of his earliest published mountain-climbing narratives. It appeared 13 days after the fact in the eight-page New Hampshire weekly, the *Berlin Reporter*, sandwiched between a list of local church services and news items from the town's high school.

By the winter of 1925-26, 15-year-old H. Bradford Washburn, Jr., as he signed himself, had gone a long way toward convincing his parents that he had the skill he needed to handle himself safely on the slopes. The previous winter he also had shown that he had another asset vital to all those who venture into unforgiving environments: good judgment.

DURING THE CHRISTMAS of 1924 I was home on semester break from my second year at Groton. It was getting close to the end of the holiday and we were getting a bit of cabin fever, so I suggested that we take a train up to New Hampshire and do some mountain climbing. There would be four of us: my father, Sherry, and me, plus Waters Kellogg, a friend about my age from Squam Lake.

We'd already done a lot of exploring in the White Mountains by then. Dad liked doing things with us, and he'd been up there quite a bit with me and my brother, Sherry. But none of us had ever been on Mount Chocorua in the winter.

The mountain was named for a Penacook Indian, either a chief or a hunter, or both—stories vary—who supposedly fell to his death from the top, though this might just be a cautionary fable put out so people wouldn't underestimate the mountain. It's 3,475 feet high, nowhere near the tallest in its range, but it's interesting partly for its distinctive shape. Some say it reminds them of the Matterhorn because of the way the upper part, which is bare rock, comes to a very steep, rocky summit. It will give you a good workout: The climb is listed in current guidebooks as "strenuous."

It was a beautiful fresh morning with bright sunlight. The hotel where we were staying had packed us box lunches to eat along the route. We started off in the woods on a good trail, and within about three hours we'd broken through the tree line. Then, when we were about 50

yards from the top, we noticed something strange. The rocks in front of us were glittering. I had never seen this phenomenon before. The French call it verglas. *A rainstorm that had come through several days before had done the trick. When rain hits the mountain at just the right temperature, it freezes the instant it lands. The whole expanse above us was completely painted with ice. All you had to do was look to know it would be very dangerous to continue.*

We could've gotten to the top, I think, if we'd wanted to spend two hours chopping out steps in that ice. But it's one thing chopping ice that's thick. If you've only got half an inch of ice, it's nearly impossible. And we needed a rope, which we didn't have.

In mountain climbing there are times when you've got to quit and get off the mountain. Or if the weather's bad, you must stop and make camp where you are until it clears. It helps to know when these times are, when you're in trouble or when trouble is approaching. I was the most experienced person in that little group that day, and I said, "Let's not do it. Let's quit here." They all agreed.

I didn't know it at the time, but this incident on Mount Chocorua when I was 14 years old came as a great relief to my father. Some time later he told me, "After that day, I never worried about you on the big mountains. I was very happy to learn something important about you. You know when to quit."

AT THE SAME TIME that Brad was gaining confidence as a climber, he was being exposed to the publishing world. His companions on the New Year's Day 1926 ascent of Mount Washington had included the son and daughter of *Boston Herald* editor Robert Lincoln O'Brien, who happened to be spending the week in a nearby hotel.

Brad had become managing editor of his class newspaper at Groton, the *Third Form Weekly,* and he was continuing to write. The previous spring a piece of fiction he'd dreamed up, a melodramatic short story entitled "Revenge," had appeared in a student-produced magazine, the *Grotonian.* It was the story of a Spanish nobleman named Don Carlos, who, with the help of his "faithful servant Jaunio," exacts retribution on a bandit chief who has killed Don Carlos' son.

Brad's fascination with the outdoors had deepened since his eye-opening—and sinus-clearing—experience atop Mount Washington with his cousin Sherman Hall. Brad had spent his fifth summer at Squam Lake, where he and a half dozen other Rockywold residents about his age had founded the Squam Mountain Club. Their main activity in the summer of 1925 had been construction of a boy-size clubhouse. Built atop nearby 2,100-foot Mount Morgan with some advice from a local carpenter, the cabin was patterned after an Appalachian Mountain Club trail hut; but it was

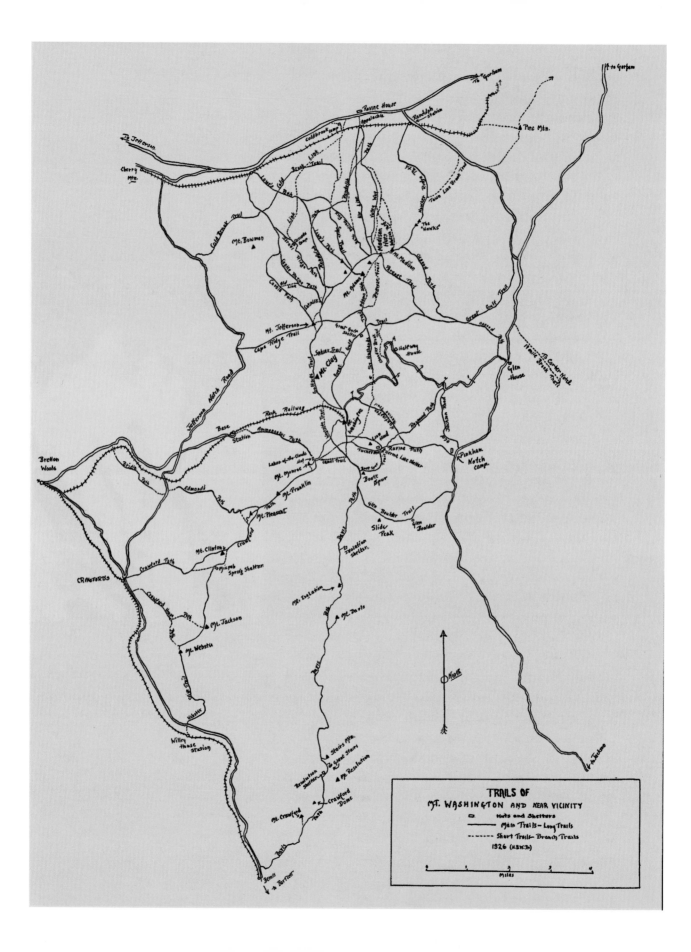

TRAILS OF
MT. WASHINGTON AND NEAR VICINITY

⊡ Huts and Shelters
── Main Trails – Long Trails
- - - Short Trails – Branch Trails
1926 (K.B.W. Jr.)

Miles

only eight feet square, just enough room for a pair of double-deck bunks and a heavy iron stove. A 15-foot observation tower sat atop its roof.

As much as he relished the hills around Squam Lake, Brad had been exposed to bigger stuff through Cousin Sherman. During the five summers following his first trip to Mount Washington he regularly commuted between Squam Lake and the White Mountains. The Presidential Range—so called because of its peaks named for U.S. Presidents—was his favorite area. He climbed every peak in the range at least once.

Brad's twin interests in writing and hiking were about to bear fruit. He started thinking about writing a guidebook.

Excellent hiking guides to the White Mountains had been around for a while. The Appalachian Mountain Club had first published its authoritative version in 1907, responding to the ever increasing fascination with the area by outdoor-minded city folks. By 1926 the club had updated and added material to its publication five times. Nevertheless, Washburn had found nothing in the way of a guide that covered the section he knew best, the Presidential Range, in the packable format that he thought would be most useful to trekkers.

IF YOU'RE only going to climb mountains in one small part of New Hampshire, why carry along a guidebook for all the trails in the state?

My father's brother Charles—the one who was financing my studies at Groton—immediately embraced the idea. Uncle Charlie by now was 69 years old. He had retired from his congressional career and was comfortably well off due to his various business enterprises in Massachusetts. And he was himself a published author: His books and articles on history, economics, and politics included an authoritative biography of his old friend Theodore Roosevelt. When his 15-year-old nephew proposed writing a trail guide, he enthusiastically took over the job of publisher and financial angel. We were going to print 500 copies.

He lined up a printer, the Davis Press of Worcester, whose operator pointed out that the cost of a 500-copy press run would be $474, whereas for only $118 more we could have a thousand. This was an economy of scale that Uncle Charles understood. He chipped in the money. Then, as soon as it was off the press, he launched an aggressive promotion and distribution campaign, mailing review copies to newspaper and mountain-climbing organizations, producing advertising posters and circulars, and making sure that hotels and shops in the White Mountains region were especially well stocked.

No business detail was too small to escape his attention. I still have a "Dear Braddie" letter he wrote me in April 1926 saying that he had talked to a publishing-industry executive "whom your Uncle Reginald says is competent to advise." Based on their conversation Charles had determined we should offer 40 percent discounts for wholesalers and one-third for retailers. We would ship boxes of books to the New England News Company of Boston, Chisholm

MAPPING *landforms and creating trail maps became early and avid interests of young Washburn, as his 1926 map of Mount Washington (opposite) shows. His trail book on the Presidential Range (above) was his first publishing success.*

Brothers of Portland, Maine, and Portland's Eastern News Co. These companies would distribute to bookstores, newsstands, train stations, and hotels in their respective areas.

My uncle was a shameless promoter. In a cover letter to the editor of a Worcester, Massachussetts, newspaper, this man of stature in that community advised the editor: "I am enclosing a little book written by my nephew.... It seems to me that this is a rather creditable piece of work for a boy of 15. If you can find some space to notice this book in the Telegram and Gazette, I shall appreciate it."

THE TRAILS AND PEAKS of the Presidential Range of the White Mountains is an 80-page booklet bound in a sturdy flexible cardboard cover and sized to fit inside a shirt pocket. It contains 39 very serviceable, if not inspiring, photographs. Some of the shots were furnished by the Shorey Studio in Gorham, New Hampshire, whose owner was a good friend of Brad's, and the rest by the author and his Kodak Brownie— the Vest Pocket Autographic having arrived too late for use here. The book also included Washburn's first published map: a neatly hand-captioned pen-and-ink drawing of trails around Mount Washington and vicinity. Originally priced at 80 cents

per copy but soon marked up to a dollar, the guide was praised as "an accurate and comprehensive treatment of the subject and the book has received the hearty approval of those interested in the subject who have examined it," according to identical typewritten notes the author tucked inside sample copies.

Brad Washburn's first book-publishing venture did indeed receive good notices from both the press and the climbing community. In a March 16, 1926, letter the chairman of the Appalachian Mountain Club Guide Book Committee wrote: "Let me congratulate you upon your work. Both in appearance and in the material, the pamphlet is an excellent one." The club official went on to solicit Brad's help in putting together the next edition of his organization's own guide.

Even as uncle and nephew were bombarding outlets and the media with their little volume during the spring of 1926, Brad was becoming increasingly enthralled by mountaineering. That February, when he was only 15 years old, he became one of the youngest members of the Appalachian Mountain Club.

He would put it this way in something he wrote the following year: "Once you get interested in climbing, you keep on growing more fascinated every year, and wherever there are mountains, large or small, you are happy."

MY FAMILY KNEW that when I wasn't climbing, I was happiest when reading about climbing. Among my Christmas presents in 1926 was a book about the French Alps that had been published in France the previous year. Roger Tissot's Mont Blanc *dealt in particular with the history and allure of that mountain, the highest in Western Europe. I eagerly devoured this book, along with another gift:* My Climbs on Alpine Peaks, *written in 1923 by Catholic clergyman Abate Achille Ratti, also known as Pope Pius XI. He had made some really remarkable Alpine ascents before he moved to the Vatican.*

By the winter of 1925-26 my school situation had brightened. In the two and a half years since my shaky start at Groton, I had pulled my grades up to a solid "B" average. Sherry, who had just entered Groton himself, was also doing well. And he too had taken a shine to mountaineering. And so it was around this time that a mountain-climbing trip to Europe entered into my family's thinking.

Travel to Europe involved expensive steamship voyages and large commitments of time. But in those pre-stock market-crash days our financial situation—always comfortable thanks to Mother's Colgate money—had been getting even better. In 1920 Dad had received a promotion at the Episcopal Theological School: He became its dean, with an attendant increase in salary and the gift of free housing in the Deanery.

From Christmas to early June in 1926, Dad had a "semi-sabbatical" in London, where he was studying details of church history. One day, Mother announced that she and Sherry and I were going to take an ocean liner across the Atlantic and join Dad in England. Then we would cross the English Channel in a boat and cross France to the city of Lyon by train. At Lyon we were to fly across the lofty Jura Mountains to Geneva, whence we'd drive to

AN AERIAL of Mount Washington shows Summit House, since burned (foreground, left,), and the other peaks of the White Mountains stretching to the horizon beyond.

Chamonix in the French Alps by automobile. What a terrific plan that was. I'd done lots of reading about the Alps and now we were actually going to be in them—and I secretly hoped that Sherry and I could make some real Alpine climbs!

When we reached Lyon, Dad bought two seats in each of two small, three-seater airplanes for our 75-mile flight to Geneva. It was just plain terrific. Halfway into it, we reached an altitude of about 8,000 feet, and then, as we started our descent to Geneva, all of a sudden I realized that some of the huge clouds ahead of us weren't clouds at all. They were the Alps—and the great white dome of Mont Blanc towered above everything else in sight! I guess this flight was one of the most exciting events in all of my life.

After supper overlooking the lake and admiring Mont Blanc from below, we hired a huge Cadillac with a nickel-plated hood for the 60-mile drive into the small town of Chamonix-Mont Blanc, capital of the French Alpine world. This popular resort town—the archrival of Switzerland's Zermatt—was the fabled starting point for the ascents of Mont Blanc and its famous "Aiguilles," the best rock-climbing in the world.

Night was falling as we approached, and the moon was rising over the mountains. I recognized the Chamonix valley the second it came into view from pictures I'd seen. Sparkling in the moonlight to our right were the steep, snowy slopes of the Aiguille du Gouter, which ran directly to the top of Mont Blanc. As the clouds played a showy game of hide-and-seek among those icy, wind-whipped crags, the lights of Chamonix sprang up before us, and in the next moment we were threading our way through its crowded streets.

Later that night I could see Mont Blanc clearly from my hotel window. The scene was so beautiful I had trouble tearing myself away. Once I did fall into bed, I was asleep in minutes.

But this was no dream. I was in Chamonix, and outside my window was Mont Blanc.

THE MOUNTAIN-CLIMBING world that young Brad was entering was in something of an upheaval. The world at large was in a trough between two epochs. The Great War was over, and already there were portents of more strife on the distant horizon. A number of well-known climbing figures had been killed on the battlefield, and age was overtaking others. Also, controversies concerning ethics and sportsmanship were springing up. Some among the new generation of climbers moving onto the slopes were experimenting with the technology of their craft.

A social shift was taking place during the 1920s as well. Once the province of the very rich, the mountains were becoming infused with the spirit of egalitarianism. Membership in France's Groupe de Haute Montagne was based strictly on merit: Women and even non-French citizens were allowed in as long as they could meet its high standards of achievement. Even in England—where Matterhorn conqueror Edward Whymper once had been blackballed from the British Alpine Club because of his lack of connections—climbers were diversifying down the social ladder.

The true working class in mountaineering remained the professional guide, a skilled group of French, Italian, and Bavarian men who supplemented their day jobs,

and sometimes earned livings entirely, by escorting clients onto the slopes. However, here, too, social lines were being blurred. By the 1920s a select few individuals other than guides were discovering that there was money to be made above tree line. Legend-in-his-own-time Whymper himself—a commercial artist by trade—was paid substantial sums to lecture about his climbing in the Alps. In America, Smith College Latin professor Annie Smith Peck—who turned 76 the year Brad Washburn alighted in Chamonix—had been one of the first to solicit sponsorships for climbing expeditions: The *New York World* had underwritten her reputation-making climbs in Mexico during the late 1890s. And young British war veteran Frank Smythe, one of the most competent mountaineers of all time—but like Whymper and Peck not one of the wealthy ones—eventually found he could sustain himself by writing and selling his dramatic photographs of Alpine peaks.

During the period between the wars, many of Smythe's British compatriots as well as Smythe himself were shifting their focus away from the Alps to concentrate on the ultimate challenge: Mount Everest, which only a lifetime earlier had been firmly established as the world's tallest mountain. The Alpine Club in 1921 had formed a special Everest Committee for the purpose of finding a route to the top and then climbing it. Three years later the charismatic George Mallory had disappeared only a few hundred feet below the summit of Everest.

This was the tumultuous high-altitude world that 16-year-old White Mountains ace Brad Washburn was entering when he set up for business that moonstruck evening in the late summer of 1926.

My climb up Mont Blanc was the best fun I'd ever had on a mountain up until then. I wouldn't have missed my climb up Mount Washington the previous winter for anything: It isn't an easy climb in the snow. But Mont Blanc, after all, is more than twice as high as anything in New Hampshire.

I was accompanied on my first Mont Blanc climb by a guide, Alfred Balmat, and a porter and guide-in-training by the name of Georges Cachat. We were joined by a Canadian gentleman by the name of Meloney, who had decided to make the climb at the last minute. I'd spent an evening taking him to every shop in the town to get him outfitted. The next morning we dumped everything into a tiny train for the short downhill ride to Les Bossons, the place where the trail up Mont Blanc begins.

Almost every tourist who comes to Les Bossons goes up the first half mile of that trail, which isn't very exciting. There's a chalet at that point which provides a nice view of the Glacier des Bossons. After we passed that, the trail became very beautiful: The trees were huge, the undergrowth thick, and there was a notable lack of litter. At about 10 a.m. we reached another chalet situated about two-thirds of the way to the tree line. There we had lunch. I discovered a telescope that allowed me to see my brother, Sherry, walking back and forth on the balcony of our room at the hotel 4,000 feet below.

In the Alps

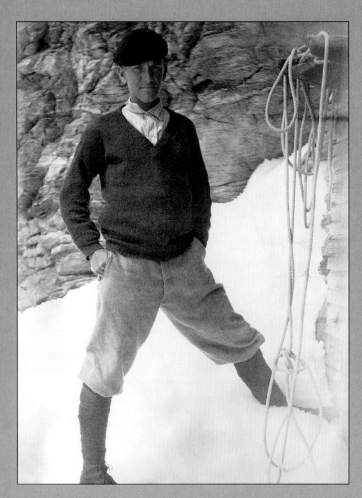

Brad on his way up the Matterhorn, 1926

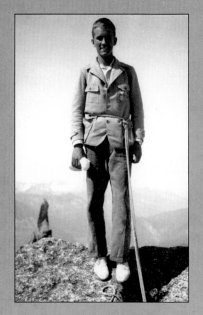

Brad on the summit of
the Grépon, 1929

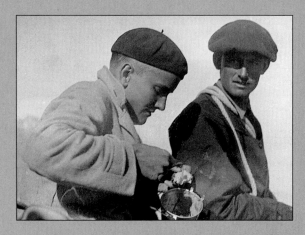

Lunchtime on the Grépon, Brad and guide
Georges Charlet

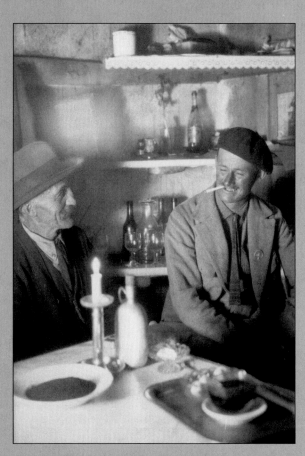

Dinner with guides the night before climbing
Aiguille Verte, 1929

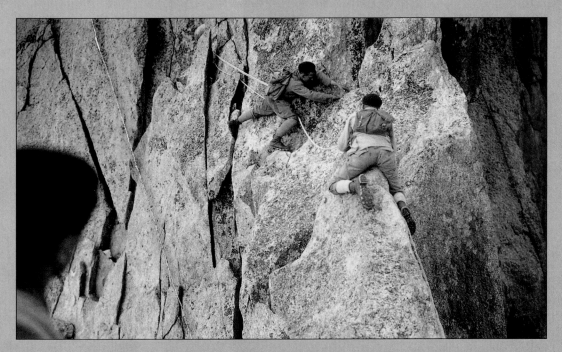

Brad (left) guides Sherry to a precarious handhold during a climb in the Alps.

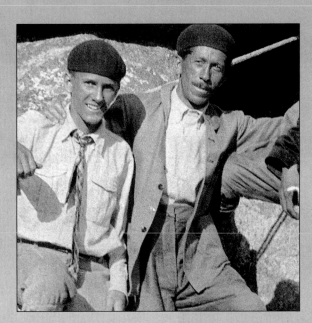

Brad and guide Alfred Couttet, 1929

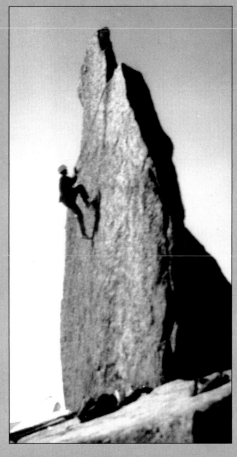

Brad climbs the daunting North Peak of the Grépon.

After another upward hike we reached the edge of a glacier, and things started getting exciting. Our guides roped us up. Balmat put a loop around his waist, paid out 30 feet and tied me on. Another 30 feet was measured out, and then Cachat fastened himself, so that I was safely hitched between the two of them. We put on yellow snow-glasses, and within minutes we were on a glacier, with its snow bridges and huge crevasses—a dramatic spot known as the "Jonction."

Glacier-climbing can be nerve-racking. The guide goes ahead testing the snow with his ice ax, while the person behind him slowly pays out the rope. When the guide is safely across, he firmly plants his ice ax and the next person crosses. Every so often someone falls partway down a crevasse, but if everyone has done his job correctly, it has a happy ending.

We safely arrived at our destination for the night, the Grands Mulets Hut at 10,000 feet. Another, larger, party pulled in after us. Meloney and I were the only English speakers: The guides spoke French, and they were hardly on speaking terms with the rest, who were all Germans.

We arose at 1:45 a.m. and, after a horrible breakfast of cheese, tea, and bread, roped up again and started our climb in the inky darkness, each with his own tiny candle lantern. The slope was steep, but the guides made a firm path in the deep snow. Nobody said a word. We just climbed and climbed. In about three hours we reached a level area known as the "Great Plateau," at an altitude of about 12,000 feet. There the first signs of daylight began to appear.

Another steep slope brought us up to the famous Vallot Refuge—a tiny hut at an altitude of nearly 15,000 feet. The summit was now less than a thousand feet above us, and I was beginning to feel a bit nauseous—an illness which the guides call mal de montagne— mountain sickness.

After a brief rest, we started up the really steep ridge that leads to the very top. As we neared the summit, this ridge became much more narrow, with extremely steep slopes to the Grand Plateau on our left, and down for thousands of feet on our right to Courmayeur in Italy. And at last, at exactly 10 o'clock in the morning, the grade ended and we stood triumphant atop the highest snowdrift in Europe—the 15,770-foot summit of Mont Blanc.

The view was amazing. On one side, many miles away, were the famous Matterhorn and Monte Rosa (the second highest peak in Europe). The Dolomites lay to the south in Italy, and to our north was Lake Geneva. A never-to-be-forgotten experience.

Before that wonderful summer came to an end, I'd climbed not only Mont Blanc but also Monte Rosa and the Matterhorn—an almost unbelievable experience for a kid of just 16.

My first season of climbing in the Alps had not involved any really death-defying feats. But in addition to getting my feet atop some of the world's most famous mountains, I had gotten a look at some of the more competitive areas, especially the Mont Blanc chain's groups of imposing, nearly vertical columns of granite known as the Aiguilles—a French word meaning "needles."

From the top of Mont Blanc the mighty Aiguilles, which loom prominently above Chamonix, looked to this boy's eyes like the "bristles of a large hairbrush lying on its back."

I knew that I would return.

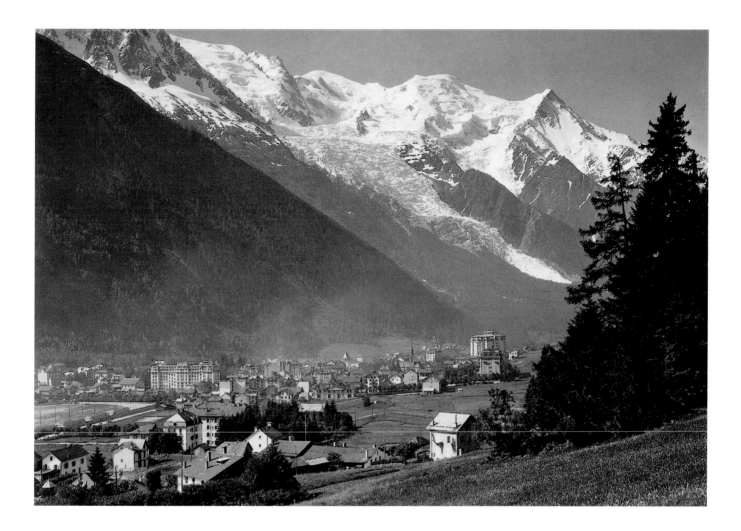

WHILE HARDLY EARTHSHAKING, Brad's first Alpine adventures were novel enough to attract the interest of editors of the *Youth's Companion,* a photo-illustrated magazine published weekly from Boston and catering to fellows about Brad's age and younger. In quick succession Brad sold two cover articles. "A Boy on the Matterhorn: A Sixteen-Year-Old Boy Tackles the Alps" appeared in the issue of March 17, 1927. "I Climb Mont Blanc: A Seventeen-Year-Old Boy Conquers Europe's Monarch Mountain" came three and a half months later. (Although Brad was still 16 when he'd gone up Mont Blanc, the story was published three weeks after his 17th birthday.) Illustrated with his own photographs, plus a stock picture of the Matterhorn on one cover and on the other a shot of Brad jauntily straddling a sharp lower peak with cloud-specked mountains in the background, the articles consisted of chatty accounts of his summer vacation, along with smidgens of the history of each climbing area.

These articles provided Brad his first exposure to a nationwide readership and also set a tone for subsequent writings. He streamlined his byline to simply "Bradford Washburn," the version of his name that would appear on his books, articles, photographs, and maps for the rest of his life.

Among those who spotted this new talent was one of the *Youth's Companion's* most devoted readers: George Palmer Putnam, head of G. P. Putnam & Sons, a venerable book-publishing concern with main offices in New York. Formed in 1838, the company had published such 19th-century American giants as Washington Irving, Edgar Allan Poe, and Nathaniel Hawthorne.

Putnam, whom everyone called "G. P.," was something of an enfant terrible in the New York publishing world: brash, energetic, extremely bright, and famous for his speedy conversions of manuscripts into books. He was collecting for his imprint a new generation of literati, including Alexander Woollcott, Heywood Broun, and Edward Streeter. But Putnam's most heartfelt interest lay in stories of adventure written by the adventurers themselves. The exploits of William Beebe, Knud Rasmussen, Lincoln Ellsworth, and Roy Chapman Andrews would eventually adorn the Putnam shelf, as would the aerial feats of Richard E. Byrd, Billy Mitchell, Charles Lindbergh, and G. P.'s famous second wife, Amelia Earhart.

Putnam immediately recognized that Brad Washburn would be perfect for a new line of books he was developing. G. P. was especially fond of boyhood adventures, having spent a good part of his own youth hunting, trout fishing, and rock climbing around northwestern Connecticut.

He had dispatched his own son, David Binney Putnam, to the Galápagos Islands off the coast of Ecuador on a scientific mission with deep-sea pioneer William Beebe. David's account of his next outing, *David Goes To Greenland,* was the first volume in a series that G. P. decided to christen *Putnam's Boys Books by Boys: Their Own Stories of their Own Adventures.*

Brad was thrilled by G. P.'s proposal that he write a book and was determined to make it a good one. Before beginning, he spent the summer of 1927 in the Alps. Returning to Chamonix, he and brother Sherry hired new guides: Alfred Couttet and Georges Charlet, both from well-established Chamonix families, as well as Antoine Ravanal. Brad characterized them as belonging to a "new school" of guides: "young men who survived the war, wild with the desire for a rough, out-of-door life, and in wonderful physical condition." He called Couttet and Charlet "the most sure-footed, agile and strong pair that I have ever seen."

WITH THESE young professionals showing the way, I made my second ascent of Mont Blanc. Soon Sherry and I were tackling more difficult and in some cases heretofore unattempted routes among the needle-pointed Aiguilles. My first climb there was a traverse of the 11,000-foot Grands Charmoz and Grépon, a group composing one of the four great groups in the range.

Among these weirdly pointed fingers of stone I practiced such skills as grasping tiny hand- and footholds in sheer rock faces; and "crack climbing"—which involved wedging body parts inside vertical fissures in rock faces. We used the ordinary trick for crack climbing of sticking your right knee in the hole, then advancing slowly but surely by jamming in your right

elbow and changing the position of your knee. It's terribly slow until you get used to it, but after a little experience, you can climb a crack like lightning.

The Aiguilles are not a good place for anyone uncomfortable with really steep places. But if you really want to try this sort of climbing, Chamonix's Grépon is the ideal spot to test your competence. Its 80-foot "Mummery Crack" starts you up the granitic Grépon with a bang. My guide, Alfred Couttet, said that if I could climb that crack without any help from him, I'd become a real "Alpinist." I succeeded—and then, just above that crack came another beauty: shorter, but no less difficult.

When I'd managed to top these two of the Grépon's main defenses, Alfred suggested that we attempt the Grépon's rarely climbed North Peak. With his advice and that of Charlet I did exactly that; and when I was on the very tip of the Grépon's North Peak, they took two pictures of me up there—the best photographs in any of my albums.

I climbed the Aiguilles that summer in the traditional way: I didn't use pitons. As for other equipment, I found that hobnailed boots were better than sneakers for climbing in tiny footholds or in snow. But for climbing where there are no footholds at all, and simple pressure or stickiness is needed, I discovered that nothing could beat a pair of crepe-soled sneakers. My guides told Sherry and me that we were the first people who ever used tennis sneakers on a big Alpine rock climb.

I knew the book I wanted to write would require something better in the way of photographs than the snapshots that had appeared in the White Mountains trail guide. I planned to take some pictures myself; but for the professional touch I found a young Chamonix climber-photographer, Georges Tairraz, to document the exploits of Sherry and me. Tairraz, whose family had been involved in Chamonix guiding since the mid-1800s, brought along two still cameras—one to take large-format (5" by 7") negatives, and the other capable of wide-angle panoramic shots.

He also packed a 16mm movie camera. I figured some movies of the Washburn brothers in action would make entertaining souvenirs. Also, Putnam had mentioned the possibility of my making personal appearances in connection with promoting the book. Movies, he'd pointed out, would enliven these events. Tairraz even shot some aerial footage of the Aiguilles during a spin we took in a hired airplane.

The photographic activities slowed down the pace on the slopes a bit. Often Tairraz, with his heavy pack, didn't arrive in time to shoot a climbing segment, so we would repeat it for his benefit. Other times we would do something twice, so he could get it in both stills and movies. It was all done in a spirit of fun and adventure—and with absolutely no qualms about performing for the cameras.

BY THE TIME his second summer in the Alps was drawing to an end, Brad had gained considerable confidence in his abilities, enough so that he was planning even more challenging climbs for the next visit. Any idea that his interest in scaling mountains was only a passing phase was completely gone, at least from his own mind.

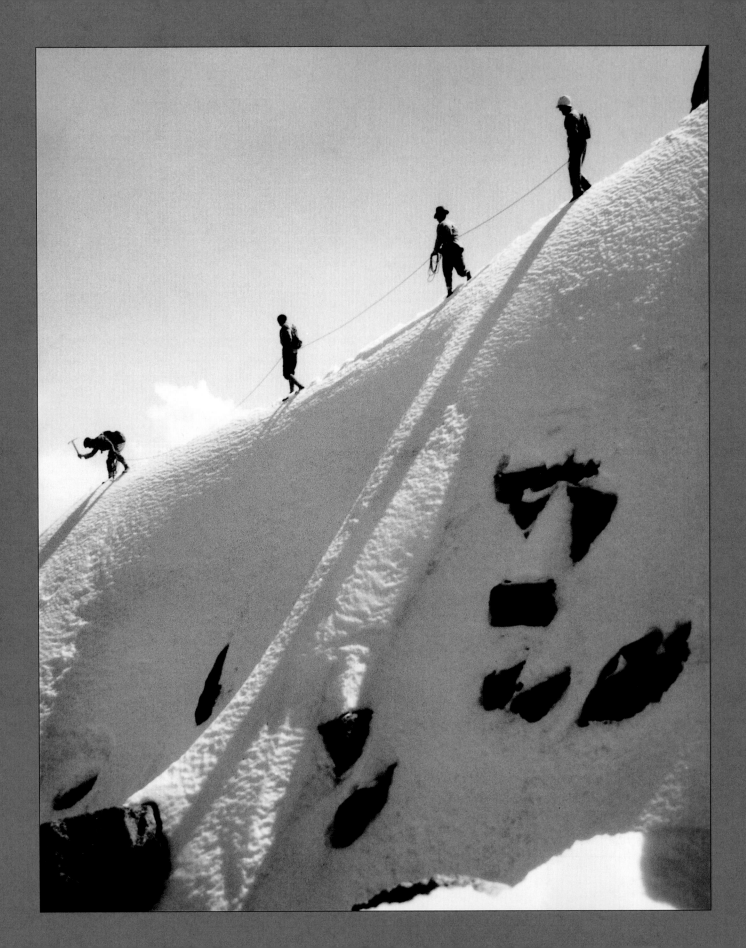

CLIMBERS IN THE FRENCH ALPS

SINCE THE BEGINNING of mountaineering—which generally is traced back to the first ascent of Mont Blanc in 1786, though humans no doubt began investigating high places as soon as they could walk—climbing gear had remained simple. A typical prewar climbing party would have carried not much more than what Englishman Edward Whymper had when he summited the Matterhorn in 1865. His kit consisted principally of poorly insulated leather boots, long-handled ice axes, and lengths of hemp rope. Lithographs from Whymper's period portray climbers wearing snap-brimmed hats with feathered plumes tucked jauntily into their bands.

Harnesses were unknown: Climbers linked themselves by tying rope around their waists. Simple crampons—long spikes worn over boots for ice and steep snow climbing—had been used since ancient times. Nevertheless most Brits considered their use unsportsmanlike and possibly dangerous.

Many elite climbers continued using the same kinds of boots and rope, and little else in the way of specialized gear, into the 1930s. But a new gadget was appearing in some rucksacks. Pitons were small metal spikes that could be hammered into rock cracks. Rings or holes in the ends provided for what the Germans called *Karabiners:* metal links through which ropes could be threaded. Supposedly the rig developed from a piece of fire-fighting equipment used in Munich in the early part of the century.

German climbers in the late '20s and '30s increasingly relied on such mechanical devices to push the limits of what was thought humanly possible. Known collectively as the "Munich School," these Germans, along with members of the Groupe de Haute Montagne, an elite subgroup of the French Alpine Club formed after the war ended, were shinnying up previously unclimbed sheer rock faces and even overhangs in the French Alps and the Dolomites, Western Europe's other climbing mecca. This region of the Alps had been Austrian South Tyrol before the war but after the war became part of Italy.

Early use of pitons had been excused by purists, if at all, as a matter of safety. Spikes set in stone provided backups in cases of slips and stumbles.

Previously, climbers had relied on the steadfastness of roped-together comrades to stop falls, which occasionally led to whole parties being swept away. Four of Whymper's seven-man Matterhorn summit party died just that way when one lost his footing while descending. A section of rope snapped, leaving Whymper and the other two survivors staring in horror as their friends plunged 4,000 feet to their deaths down the north face.

But the piton quickly became more than just a safety device. By the 1920s ambitious climbers were using them not only to stop falls but also to extend their reach. As a matter of aesthetics alone, this practice, in the opinion of critics, was turning mountains into pincushions.

The British, always concerned with what they considered the "good show," were among the unhappiest, maintaining that if one couldn't climb a mountain without an excess of hardware, one should leave the honor to someone else with more skill and nerve.

BRAD (far left), Sherry, David Murray, and their guide descend the summit of the Grand Dru, 1929.

Before boarding the boat back to the States, the family stopped off in Venice for a final late-summer fling. They stayed in the Pensione Calcina, a comfortable small hotel in the southern part of the city where, Brad learned many years later, Victorian art and social critic John Ruskin had done a good deal of his writing. It was here in August 1927, while Sherry and the rest of the family entertained themselves by visiting places of interest around the elegant old city of canals, that Brad composed his first hardcover book, *Among the Alps with Bradford.*

Working with a pencil, copying liberally from the daily journal he'd kept on the trip, he rapidly filled pages of lined, three-hole notebook paper with about 27,000 words in a small, neat script. He remembered later: "I was irritated because my brother and my father and mother were off visiting glass factories and things like that, and I was sitting there in the Pensione Calcina just writing that damned book. I wrote it all, the whole doggone thing, in about ten days."

The 160-page volume measures 5" by 8", about the size of a large-format modern paperback. It contains an assortment of Georges Tairraz's photographs of the participants, especially Brad, scaling vertiginous rock walls and posing atop needle-pointed peaks. The text includes a smattering of history of Alpine climbing but consists mostly of Brad's experiences told just as they happened, day by day, with doses of heart-stopping action, such as this description of an episode on the North Peak of the Grépon:

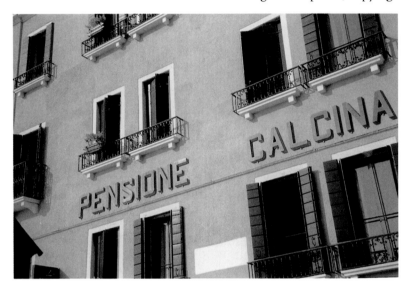

IN THIS pleasant Venetian pensione, the 17-year-old Washburn finished the book describing his Alpine adventures for G. P. Putnam.

COMING DOWN was worse than going up, because I could not see a single thing unless I looked between my feet. That was positively sickening for it made everything look upside down! It seemed as if I had been stepping for hours when I felt the crack in my left hand. I grabbed it, let my legs swing, and at last landed on Sherry's shoulders. He let me down again to the platform.

Even though I wasn't pulled at all during the ascent of the North Peak, the very presence of the rope, and the feeling that I was safe with it around my waist made me do easily things that would otherwise have been very difficult.... The first man up must always have real confidence in himself and iron nerves.

FOR CHRISTMAS THAT YEAR Brad sent out cards featuring a photograph of himself in profile standing on the brink of one of those needle-pointed precipices with the

Mont Blanc massif looming in the background. But the promotion machine that really counted was the one that belonged to G. P. Putnam—who was as famous for his marketing acumen as for his quick turnarounds of authors' manuscripts. That spring he'd gotten Charles Lindbergh's 40,000-word account of his solo New York-to-Paris trip aboard the *Spirit of St. Louis* into bookstores the month after the flight, while interest was still running high. Brad's book required about the same length of time to print, bind, and ship, and by October the promotion wheels were spinning at full speed.

A story about Brad and Sherry in the Alps consumed the entire front page of the *Boston Evening Transcript* pictorial section on October 8. The *New York Herald Tribune* ran three large pictures of a sun-darkened and youthfully rugged-looking Brad in its October 23 rotogravure section, explaining that the subject "is sixteen years old and has won a name for himself as a daring climber."

G. P. himself and son David got into the act that Christmas, accompanying Brad on yet another winter ascent of Mount Washington. Although G. P. had a reputation as an outdoorsman, Brad remembered that the publisher was "horribly miserable" throughout the trip. "It can be an awful place to be in the winter if the weather's bad, and it was. We slogged up the Tuckerman Ravine trail, and by the time we got to the headwall he'd had his belly full of it. We all had things we needed to do, so we just turned back. We didn't get anywhere near the summit. As far as I know he lost interest in mountain climbing after that. It just wasn't his dish."

Nevertheless, Putnam's image appeared in two photographs of the outing in the January 22, 1928, rotogravure section of the *New York Times,* along with two shots of Brad—one of him rappelling down the frozen Crystal Cascade waterfall near the base of the mountain and the other using a rope bridge of his own making to cross a snowy ravine.

The following day the front page of the *Buffalo Evening News* sports section carried the same waterfall picture with the following truth-bending caption: "Bradford Washburn, a member of George Palmer Putnam's party that scaled Mount Washington in New Hampshire, climbs a frozen waterfall. Alpine ropes were a necessity in more than one hazardous spot on the ascent."

With all this publicity, *Among the Alps with Bradford* was enjoying brisk sales. Discussions soon began for a second book, this one to deal with Brad's experiences in the White Mountains. But once again Brad decided that another season at the scene would be in order before he'd be ready to write. In a June 6, 1928, letter Putnam advised his young author: "I note that you won't be able to do more on the book until after June 21. All right. If you have the book all washed up and in our hands by August first, it will be bully."

And so, after a two-summer European hiatus, the Washburns returned to their old cottage at Rockywold Camp. Brad wrote in his journal every night, and the

Putnam manufacturing machine had *Bradford on Mt. Washington* in bookstores that September. Lest some might think New Hampshire's slopes a bit anticlimactic after the Aiguilles, Brad assured readers that he found winter ascents of Mount Washington more difficult than anything he'd encountered during his summer spent in the Alps.

Returning to Chamonix the following summer for two more months, he rejoined guides Alfred Couttet and Georges Charlet, who had taught him well. A breathtaking series of climbs followed, including the first ascents anyone had ever made of the North Face of the Aiguille Verte and the Aiguille du Midi via the Glacier Rond.

"Sunrise on the Aiguille du Midi," an early Washburn photograph, took first place in the Appalachian Mountain Club's 1929 photo show.

THE AIGUILLE VERTE (Green Needle) climb was the most notable. News of our success flashed across the wires of the Associated Press, whose reporter called it a "feat of Alpine climbing which for years has defeated the ambitions of Alpinists of the Chamonix region."

The journalist added: "The passage over an ice-field more than 3,000 feet in length inclined at an angle of 60 degrees has been unsuccessfully attempted many times by the best Alpinists. Young Washburn was the first to reach the summit, at an altitude of 13,770 feet, by this route."

The AP story also carried my explanation that I had first spotted this opportunity in a French guidebook that indicated by dotted lines the routes in the Mont Blanc range that had been followed by successful climbers. I'd told the reporter, "I made up my mind that sometime I would put a new dotted line across that map." And so I did.

THIS AND BRAD'S other trailblazing feats that year earned him a very high distinction after the season ended. At only 19 years of age he was elected to the elite climbing guild, the Groupe de Haute Montagne.

By the fall of 1929 Brad Washburn was an expert mountaineer not only in the minds of the Putnam & Sons promotion department and the media but also among his peers. And he was no longer a boy. He had said his good-byes to Groton and was about to enter his freshman year at Harvard. Nevertheless, G. P. Putnam reckoned that he had one more boy's book in him.

That book, Brad soon would be thinking, might just be about a place that had been coming up with increasing frequency in long winters' conversations with climbing friends: a place located a world away from both New Hampshire and the French Alps.

The place was in coastal Alaska. Its name was Mount Fairweather.

MOONRISE OVER THE GRANDES JORASSES, FRANCE, 1958

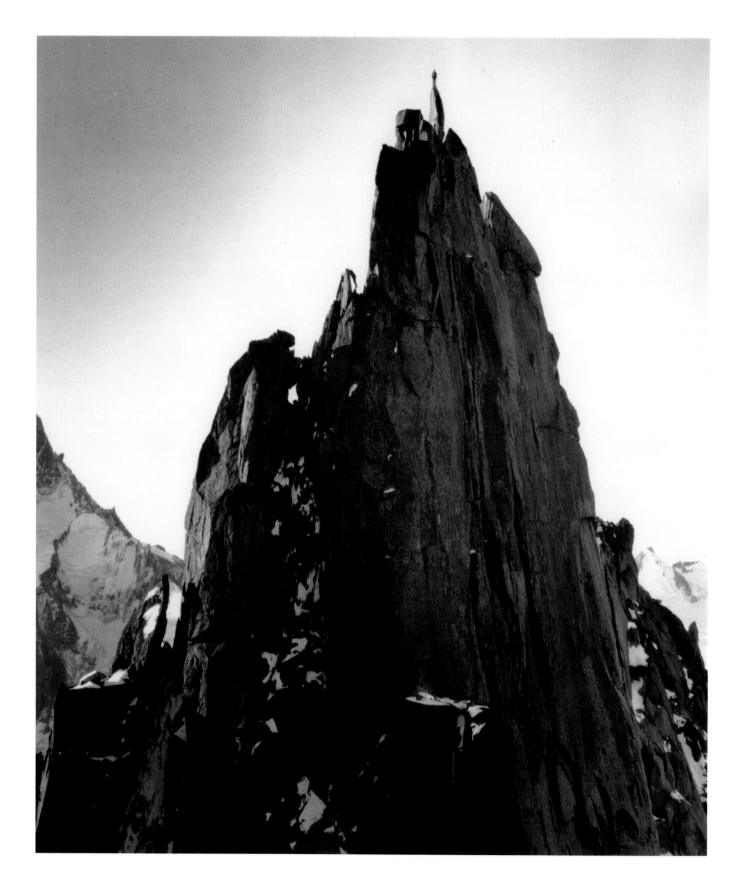

BRAD ON THE RARELY ASCENDED NORTH PEAK OF THE GRÉPON, FRANCE, 1929 (ABOVE AND OPPOSITE)

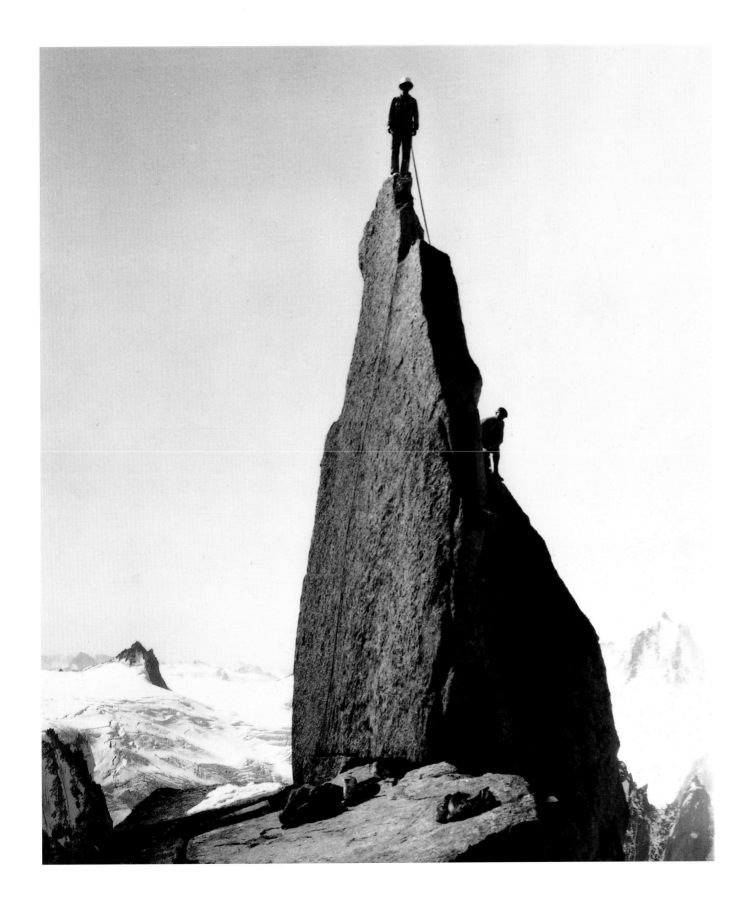

THE CHAIN OF THE AIGUILLE VERTE, TAKEN
FROM THE AIGUILLE DU MIDI, FRANCE, 1957

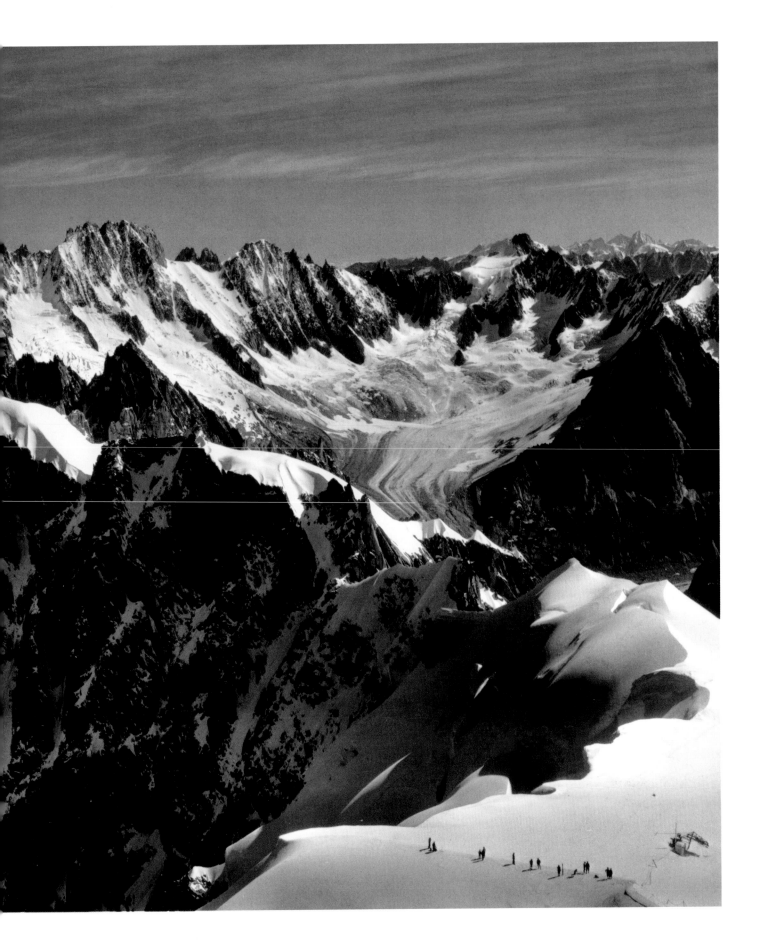

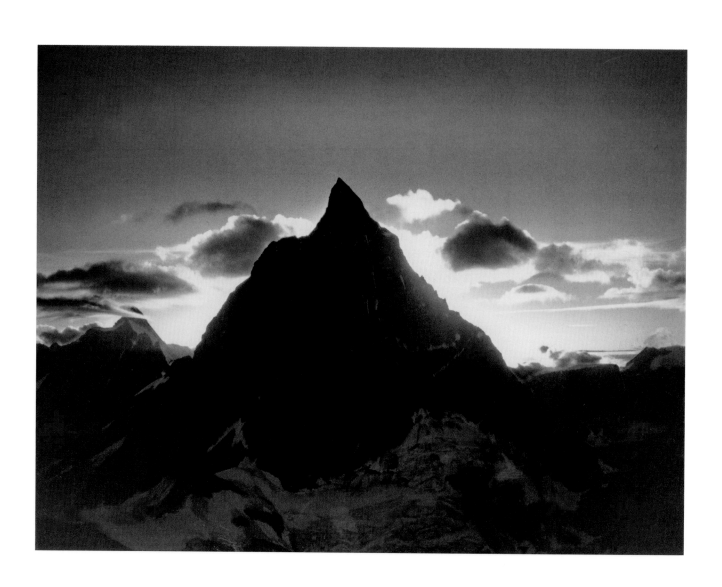

SUNSET ON THE MATTERHORN, SWITZERLAND, 1958

FRONTIERS

1931-1935

In the 1920s a buzz was going around the mountaineering community about Alaska. Climbers were coming back with breathless tales about miles and miles of snow-covered giants untouched by human boots. Except for the roamings of its sparse indigenous population, sizable chunks of the western Arctic were as yet completely unexplored, partly because of their remoteness. Regular air travel from the 48 states wasn't even dreamed of seriously until a pioneering 1920 U. S. Army flight from New York to Nome. The Alaska Railroad wasn't completed until 1923. Nevertheless, increasing numbers of people were being drawn to the region, beginning with the 1880s discovery of gold in the Gastineau Channel, plus a subsequent boom in copper mining and a burgeoning salmon fishery. The place was a magnet for the adventure-minded, some of them lured by the lyrical writings of naturalist John Muir. By the time the Alaska highlands attracted Brad Washburn's restless eyes, they were being vigorously probed.

Some of the peaks that climbers were focusing on had been first spotted from the sea in the 18th century by such explorers as Vitus Bering, James Cook, and George Vancouver. The first major Alaska mountain to be scaled was off the northern coast: Mount St. Elias, which

REGAL and forbidding, Mount Fairweather rises 15,330 feet above Alaska's southeastern panhandle. Fairweather would give Washburn his first taste of mountaineering in the Alaska wilderness.

at 18,008 feet was once thought to be the continent's highest peak. It was summited in 1897 by a team led by the 24-year-old Duke of Abruzzi, an Italian royal who had cut his climbing teeth in the Alps; his success had come only after numerous attempts by others, beginning with an expedition sponsored by the *New York Times* in 1886.

In 1913 bragging rights to Mount Blackburn, at 16,390 feet the highest of the Wrangell Mountains and fourth highest peak in Alaska, went to a team led by American world traveler and mountaineer Dora Keen—whose résumé included Mont Blanc. The actual highest mountain in North America, the south peak of 20,320-foot Mount McKinley in south-central Alaska, was conquered the same year as Blackburn by a four-man team organized by Episcopal missionary Hudson Stuck, the "archdeacon of the Yukon." The event occurred on June 7, 1913—Brad Washburn's third birthday. By the 1920s Alaska was attracting all manner of ambitious climbers, many of them veterans of the Alps, aspiring to score first ascents. Mount Logan, at 19,550 feet the second highest mountain on the continent, was claimed in 1925 by an American team that included Bob Morgan, an older friend and Cambridge neighbor of Washburn.

As twilight settles across Mount Fairweather, the high peaks of the St. Elias Range rear above an undercast of cloud—typical weather for coastal Alaska.

One of the chief remaining targets was 15,330-foot Mount Fairweather, whose majestic profile still beckoned from the Gulf of Alaska just as it had when Captain Cook first saw it in 1778 from the deck of H.M.S. *Endeavour.* Many regard the Fairweather Range as the most impressive coastal peaks on Earth. The main peak, only 14 miles from the ocean, was named Fair Weather by Cook because he noted that whenever he could see it, the weather was good for sailing: Located in the southeastern panhandle 150 miles south of St. Elias, Fairweather is three-quarters the height of McKinley and compares favorably in terms of height and grandeur to the only slightly higher Sierra Nevada de Santa Marta of Colombia.

In 1926—the same year that 16-year-old Washburn was taking his first tentative steps up Mont Blanc—32-year-old American electrical engineer Allen Carpé, who had learned mountaineering in Germany and was considered among the best climbers of the day, led a three-person team that got almost two-thirds of the way up Fairweather before having to turn back. For certain, somebody was going to claim the peak. And it probably would be done soon.

As Washburn finished his first semester at Harvard and began the Christmas 1929 break, he was already thinking about how he would spend his next summer vacation. Alaska was beginning to look irresistible. During a January evening at Bob Morgan's house, while discussing Morgan's 1925 Mount Logan climb, the two friends noted that there were still many unexplored areas in the Fairweather Range.

Several weeks later we happened to be together again and somehow or other the subject of Fairweather came up. We talked it over all one evening and decided that someday we should try to climb the mountain—some day in the far future. But, having nothing better to do and

knowing the value of plans made a long time in advance, we spent many enjoyable February evenings counting up probable costs of a trip to Alaska and listing up food and equipment.

OF COURSE, it didn't take them long to decide that the trip should be done as soon as possible, if Brad wanted his team to be first on top—that very summer in fact. Age as well as work commitments prevented Morgan from going, but Washburn had no trouble rounding up an eager bunch, all about his own age. "The Fairweather Crew" included Washburn's Harvard classmate Art Emmons and fellow Appalachian Mountain Club members Dick Hodges, Gene Kraetzer, and Ralph "Batch" Batchelder.

The trip began agreeably enough. The crew set out from Boston on Friday, June 13—an inauspicious date for a superstitious person, Washburn thought, as they boarded the train at the city's North Station. But superstition simply didn't run in the Washburn family. The crew crossed the continent on the Canadian National Railroad from Montreal to Prince Rupert, British Columbia, where they were joined by

a sixth climber, Harvard Medical School student Ken Olson, and all boarded a steamship for Juneau. From there they headed for the place from which they intended to begin their trek: Sea-otter Creek, exactly where Carpé had started his attempt four years before. Their conveyance was an aging 34-foot gasoline-powered deckhouse boat named *Typhoon*. Its owner claimed extensive knowledge of the local waters. Accustomed to the renowned credibility of Alpine guides, Washburn accepted this statement without much scrutiny.

The weather gods favored them to a point, but they hadn't fully appreciated one of the key differences between Alaska and the Alps—the difficulty of simply reaching the bottom of a big mountain. A setback in their journey to Cape Fairweather all but wiped out room for further delay in reaching the summit within the limits of their travel schedules and supplies.

The trouble began on their way to a stopover point called Lituya Bay. The plan called for them to rest there before continuing on to the cape, where they would land on the beach and set up a base camp. Good luck seemed to have followed them every step from Boston. But now, nearing Lituya Bay, the tables began to turn.

EASILY *toting a hundred-pound pack, Washburn poses on the beach at Cape Fairweather before heading for Lituya Bay. Weeks of rough slogging lay ahead. (Opposite) Washburn's aerial of the tip of the Fairweather Glacier shows the sweeping forest rooted in the dirt on the glacier's surface.*

THE CHANNEL *we had to take into Lituya was only two hundred yards in width. Treacherous submerged rocks lay on either side. The weather was deteriorating: A swell was tossing our little peanut shell of a boat to and fro and we were seeing whitecaps. Rather than risk getting caught in the open during a storm with limited options, we turned southward. We put in at a sheltered cove to wait for more promising weather.*

At 4 a.m. on June 24 we set out for another run at Lituya Bay, which offered more protection than the cove, only to run into another stiff wind, this one from the northwest. The water developed a chop that seemed especially worrisome to our boat's owner, whose name was Bill. He wanted to turn back. But we were tired of biding our time, and losing faith in our pilot's judgment. We diverted his attention by getting him to talk about his experiences navigating Alaskan waters, which he happily did. Before he knew it, we'd passed the point of no return: We were closer to Lituya than any other safe harbor. Captain Bill had no choice but to keep going.

Due to tremendous tidal currents, the bay could be entered safely only at slack tide—the short period when the water was neither rising nor falling. We reached the mouth of the bay several minutes before slack, and it was then that Bill informed us that his vast experience had not included operations in these particular waters. He'd entered Lituya only once, and that had been 35 years ago.

Annoyed and a little frightened, we turned to an Alaskan navigation book that someone had thought to bring along containing directions for going in. What we read wasn't very

reassuring. At least a dozen men, we discovered, had been drowned when the first attempt to enter the bay was made by French explorer La Pérouse 150 years ago, and scores of fatal accidents had happened there since then. The pilot book advised us to "stick within 75 yards of Cormorant Rock, and then, swept along by the current, you can't help getting in. Never try to go in on an ebbing tide, as it may prove to be too much for you and carry you into the breakers off the rocks."

That all sounded reasonable enough, but the tide was already beginning to flow in at the entrance—and where on Earth was Cormorant Rock? The whole narrow entrance to the bay was nothing but huge boulders. We chose the biggest rock in sight and headed 75 yards west of it. The current was already flowing faster than we had expected, and before we knew it we were whisked through the narrow entrance, past the rocks, and into the beautiful calm lagoon beyond. We heaved a sigh of relief that seven more men hadn't been added to the Lituya Bay "death list."

The next day we left the bay and resumed our trip. But when we arrived at Cape Fairweather, we realized that a landing would be impossible. Heavy breakers on the beach would swamp us. We beat it back to Lituya Bay, where our reentry was even more hair-raising than the first time we'd gone in. When we got opposite the entrance, the tide, which we'd left low in the morning, was pouring through the narrow crack in the rocks like a whirlwind. Great sheets of spray crashed far up onto the rocky shore. In the meantime the waves outside the bay were beginning to get nastier. As we ran back and forth at the mouth of the bay waiting for the tide to slack, our old boat took some pretty fine seas over her bows.

At noon we decided it would be safer to ride the current in than to wait outside for another hour in the steadily worsening weather. So Gene and I stayed in the cockpit while the others went below, and we closed fast the hatch door. With Gene at the helm, we spun the boat around once more and headed for the harbor mouth. According to the book we were absolutely safe but in for a rather rough ride.

The nearer we got the worse things looked. The current was roaring through the entrance as the ocean struggled to get in and fill up the bay. I noticed cormorants sitting on our big rock sunning themselves as the water lashed all about. At that moment I wished that I were a cormorant, or a rock, or anything at all as long as it wasn't in that boat.

At last we were in the maelstrom. It was even worse than it had appeared from a distance. Swept along with eddying waves and whirlpools flecked with foam, we surged toward the mouth of the bay. In the next second the boat was in the apex of the rapids. Several seals flashed by, fighting the current and catching fish in the swirling water. They appeared happy and calm.

And then it was over, just as the book had said. We were inside the lagoon, wiping the perspiration from our brows and opening the deckhouse door.

Clearly, we couldn't reach the base of Mount Fairweather by sea. So we headed for Cenotaph Island in the middle of the bay, and there we sought the advice of its sole resident: a hermit by the name of Jim Huscroft who made a living selling fox skins. When we'd

left Juneau we'd been given Jim's mail and urged to seek his advice about the best way to approach Fairweather. Jim's advice for reaching the base of the mountain by foot was simple: "Don't try to follow the beach along the Gulf of Alaska. Instead, go to the head of the bay, turn sharp to the left, and head westward along the valley that parallels the coast behind the foothills."

We followed Jim's advice, trekking for miles and miles of the most miserable going imaginable along what we called Desolation Valley, plagued by bugs, humidity, and rain, until we reached the bottom of Fairweather. Along the way we were finding time to observe the geology of the rocks we were passing over and to take measurements of the landscape for the purpose of adding detail to existing maps. We began climbing.

Finally, on July 20, we broke through the heavy mists that had dogged us for so long. All that moisture now had become picturesque. It was now a gleaming, foaming sea that billowed around the mountain below us.

Early the next morning an advance party of myself, Dick Hodges, and Art Emmons set out to reconnoiter the route ahead. We roped up in the approved Alpine fashion, with me in the lead. We reached a rocky shelf at 11 a.m., and, after a break for lunch, continued up a short, gently rising snow slope that had hidden the upper part of the mountain from our view all day.

I was the first to reach the top of the slope, and that's when I saw it. A 400-foot ice-covered cliff stood between us and the summit, like the wall of a well-fortified castle.

Climbing it was out of the question. The only possible solution I could see involved an alternate path that would have taken us on a looping 900-foot descent below the level of our highest camp before we could resume our upward progress. And even then we couldn't be assured we could reach the top. We now could see another problem: Towering about 3,000 feet above us was a sharp, steep snow ridge that would be distinctly tough going.

Dick, Art, and I retreated to our highest camp, where we looked at our situation from every possible angle. Food had become the most pressing issue. When our supplies and equipment—including the 16mm movie camera I was using—had been carefully counted, only 14 days of edibles would remain to take us to the summit and all the way back to our base camp—and that was still a long, long way from Lituya Bay.

The top could be reached in 14 days from where we were, but that would be possible only if we had continual good weather. Besides, it would be impossible to work steadily up such steep slopes without at least 2 days off in 14. And last but not least, a 900-foot descent in the middle of our line of camps would be a very dangerous handicap if somebody got hurt high up on the mountain.

At 2:30 a.m. on July 23 we cooked breakfast and started for the base camp to rejoin the others. It was gloriously clear outside. Not a cloud was in sight anywhere, and the stars already were beginning to disappear at the end of the short Alaskan night. Tiny banks of morning fog scurried across the dark face of the Pacific Ocean, which stretched out like a great plain 5,000 feet below us. A fine day for a retreat.

Roping up, we started down the gully, and in two hours arrived at the camp. The fellows there were just getting ready for an early day's work. Sitting down with them to a steaming pail of cornmeal mush, we talked the future over together.

We finally agreed that the time had come to turn back. It was a great disappointment, but the chance for the top was really awfully slim. The risks of so hurried a campaign would be great. All weights would have to be cut to a minimum, and we couldn't possibly take along any moving picture equipment. From every point of view our trip would be more of a success if we returned to the lower camp and continued our exploration of the base of the mountain for the next ten days or two weeks.

It would be a lot better to go home loaded with knowledge and pictures of the region and in good health than to stake everything in a risky struggle for the top, and to return worn out with nothing to show for our work.

A load off our minds, we climbed back to the ridge and spent the rest of the day taking movies and still pictures of the camp and the icefall. Then, late in the afternoon, we gathered

BRAD WASHBURN: ON HIGH

everything together and packed it up. Saying farewell to the icefall, we started down our gully for the last time.

We discovered packing loads down a gully to be quite a different proposition from going up, especially since we had two loads each to take down all at once. Only three of us could work at a time because of the great danger of falling rocks. So Art, Batch, and I took light loads and went ahead, and the three others stayed to let the stuff down with rope to the glacier below.

At ten that night Ken, Dick, and Gene tumbled hot and exhausted into camp. What a tale they had to tell about getting down that gully! Duffle bags had broken loose and gone bounding down for hundreds of feet, lodging at last on narrow ledges. The ropes had gotten tangled in the rocks. The tent poles were lost. They had three heavy loads with them. The rest of the stuff they'd left halfway down the gully when darkness fell and they couldn't see to gather up our unfortunate equipment, which was now strewn from one end of the gully to the other.

A hot supper put new life into them, and in an hour we were all sound asleep.

IN TERMS of pure adventure, the trip was a rousing success. But since the team had failed to reach the summit, what would happen to the Putnam book deal? Could Washburn sell the Fairweather trip on the lecture circuit? What would this do to his reputation?

These were questions that he would have to deal with later. But in the narrative that he did finally get around to publishing, he skipped this telling detail: One of the crew had strenuously held out for continuing to the top of Fairweather. And it hadn't been Washburn.

Many years later Washburn explained:

ART EMMONS was unhappy. He was the only member of the party who thought we ought to smash it out, run out of food, and somehow or other do it. Emmons said, "I think you can do this through." And I said, "I think we can't do it. We haven't got the time, and we haven't got the food. And I'm not at all sure whether this is the right way up anyway. Look, we're either going to get up this thing and do it right, or we're going to get the hell out while we can." Everybody in the party but Emmons agreed. I don't think he ever forgave me.

BEFORE THEY LEFT, Emmons made one last attempt to prove that the deed was doable, dashing off by himself to try to find another route. It didn't work, and nothing was changed. What Emmons didn't fully appreciate that day of decision on Mount Fairweather was that, like many other successful explorers before and since, once Washburn made a decision, based on one of his unflinchingly honest assessments of a situation—and having heard out all other points of view—it was impossible to change his mind.

BACKLIT *by the late afternoon sun, Mount Fairweather looks misleadingly serene. But climbers consider it one of the most difficult Alaska peaks. Even before Washburn attempted its summit, it had challenged and defeated respected American climber Allen Carpé.*

He knew when to quit.

The decision to go back had not been an easy one. By the summer of 1930 the business of writing and lecturing mattered a great deal. Uncle Charles was no longer around to take up financial slack: He had died in the spring of 1928, leaving $10,000 each to Brad and Sherry with the intention that the money be applied to their educations. But Brad had diverted a good part of his share to climbing activities, including paying the salaries of his guides during the 1929 climbing season in the Alps. Royalties from his 1927 Putnam book about the Alps and the 1928 Mount Wash-

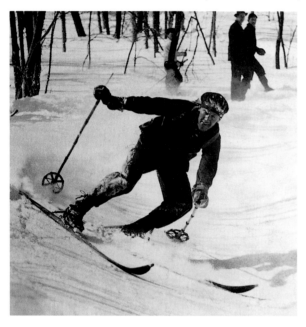

ington book, plus an increasing number of speaking engagements, had even emboldened him to buy a car. At the end of the summer of 1929, freshly returned from the Alps and about to enter Harvard, he plunked down $520 in cash for a brand-new, glossy black Model A Ford Sport Roadster.

After the stock market reversal, however, Brad's writing and public speaking became critical. The family now had its hands full paying college bills and could no longer afford to subsidize summers in Europe or Alaska. He saved some money by continuing to live in his parents' spacious home, within comfortable walking distance of the Harvard campus. But if he intended to continue both college and climbing, he would have to rely on his own income.

The potential was certainly there. Public speaking was a thriving industry in 1930 America. During the previous century such luminaries as Mark Twain had resorted to the lecture-hall trail in times of financial need. Literary figures, along with psychologists and others who could speak on the general subject of self-improvement, were still in demand, especially among women's clubs in the upscale suburbs surrounding major cities like New York and Chicago. A typical club budget for a season's worth of 12 speakers would run in the neighborhood of $2,500, with individual fees varying between $150 to $300 for a good lecturer. Famous names commanded $400 to $500, with superstars—especially British literary lions—ranging even higher.

Closer to Washburn's niche in travel and adventure was the kind of thing then being offered by one of the nation's foremost lecturers, Burton Holmes, who is credited with inventing the term "travelogue." Holmes was an elocutionary role model for the teenage Brad Washburn. Sixty years old in 1930, Holmes made a princely living talking about his visits to exotic locations around the world—and not only for women's clubs. He typically made all arrangements himself, beginning by renting the best theater or concert hall that a town had to offer and then heavily promoting the event. At a time when first-run Hollywood movies cost ten cents,

he would deliver his program to audiences wrapped in evening clothes for $1.50 a head. As good a photographer as he was a speaker, he illustrated his performances with his own slides. Long before the introduction of color film, some of his pictures were meticulously hand tinted to provide dashes of color in between the black-and-white photographs.

Another advantage of the lecture circuit for authors was that it sold books. It was no coincidence that Washburn's professional speaking career began in 1927, the same year as his first outing as an author with Putnam. G. P. himself personally encouraged this activity, advising his young protégé on such matters as choice of 16mm movie camera equipment to pack on climbing adventures for the enlivenment of his presentations. In an October 1928 letter Putnam wrote: "Certainly you should have a standard film hand camera. The DeVry is what we have used. I can help you with that."

Washburn was well prepared for such lecture work. He had received formal training in the craft at Groton, where his skill on the podium had earned him the captaincy of his debating team. He started on a small scale, expanding the slide shows he'd been assembling for family and friends by signing up local church and school groups, and making himself available for travel during school breaks. He wasn't yet sufficiently famous to draw large crowds—or paychecks. In another letter from Washburn's Manhattan cheering section, G. P. Putnam told him in February 1929 that "I haven't any inspiration for lecturing in the Easter vacation. Sorry. It's pretty hard to get a professional line-up of that kind unless the folks know you in advance."

However, the business was steadily picking up. Brad was beginning to receive invitations from the likes of the West End Club, a women's group located in New Haven, Connecticut, and the Boston City Club, which wanted him to be the main speaker at its "Sons of Members Night" in late March. As usual the family rallied behind his efforts. For the Boston engagement, his father wrote him on February 28 that "the following places are willing to put your tickets on sale: The [Harvard] Cooperative, Amee's, Cambridge Social Union, and at the door at the time of the lecture.... By the time you get this letter you should get the poster.... When you tell me to do so I will get some of the boys [in the theological school] to take tickets for sale If there is anything else I can do let me know."

In addition to G. P.'s personal counsel, Putnam & Sons offered professional public relations support. In the spring of 1929 the company was pushing *Bradford on Mt. Washington,* which had been published the previous fall. In a March 1 letter, Putnam's sales manager requested of Washburn the dates, times, and other particulars of an upcoming series of lectures at some New Haven-area public schools, explaining that "I want to be in a position to do some more promotion work in New Haven, and I can't very well do it without having the above information." Washburn responded promptly, and the Putnam executive promised by return mail to "do what we can to promote the sale in connection with these engagements."

On his home turf in New England, Washburn races down Mount Washington, the first major mountain he ever climbed.

FREDERICK COOK

ON SEPTEMBER 15, 1906, a cold and exhausted Frederick Albert Cook, gasping for breath in the oxygen-poor air, stumbled across a final few yards of hard-packed Alaska snow to become the first person known to have set foot atop 20,320-foot Mount McKinley. The 41-year-old sometime physician's achievement capped several decades of unsuccessful attempts by some of the world's most accomplished mountaineers to summit North America's highest peak.

Or so Cook claimed.

The yarn included elaborate details. He had built a survival igloo to escape treacherous winds on one of the upper slopes. He'd marveled at the sight of a sky "as black as that of midnight," at snow that glittered beneath his feet "with a ghastly light," and, at the very top, at seeing 50,000 square miles of "Arctic wonderland … spread out under our enlarged horizon."

The more likely truth about Cook's expedition is as stunning as his account of it was bold. An enormous body of evidence—some of it developed over more than four decades of study by Brad Washburn—indicates that Cook's account of his dash for the top was a complete fiction. According to a confessional affidavit by his lone climbing companion, Montana blacksmith Edward Barrill, the two never got more than halfway up.

Washburn's interest in one of the greatest exploration hoaxes of all time was triggered by his own early experiences on McKinley—Denali to local Indian residents—beginning with his 1936 National Geographic Society-sponsored aerial photographic surveys. In 1955 he began a long-term, detailed field investigation of the 1906 Cook expedition. A string of authorities, including the Explorers Club, had denounced Cook's story. Yet, the charismatic explorer still had a cadre of passionate defenders—as he has to this day.

Washburn's findings supported and in some cases added to the evidence that already contradicted Cook's claims. Among Washburn's conclusions: It would have been physically impossible for Cook to complete his 44-mile route in eight days, since each day he would have had to ascend 5.5 miles and climb 2,465 feet—approximately five times the distance and almost three times the altitude gain required by the average climber taking the much easier West Buttress route up McKinley.

Some of the most incriminating evidence stems from Washburn's efforts over the years to find the exact places Cook stood to take his photographs of the climb, including one infamous shot purporting to show Barrill posing on the summit holding an American flag. What has become known as Cook's "Fake Peak" (far right in photograph above) lies almost 20 miles southeast of McKinley's actual summit—at only 5,386 feet.

Cook—whose later claim to have reached the North Pole was also discredited—died in 1940 after serving a prison sentence for fraud in connection with a Texas oil deal.

No doubt young Brad Washburn was delivering good value for his fee. For his record-making return to the Alps in the summer of 1929 he paid $500 to finance his most ambitious film to date. *The Traverse of the Grépon,* starring Sherry and himself, was shot by Georges Tairraz in 35mm—a format that projected much better on large auditorium screens than Brad's previous 16mm efforts. That same summer he laid aside his Kodak Vest Pocket Autographic and bought an Ica Trix. The camera, made in Europe, came with a high-quality Zeiss Tessar lens and produced 4" by 6" negatives, which resulted in notably sharper images of the large subjects he was photographing.

Only weeks before the chaos broke loose on Wall Street in late October, Washburn mailed a proposition to the master travel lecturer himself, Burton Holmes. He advised Holmes of his new film of the Grépon—which had not yet been edited—and offered to allow Holmes to show it as part of his upcoming program on France. In reply, Holmes's business manager noted that though the great man himself was "now filling engagements in the Far West," he would be in Boston in late November and could discuss the matter then. The manager added: "No doubt you will hear from Mr. Holmes. If you have something that he can use, I feel quite sure that you will have no difficulty in coming to terms."

Partly on the strength of this encouraging reply, on October 25 Washburn used another chunk of his inheritance from Uncle Charles to buy an expensive 35mm DeVry projector. Four days later the stock market collapsed, and Harvard sophomore Brad Washburn faced a new set of economic facts. But the projector proved a good investment. Washburn was soon licensing his film to Holmes, and even on occasion traveling with him and taking over the part of Holmes's program on France that concerned the Alps.

"I would go along with him and talk about the Alps for 12 or 15 minutes in the middle of the lecture," Washburn recalled. "He found that this was much better—to have the person who had actually been there telling the story of what we did rather than him running the picture alone."

In addition to his fee, Washburn picked up from Holmes the most valuable advice he'd ever had on the subject of public speaking.

HOLMES said that when you are in a big lecture hall the temptation is always to talk to the people right in front of you, because you can see their faces. He said never, never, never do that. You talk to the first gallery. You can peek down once in a while to see if people below look happy, if they are enjoying it. They will either look intent or they will laugh and you will see the happiness in their faces. But always talk to the first balcony. Always stand up on the edge of the platform because if you get in behind the proscenium a lot of your voice gets lost. He was a real pro at this thing and had made a real fortune doing it.

HOLMES WAS Washburn's ticket into the big leagues. In 1930 they appeared together at Boston's Symphony Hall, Carnegie Halls in New York and Pittsburgh, Philadelphia's Academy of Music, and Orchestra Hall in Chicago. Washburn soon signed on with a veteran Boston firm—the A. H. Handley agency—to book and promote engagements for his own one-man show. His growing fame and exciting presentations quickly earned him prominence—and high-profile bookings. That March he gave his first lecture for the National Geographic Society, which hired Constitution Hall in Washington, D.C., for his movie-enhanced presentation entitled "Treading a New Trail to Green Needle's Tip."

His fresh young face and energetic presentation made Washburn a big hit. In the Player's agency brochure for the following season, Washburn shared top billing with two eminent scientist-explorers: Capt. Donald MacMillan of Arctic fame, and Eugene DuBois, discoverer of the remains of Java man, the first known fossil of *Homo erectus.* A photograph of young Washburn dressed in suit and tie, with his hair closely trimmed at the sides and a very earnest look on his face, appeared in the middle of shots of the two older and more established adventurers. His caption read: "Bradford Washburn, Mountaineer: The Ascent of the Grépon (1929), Exploration of Mt. Fairweather (1930)—A fascinating story graphically told and illustrated by remarkable motion pictures."

As for his failure to summit Fairweather, Washburn followed his father's wisdom about Brad's disappointing football career at Groton: Accept defeat and move on. Defining the expedition as an "exploration" was just fine with G. P. Putnam. He cranked out the third and final installment of Washburn's contributions to the Putnam *Boys' Books for Boys* series. *Bradford on Mt. Fairweather: Exploring the Famous Alaskan Peak,* which arrived in bookstores in October 1930.

Although he had to pack his public speaking into weekends and breaks in his Harvard class schedule, Washburn's lecturing career took off. His calendar around Easter 1931 was crammed. On Monday April 6 he had an anthropology exam. The next day he was due 900 miles away in Chicago—a grueling overnight train ride—for two speeches, including one at the Rotary Club, which was paying $100. Wednesday it was on to the Milwaukee City Club for dinner at 5 p.m. and a $200 lecture at 8 p.m. Thursday he was to be at the Milwaukee State Teachers College at 10 a.m. ($75), and then New Trier High School in Winnetka at 1:45 p.m. ($100). Friday he was due in St. Louis. And so it went through most of the Easter break.

He wasn't allowing this frantic pace to interfere with his grades, although it was to keep him from earning highest honors. He finished his first year at Harvard with a B average. Lecturing wasn't getting in the way of a fairly active social life, either, though this was the aspect of college life that least interested Washburn. Famous bands sometimes entertained at the campus dances he attended, but he never paid much attention to who they were or what they were playing. He said, "I think a lot

of people viewed us climbers as sort of cockeyed people. We didn't get involved with that sort of thing. I didn't even pay much attention to girls. I suppose I was too damned busy with mountaineering and lecturing."

Nevertheless, as one would expect of a young man who was bright, athletic, good-looking, and famous, Brad found himself in demand at Harvard social functions. He routinely received notices from organizers of dances at such places as Harvard's Brattle Hall and the Somerset Hotel in Boston. Occasionally, to kick off an evening he would have a date over for dinner with his parents at the place where they all still lived together, the Episcopal Theological School's "Deanery." A vellum card received by his parents, dated December 5, 1929, reads: "Miss Martha Stearns accepts with pleasure the kind invitation of Mr. and Mrs. Henry B. Washburn to dinner on Saturday evening, on December the fourteenth before the Brattle Hall Dance." However, Brad's graceful negotiations of 60-degree granite walls didn't carry over to the ballroom floor. He gamely struggled to improve himself with dancing lessons, which at $3.75 per session in 1930 dollars weren't cheap.

He was much more smitten by the part of his Harvard experience that involved earth sciences. His entry into Harvard had coincided with the arrival on campus of a mountaineering icon: British climber Noel Odell, who had been a member of several post–World War I British expeditions to Mount Everest. Odell had signed on for two years to teach geology. Another happy coincidence was the opening of Harvard's Institute of Geographical Exploration. In 1929 Harvard grad Alexander Hamilton Rice, who had married into wealth, offered to build the institute in exchange for being named its director and a professor. Rice, who later used Harvard as a platform for his own extensive exploration and mapping of the Amazon Basin, immediately set about recruiting an impressive faculty. It included U. S. Army Capt. Albert W. Stevens, who went on to fame as a high-altitude balloonist, and another Army officer, Lt. (later Maj. Gen.) B. B. Talley, one of the earliest promoters of photogrammetry, the process of making extremely detailed maps from aerial photographs.

Washburn felt he had entered a kind of academic nirvana. Any discomfort about his less-than-elite economic status at Groton melted away in Harvard's more egalitarian environment. Since he already was fluent in French from his days at Groton as well as his travels in the Alps, he chose to major in French history and literature. But the subjects that really engaged him were the kinds being taught by Stevens, Talley, and Odell.

As the months turned into years at Harvard, Washburn's boyhood interest in mountain climbing for fun deepened into an adult understanding and appreciation of what mountains are made of, how they are formed and continue to be affected by geologic processes, and ways of understanding them through cartography. However, none of his textbook learning was lessening in the slightest his longings to dig his own boots into actual rocks and ice. He was still interested in the Alps, but

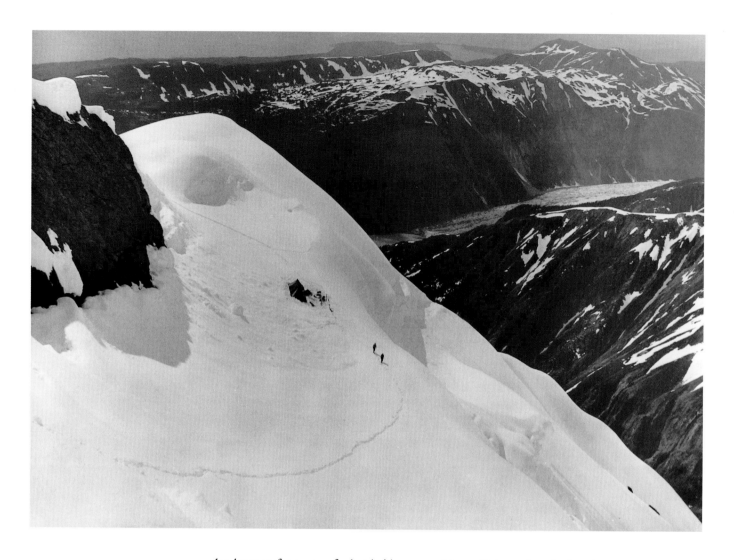

also hungry for more of what he'd seen on Mount Fairweather during that summer of 1930.

FAIRWEATHER WAS a bitter introduction to Alaska mountaineering, a great disappointment, but we learned a lot on that trip. We learned that Alaskan peaks are big, and they're remote. It's often as hard to get to the bottom as it is to get to the top. And we learned how to fail.

ANOTHER party succeeded in climbing Mount Fairweather the very next year. In the summer of 1931, while Washburn was in Europe photographing his latest ascent of Mont Blanc for Burton Holmes, Allen Carpé—who had fallen short in 1926—returned to Fairweather with three other competent and experienced climbers and enough supplies for a three-month siege. It took two months for two of the four to reach the summit: Carpé and Washburn's close friend Terris Moore.

The same summer that Carpé was finishing off Fairweather, Washburn had returned to Chamonix—this time with Harvard classmate Walter Everett. But by now,

Washburn was no longer driven to make the kinds of pioneering climbs he had done among the Aiguilles in 1929.

I HAD SEEN first-hand the quite different kinds of challenges presented by Alaska. Whereas competitive climbing in the Alps requires a high degree of technical skill—the ability to make difficult moves on steep rock and ice faces—I'd found that Alaska climbing was more akin to Arctic exploration. During the summer of 1931 in Chamonix I concentrated on developing high-altitude camping and cold-weather survival skills with an eye toward another foray into the land of the midnight sun—where there were neither guides nor porters.

Back at Harvard that fall for my junior year, my thoughts turned again to Mount Fairweather. I made up my mind to return the following year, the summer of 1932; only this time my purpose would not be simply to reach the top—the distinction of being first now belonged to Carpé. For this round I wanted to put some of my new academic knowledge to work, to expand on the relatively rudimentary mapping and geologic studies that the "Fairweather Crew" had begun in 1930.

As soon as spring finals were over, I set out once again in the company of some Harvard classmates and other climbing chums for the jumping-off place near Cape Fairweather. This time Hamilton Rice of Harvard's Institute of Geographical Exploration was contributing money and equipment. Instead of hiring a boat, which had resulted in such dicey adventures in 1930, I got a seaplane to fly us in to one of the lakes near the cape. But once again I was outsmarted by Alaska. The lake was still frozen solid. Our team wound up in a familiar place, making a perfect pontoon landing in good old Lituya Bay.

We were now facing a replay of our torturous 1930 overland trip to the base of the mountain before we could even begin the climb. I made a snap decision: I said the hell with Fairweather. We would aim instead for the mountain's somewhat smaller neighbor just to the south: Mount Crillon.

Crillon was one of those snowy peaks close to the water that had so impressed us during our 1930 journey out of Juneau aboard Typhoon. *Although not as big as Fairweather, it is respectable: at 12,726 feet, the second tallest mountain in that range. Best of all, Crillon was only 12 miles from Lituya Bay—half the distance to Fairweather— and it had never been summited or even to my knowledge attempted. This was real mountain exploration.*

Our team wasn't prepared for a summit attempt that season, so we spent the next several weeks reconnoitering a practical route up Crillon, and collecting rock samples, survey data, and photographs.

Crillon now became a full-fledged school project. During the remaining months of my senior year at Harvard, with a cadre of geology and geophysics professors looking over my shoulder, I developed an extensive set of scientific goals for the 1933 season. Principal among my objectives were a geologic survey of the surrounding mountains, and a study of movement

ON THE slopes of Mount Crillon, two members of Washburn's 1934 expedition leave Camp III on a relay trip with supplies for Camp IV. The loads on these trips often weighed more than a hundred pounds.

Mount Crillon Expedition

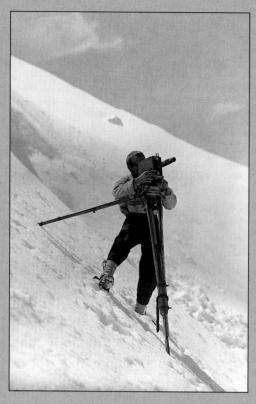

Brad trains his camera, its tripod supported by ski poles, on the summit of Crillon.

This Lockheed Vega dropped supplies on the snow-cushioned slopes of Crillon.

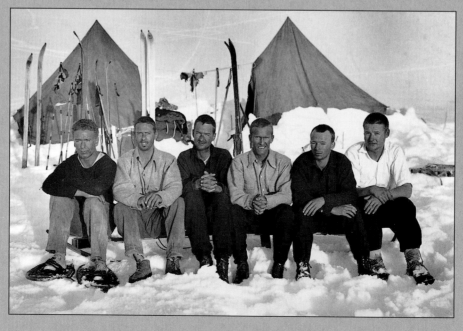

The Crillon team members relaxing at camp

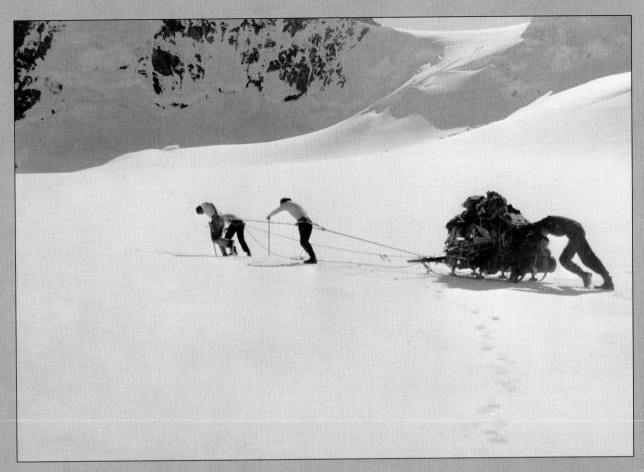

Sledging a 900-pound load was hot work, no matter the temperature.

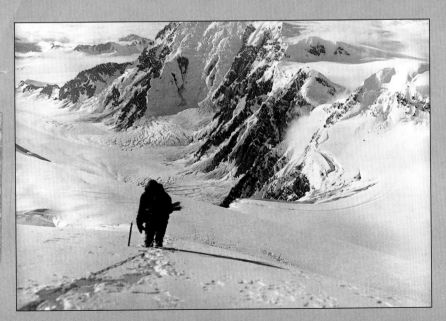

Slogging toward the final ridge of Mount Crillon

Putnam kept the base camp in contact with the outside world via shortwave radio.

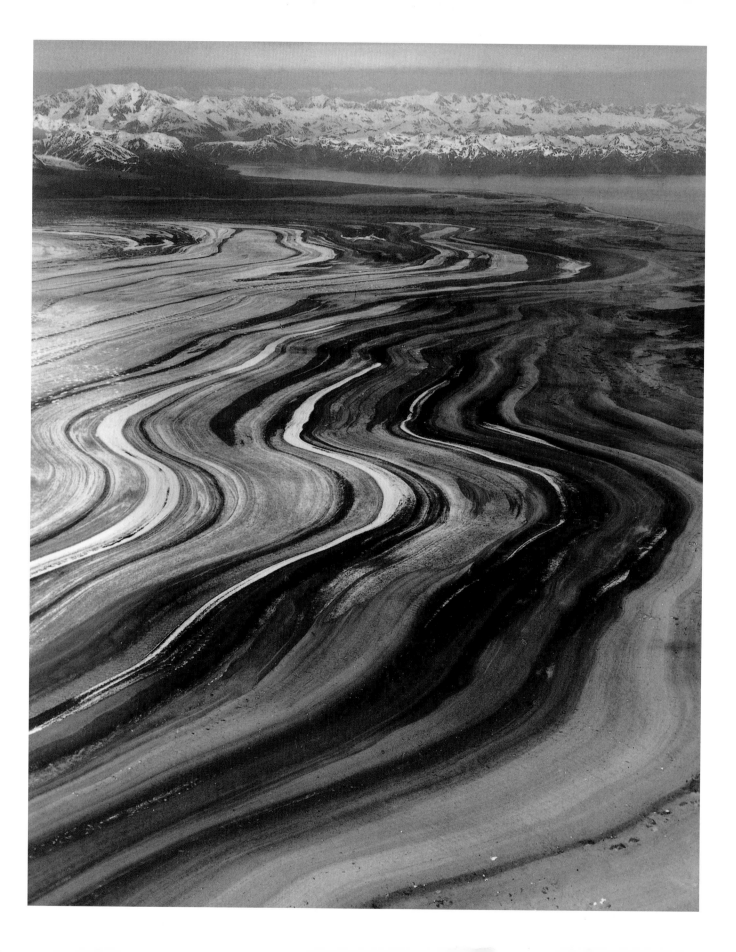

in the South Crillon Glacier. For the glacier study I recruited a brilliant young glacial geologist who had just graduated from Dartmouth College, Richard Goldthwait, who was then studying geophysics at the Massachusetts Institute of Technology. Goldthwait also wanted to bring along equipment to determine the depth and other qualities of the glacial ice.

The undertaking eventually became known as the Harvard-Dartmouth Alaskan Expeditions of 1933-1934. Over two seasons it involved parties of about a dozen people each, and was deemed significant enough to merit more funding from Rice's geographical institute as well as from the Harvard geology department, Dartmouth, and the Geological Society of America. Nevertheless, I still was left with making all the financial ends meet. I cashed in a life insurance policy to make sure the plans would go forward.

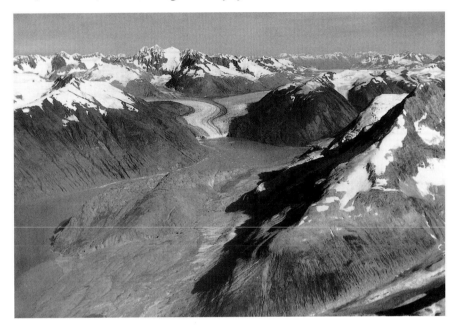

This is when I began doing serious science on my trips into the mountains. For the glacier movement study we planted an object that would show up against the snow, plus a little sharp light for night viewing, and observed it from afar with a theodolite every hour on the hour, around the clock. We found that the glacier was moving about two feet a day. Goldthwait also shattered an established belief that glaciers moved slowly and steadily, like irresistible rivers of ice. Instead, he found that South Crillon Glacier pranced along in waves and jerks, surging forward nearly twice as fast early in the morning, at noon, and around sunset as during the rest of the day.

The expeditions yielded large quantities of other data as well. Our team carried out an aerial survey of all the coastal glaciers within a hundred miles to the north and discovered big changes in the ice fields since they'd last been accurately mapped about 25 years earlier. One of them, Nunatak Glacier near Mount St. Elias, had retreated about six miles back into the mountains, leaving a deep fjord of the Pacific Ocean where it once had been. Rivers had changed their courses, and lakes had appeared and vanished.

During those two seasons we made the first extensive use of wireless communication for mountain expeditions. A shortwave radio at the base camp at Crillon Lake allowed us to keep in touch with civilization, and two ten-pound "portable" radiotelephones provided constant daily communication between the base camp and the highest camp way up on the mountain.

Another innovation was the method that I had begun using for addressing the defining

MARBLE-CAKE *moraine of the Malaspina Glacier (opposite), one of the largest nonpolar glaciers in the world, ribs the landscape near Yakutat Bay. The Crillon expedition, strongly committed to science, discovered that the Nunatak Glacier (above) had retreated significantly in 25 years.*

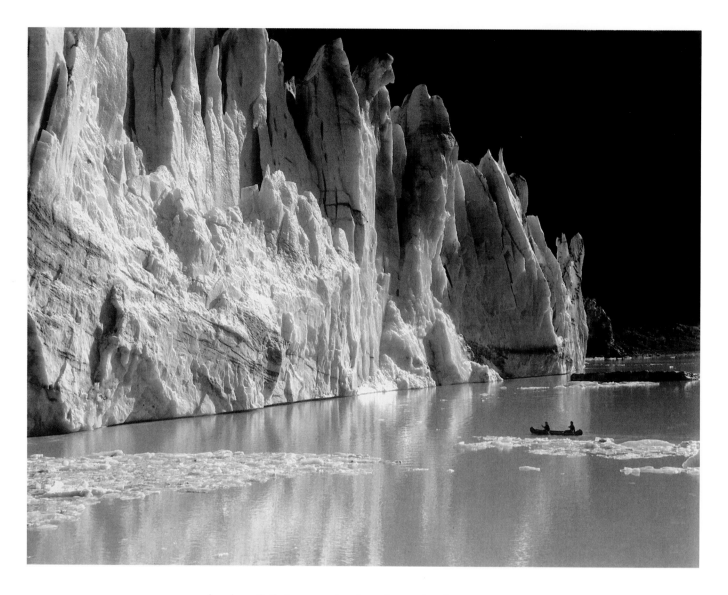

bugaboo of Alaska mountaineering—just getting there. Even our reconnaissance trip in 1932, despite our arrival by air, had involved plenty of slogging through miles of wet, rugged, insect-infested lowlands carrying heavy loads of food and equipment—the same kind of misery that had made the 1930 Fairweather expedition such an indelible memory. During the 1933 season I made even more extensive use of seaplanes, including free-falling supplies into higher camps from the air. What a luxury it was to sit in an airplane with nearly a thousand pounds of food, tents, and other gear lying in piles waiting to be tossed out!

The 1933-34 seasons resulted in some of the best aerial photographs I'd made since my 1927 flights in the Alps with the French combat pilot at the controls. By now my airborne picture-taking technique had been considerably refined by Col. Albert W. Stevens, who was teaching a class on the subject at Harvard. Equally useful was a new piece of equipment that I acquired just before leaving on the 1934 expedition: a Fairchild F-8 aerial camera. Its 5" by 7" negatives produced pictures that were big, sharp, and exquisitely detailed.

The photography and the science were intellectually gratifying. But of course I still wanted to plant my feet on top of Crillon.

Two summit attempts during the 1933 season were cut short by horrific storms, although on the second try we did manage to reach the top of Crillon's East Peak at 12,390 feet. Then, in mid-July 1934, shortly before we were due to return to Cambridge for the last time, we picked out from the air what appeared to be the most feasible route and launched our final attempt. For the better part of a week, six of us battled steep, frozen slopes, rugged crevasses, and biting wind-driven snow, all under the ever present danger of avalanche.

After many adventures we finally reached the 500-foot snow- and ice-covered cone that formed the top. Buoyed by what seemed certain success, we continued upward—only to be stopped 200 feet short of the summit by a huge, yawning crack in the snow. Its upper lip overhung far above our heads.

We stood in powder snow to our waists and examined the obstacle. With the summit only a stone's throw away, we were not going to give up without a last desperate effort. Our only option was to make a long detour up another ridge to the place where the crack ended, and then to cut a series of steps along the upper part of a colossal ice cliff that led to the top. But we had no time to dawdle. After recovering our breaths during a brief break in a sheltered ice cave, we emerged to find that the summit had disappeared in a dense cloud of frost. The same kind of weather that had blocked our two previous efforts was threatening once again.

The wind swirled bitterly around us as we inched up a 50-degree slope of bluish-green ice. Thick, brittle crust on the surface had to be scraped away before we could find a safe surface in which to hack each step. Occasionally the mists thinned enough to reveal a widening in the ridge a hundred feet ahead. It seemed like a thousand.

Another ridge was converging toward us from the right. At last the grade lessened. We plunged wearily onward through a series of heavy drifts. A little mound appeared ahead, gray and indistinct through the eddies of swirling snow. We turned toward it.

Ten more steps, and at half past noon Adam Carter and I trudged out onto the very summit of Crillon with an exultant yell!

AFTER THE DEFEAT on Mount Fairweather, the Crillon triumph was especially sweet. It also got a lot of attention. Already familiar to National Geographic audiences through his rousing 1930 film-lecture on the Aiguille Verte, Washburn landed two more contracts from the Society: a lecture on the "Conquest of Mount Crillon" in February 1935, and an article about the same subject—his first piece for NATIONAL GEOGRAPHIC magazine, to appear in the March issue, extensively illustrated with his spectacular Fairchild F-8 aerial photographs.

Washburn had moved on. He had received his Harvard degree, *cum laude,* in the spring of 1933, and immediately had enrolled in the school's graduate program in geology. But his future was uncertain. He was a famous mountaineer and was now

RECONNOITERING *the edge of the South Crillon Glacier by canoe, members of Washburn's team glide through the waters of Crillon Lake. Contradicting earlier reports, the expedition found that, far from having drained off and vanished, the lake was a mile longer than previous charts had shown.*

earning the bona fides of a real scientist. He'd shown himself to be an effective leader and organizer. He'd also proven himself an exceptional photographer: By 1935 the camera had become a trademark of the NATIONAL GEOGRAPHIC, and standards for what the magazine would publish were extremely high. "All of us here at the National Geographic Society are much impressed by your ability and success in achieving what you set out to accomplish," Society President Gilbert H. Grosvenor informed the 25-year-old Cambridge prodigy in a November 6, 1934, letter.

However, America was now under the full gloom of the Great Depression, and Washburn himself was in financial straits. He long ago had run through his Uncle Charles's bequest and had no immediate job prospects beyond his activities on the lecture circuit. No more books were on the horizon: Sales of his last Putnam venture based on the failed Fairweather expedition had been disappointing. He continued to save money by living at home, his parents providing a comforting safety net. However it was clear that he could not afford to become a professional student. His mother on occasion had even expressed concern that he would be tempted to go into the guiding business—a calling that she felt would be a waste of his other talents.

My mother was very frightened that I was going to be a guide. I always said to her, "I'm not. I'm doing the climbing because I love to do it, and I enjoy it. I love to take pictures of the mountains because I enjoy taking pictures. But don't worry, I'm not going to be a guide."

NEVERTHELESS, even as he wrestled with questions of what he would do with the rest of his life, Washburn couldn't stop thinking about high, cold places. In a November 1934 memo to Gilbert Grosvenor, he made an immodest proposal. He asked the National Geographic to support an expedition to "the east and north of the Saint Elias Range in the Yukon Territory," a country that he noted "has never been explored by anyone." The Society's Committee for Research and Exploration approved the idea within two weeks of its formal submission.

His bank account now fattened by a $5,000 Society check, Brad Washburn turned his eyes toward Canada's fabled Yukon, one of the last uncharted wildernesses on Earth.

Roped to other team members, Henry Woods descends a sheer ice slope on Crillon. On July 19, 1934, the Washburn team became the first to summit the daunting Alaska peak.

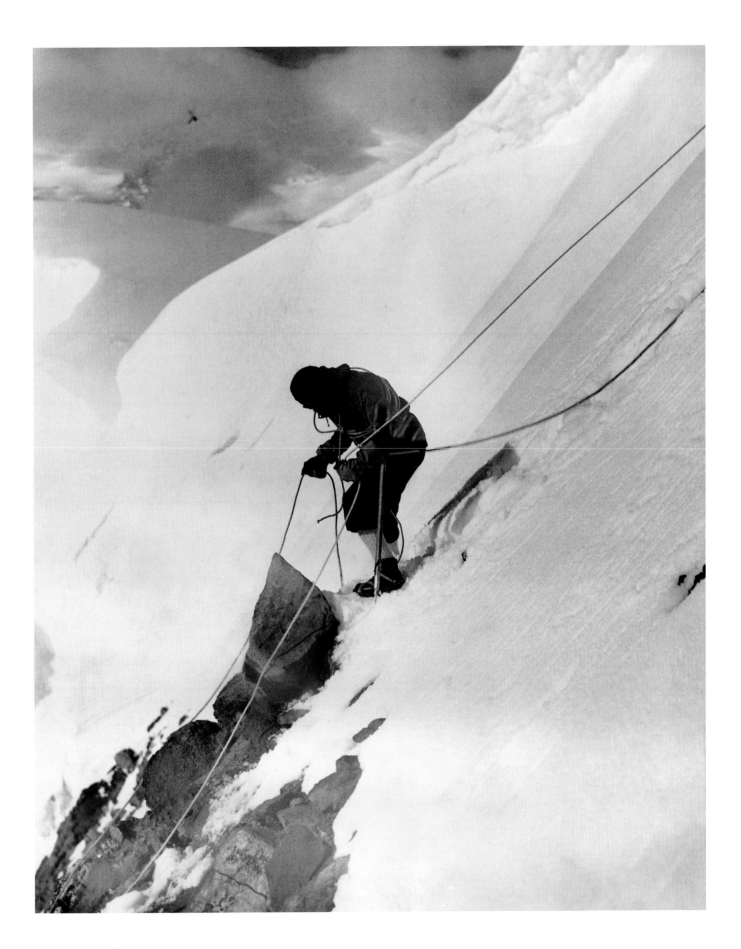

MEMBERS OF THE CRILLON EXPEDITION TAKE ON MOUNT
LOOKOUT, A NEARBY PEAK, ALASKA, 1934

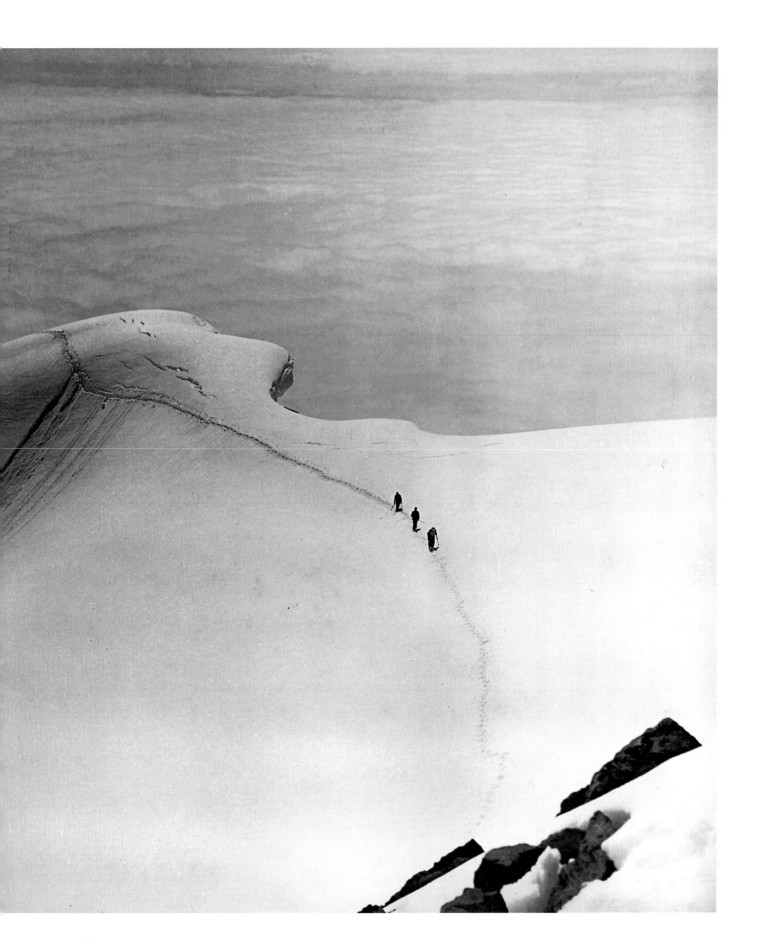

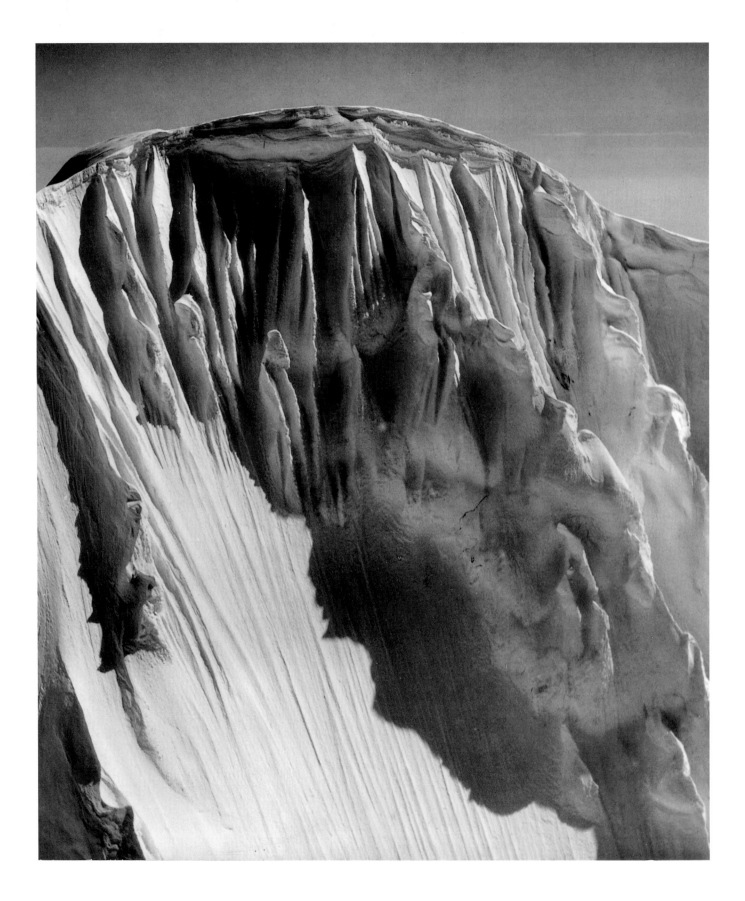

SNOW DOME OF MOUNT CRILLON, 1934

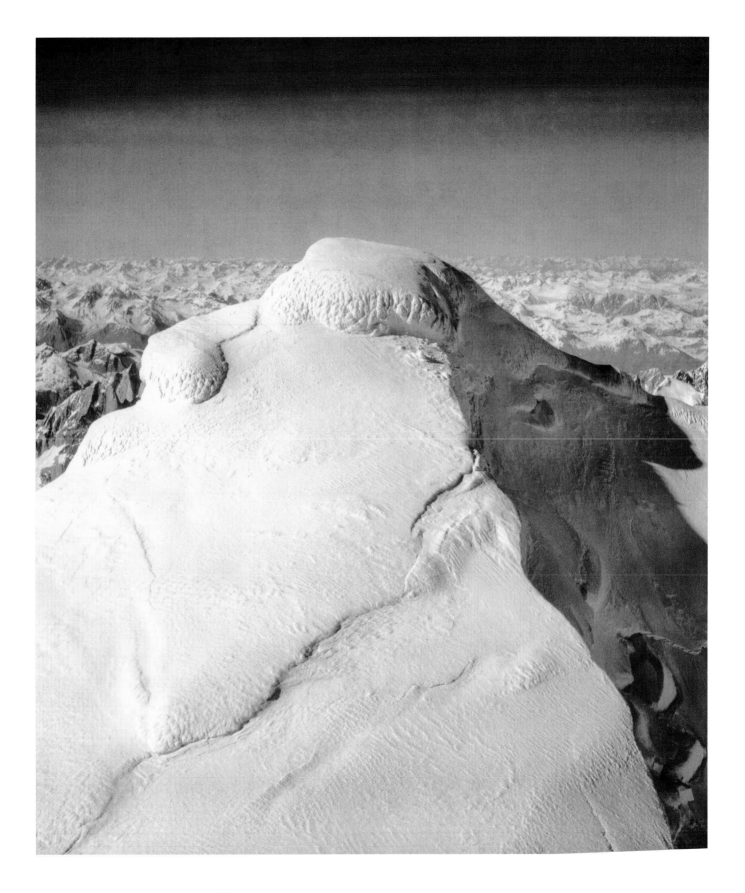

CLOSE-UP OF MOUNT CRILLON'S SUMMIT, 1937

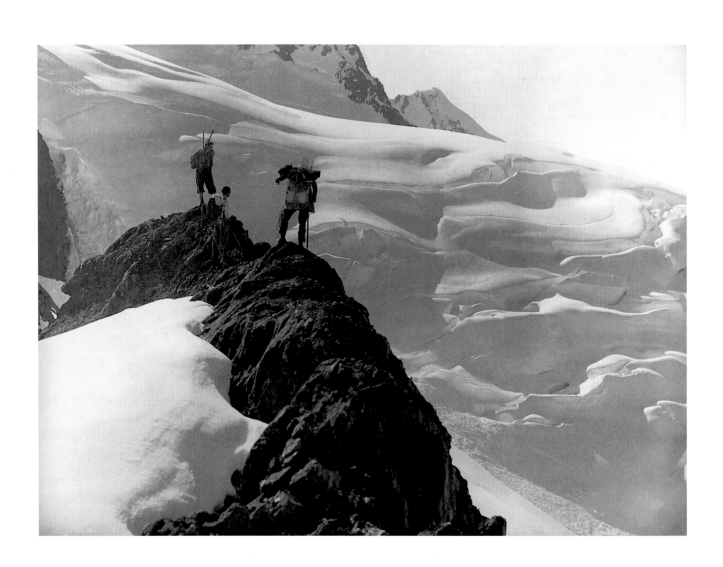

TEAM MEMBERS 5,500 FEET UP MOUNT CRILLON PAUSING AS AN AVALANCHE THUNDERS CLOSE BY, 1934

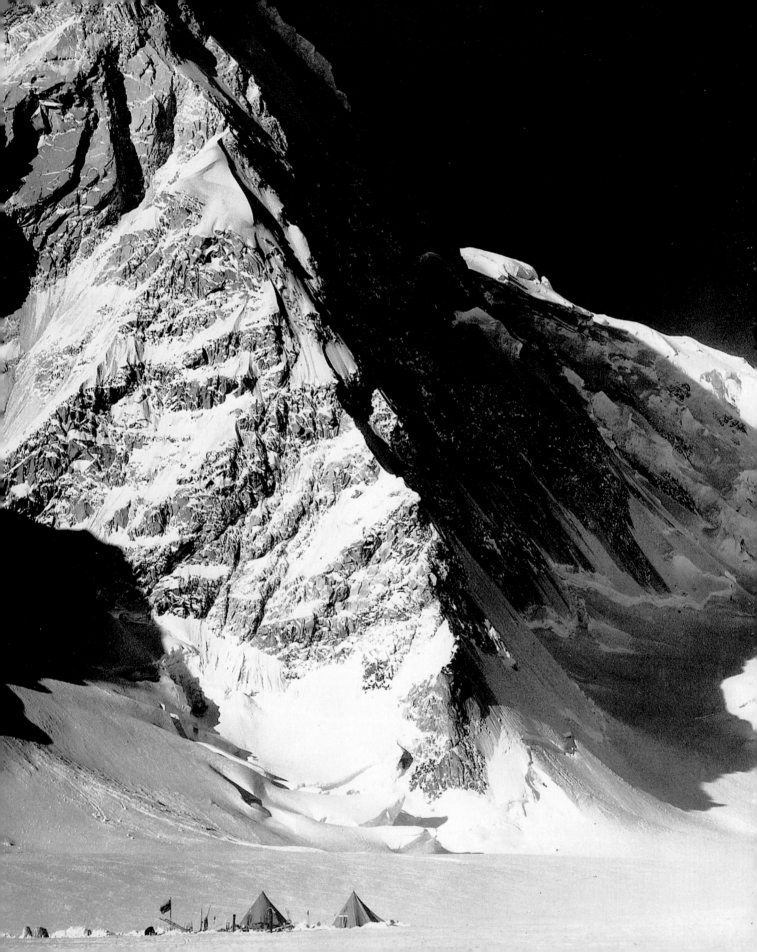

TERRA INCOGNITA

1935-1941

The dogs lay motionless at the bottom of a 70-foot crevasse, a tangled heap of fur barely visible in the dim light from above. Rappelling down the narrow ice walls to the rescue, Brad Washburn was amazed to see that all three animals had survived their sudden plunge. But dark smears of blood along the way indicated that at least one was injured. How badly, he couldn't tell. They were whimpering, barely breathing in their fright.

These were huskies, a beefy breed that, when standing on hind legs, are almost as tall as a human. Strange as it may seem, huskies behave as if they take pleasure in hauling heavily loaded wooden sledges. Washburn's 1935 National Geographic Yukon Expedition had hired six of them, along with their owner, a teenager by the name of Jack Haydon from the small Alaska village of Kluane, to help haul supplies. Washburn's group would need a lot of those. They planned to be in that corner of the Arctic for as long as three months, during which time they would explore from the air and ground unknown territory: about 5,000 square miles of snow-covered mountains and glaciers, an area more than half the size of New Hampshire, all of it blank as far as maps of the day were concerned. Washburn and his seven-member crew, which

HIGH CAMP: At 8,300 feet, the tents of Washburn's Yukon Expedition are dwarfed by the immense Arctic landscape. Washburn's 1935 photograph later inspired the Canadian government to name the magnificent mountain that dominates the frame for assassinated U. S. President John F. Kennedy.

included Mount Crillon expeditions veterans Robert H. Bates and Adams Carter, were expecting to make some important discoveries here—and maybe some headlines.

The dogs had made a favorable impression on the expedition members the instant they had arrived. Beautiful examples of their kind, with light-colored fur, floppy ears, and intelligent coal-button eyes, they were eager to please and reasonably friendly, at least for working dogs. In the Arctic, canines aren't normally regarded as pets. Washburn noted at one point in his journal: "The dogs have done their share.... God bless them all for loyal, trusty workers.... those dogs are corkers! We almost kissed them when they pulled in with the last load."

The accident that sent the dogs plunging occurred about two-thirds of the way into the expedition. The group had been crossing glaciers scored by many deep crevasses; but hard-packed snow had formed solid platforms in most areas, completely burying the bare ice and turning vast stretches of landscape into the Arctic equivalent of salt flats.

In fact, the reason for waiting until late February to launch the expedition had been to allow the winter's snowfall to build up enough to allow safe glacier travel by ski and snowshoe. In a couple of months, warmer weather would melt the snow and make travel impractical.

STEADY *and indispensable, the Yukon Expedition's team of huskies freights an enormous load of gear up the Lowell Glacier (opposite). Above, Jack Haydon takes a rest; he and Washburn had traveled 35 miles that day by hitching themselves by ropes to the dogs' harnesses.*

The youngster Haydon had taken good care of his charges throughout the mission. The team spent most of its time linked by traces fastened to each dog's harness. During rest stops and at night the lines were staked onto the hard snow, Eskimo fashion, to prevent the animals from becoming entangled or wandering off. But they were allowed stretches of freedom every day. It was during one of those free times that disaster struck. Three dogs were frolicking in powdery snow a few yards off the trail when one of them vanished, suddenly and without a sound. Two others ran over to investigate, and they too disappeared.

Haydon and Carter frantically rounded up the remaining three dogs and secured them, then with great caution approached the hole in the snow where the others had last been seen. Unable to see the bottom, Carter called down into the icy darkness. The only reply was the hollow echo of his own voice. As Washburn recalled:

WE THOUGHT THE DOGS—*Monkey, Fanny, and Brownie—were dead. It was as if three of our team suddenly had been taken from us. The crack went straight down 30 feet. Then, amid a mass of jagged slices, it twisted back and out of sight underneath us into the deep blue-green of the bowels of the glacier.*

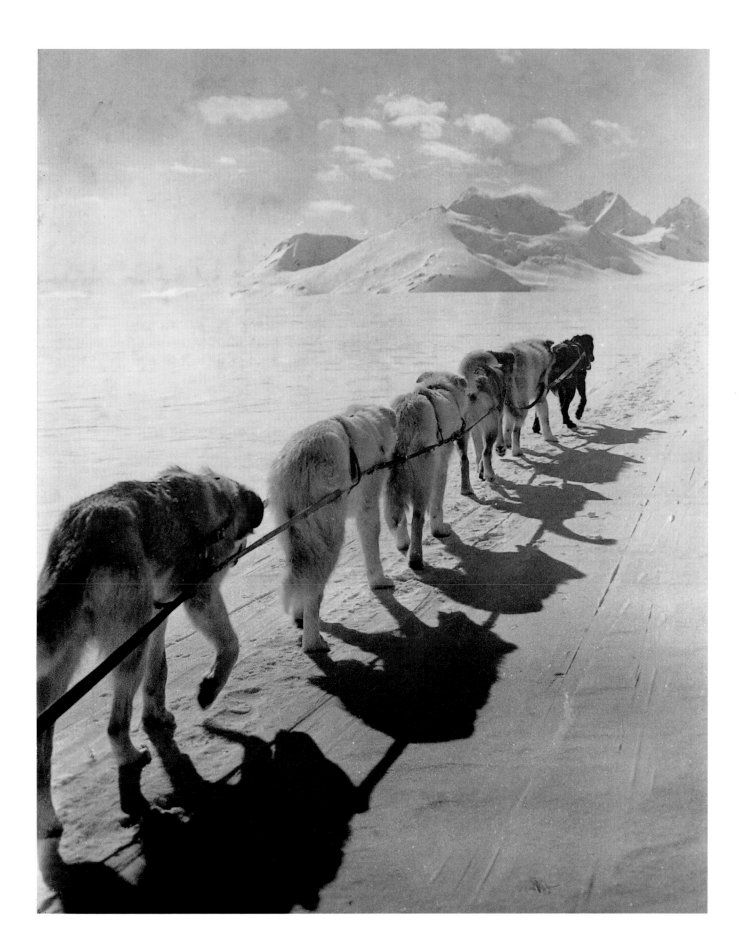

We called again: "Fanny, Monkey." Not a sound.

Bob Bates grabbed a 100-foot coil and rushed up the 45-degree pitch toward us as fast as he could. I tied myself on one end and anchored the other to a pair of skis staked firmly in the snow. Then, with Bob and the others holding onto the rope, I slid over the edge and into the chasm.

The first 20 feet consisted of hard-packed winter snow. The dogs must have glanced off the shelf where it twisted under, and continued falling.

The light became steadily dimmer as I continued descending. Finally, far below in the grayness, as my eyes became more accustomed to the light, I saw something move. They were huddled in a shivering mass on a pile of shattered ice that filled the very bottom of the crevasse. Fanny was at the bottom, then Brownie, and Monkey on top. Their narrow dungeon was all splattered with blood. I pictured reaching them and finding them terribly injured.

They were still 30 feet below me. I didn't dare move another inch until I'd pulled off a huge loose chunk of ice that was clinging tenuously to the wall just below my feet. I was sure that it would be knocked off onto either the dogs or myself if I couldn't do something about it right away. So I got even with it and called up for the guys above to hold even tighter. Then, bracing myself as securely as possible, I pried the chunk off and tossed it down a deep chasm beyond the dogs and to their right. It clattered from wall to wall for a second, then landed with a resounding roar far below us in the dark depths.

It was no place to linger, with tons of loose blocks of ice hanging just overhead, ready to fall at the slightest movement of the glacier. Another rope arrived and I speedily descended the remaining distance. I slipped a noose through the harness of each dog, then called OK and started back up. Monkey, who appeared to be bleeding slowly from one eye, gave me one last pitiful glance, and then I was out of sight.

I reached the upper grotto and crawled out over the lip of the crack into the beautiful warm sunlight of our early May morning, giving silent thanks for safe deliverance. We immediately began hauling the dogs out. But as we pulled, there was a sudden jerk on the line, and the load lightened a sickening amount. One of the harnesses must have broken.

Which one? And how far had he fallen?

In a jiffy the forms of two dogs, Fanny and Brownie, came over the edge of the crack. Though terrified, nothing seemed radically wrong with them. But what about poor Monkey—who now had fallen twice?

I'd had all I wanted of that hole, so Ad Carter volunteered to go down after him. Soon Ad returned. Then Monkey, bedraggled but still alive, reached the surface.

I'll never understand how those pups could have fallen 70 feet through such a maze of jagged, torn ice, and come out with no more injury than they had. Brownie and Monkey had cut lips, and Monkey had lost a toenail. The blood I'd seen around Monkey's eye must have come from Brownie.

The next morning when the first sled load started off, Fanny and Brownie were back in their traces and acting as if nothing had happened. Monkey howled all day because we wouldn't let him go back to work, too.

A NOTE from NATIONAL GEOGRAPHIC Editor Gilbert H. Grosvenor on the eve of the trip had indicated his concern for the very sort of youthful audacity that sent Washburn over the lip of the crevasse on his rescue mission with hardly a second thought. Grosvenor wrote: "Yours is the first expedition we have entrusted to a man as young as yourself, and your remarkable record ... might very naturally lead you to be a little overconfident and take risks ... that an older man might not venture to take." Grosvenor warned him not to take any chances that might "imperil your life or the life of any member" of the team. He'd added in conclusion: "Remember that the mountains will be there next season, also the National Geographic Society and there will be opportunities to return."

But Washburn's habit of caution, which he'd displayed as a 14-year-old refusing to summit New Hampshire's ice-coated Mount Chocorua, constantly warred with other traits. One was compassion for his crew, whether animal or human. Another was the same one that had led to his learning to develop his own film rather than waiting for mail service: impatience. And that had led to the expedition hitting pay dirt long before the dog crisis. The very day after reaching his staging area in Carcross, Alaska, with three of his crew still en route, Washburn, learning that the weather had just cleared after several days of snowstorms, had insisted on making an immediate reconnaissance flight. The trip resulted in half a dozen major discoveries.

The flight had begun with views of Mounts Crillon and Fairweather more than a hundred miles to the south as the single-engine bush plane climbed into the sky. Bearing off northward, Washburn, Andre Taylor, Ome Daiber, and pilot Everett Wasson sighted in the distance the mighty mass of the St. Elias Range, still low on the horizon. Then, at 9 a.m., less than an hour into the flight, as Washburn later wrote, "We were looking into a region that no human eye had ever seen before. Far ahead but still clear and unmistakable in the brilliant light we sighted the outlines of an immense glacier descending eastward toward us from Mount Hubbard."

They were still reveling in the discovery of a new glacier when Wasson looked out his window and exclaimed, "Why, there's another!"

Washburn recalled: "And then, before we could compose ourselves after discovering two new rivers of ice as long as any previously known in North America, a third, considerably larger than either of the other two, appeared farther to the south. We compared our finds with the large blank spot on our map. Everything fitted together perfectly." An hour later they made another startling discovery: A previously documented glacier, the Hubbard, did not stop beside Mount Vancouver as shown on their old map. Instead, it wound northward for 30 more miles and out of sight beyond the eastern buttresses of Mount Logan.

Their most exciting finds were yet to come. While winging across the newly discovered extended section of Hubbard Glacier, they looked off to the east and saw two

uncharted peaks. One was well over 12,000 feet high, the other possibly 13,000 feet. The expedition wound up discovering several mountains from the air. Washburn called one towering, ice-crusted massif simply "East Hubbard" and noted that it had "terrific cliffs."

Washburn named the two most prominent new peaks Mounts King George and Queen Mary, in honor of the British monarchs (it was the 25th anniversary of George V's enthronement) and out of respect for Canada's status as a nation of the British Commonwealth. This act of obeisance earned Washburn a telegram from London, which he received in Yakutat, Alaska, immediately after the expedition ended. Britain's Secretary of State for Foreign Affairs John Simon passed along the king's "sincere appreciation of the compliment which the National Geographic Society Yukon Expedition have paid to his Majesty and to the Queen."

Washburn's exploits in the Yukon were being closely followed by the press. The *New York Times* on March 9 reported the discovery of "hitherto unrecorded" mountains and glaciers. Three days later a front-page story carried this headline—"Fliers Conquer St. Elias Range: Washburn and Companions Makes Flight Across Heart of

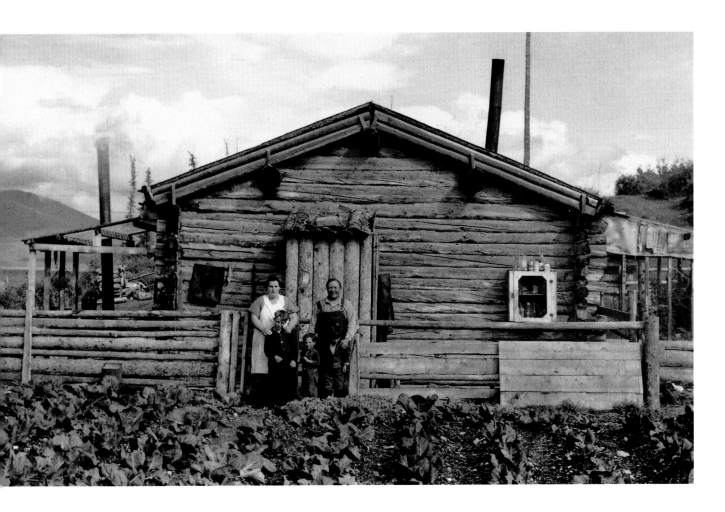

Yukon Heights." The paper reported the "completion of the first airplane flight ever made over the heart of the St. Elias Range on the Alaska-Canada border."

The Yukon Expedition propelled Washburn's stock at the National Geographic Society right into its yellow-bordered stratosphere. The June 1936 issue of the GEOGRAPHIC carried his account, "Exploring Yukon's Glacial Stronghold," as its lead article. The previous year, his piece on the Crillon expedition was the clean-up article in the issue.

Although he hadn't scored any first ascents in the Yukon, Washburn was justly proud of his accomplishments. He had organized and led a major surveying and mapping expedition across terra incognita in the dead of the Arctic winter, spending 84 days on the ice. The undertaking had involved managing tons of food and fuel, camping and photographic gear, as well as equipment for surveying and making maps. And, as it turned out, the apprehensive Grosvenor was not only relieved to see his young Marco Polo and crew return in good health but also pleasantly bemused to receive a $35 check—the sum that Washburn determined was due as a refund on his $5,000 advance on expenses.

Yukon Expedition

Brad tries his hand at running a railroad scooter up tracks in Carcross.

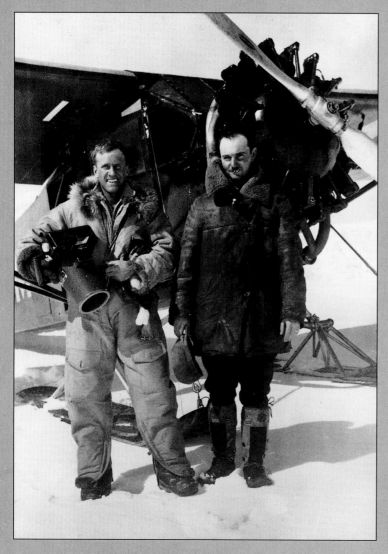

Posing with pilot Bob Randall, Brad cradles his precious Fairchild F-8 camera.

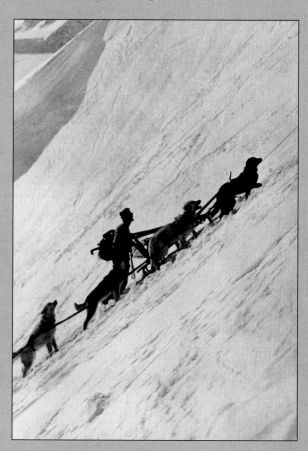

On the steep slope of Lowell Glacier, the dogs got unhitched and team members carried the gear.

Ad Carter relaxes over a chessboard while a blizzard rages outside.

The "Yakutat Four:" from left, Andy Taylor, Brad, Ad Carter, and Harty Beardsley

Bob Bates poles gear across the Alsek River on a makeshift raft.

AT THE STILL tender age of 25, Bradford Washburn was now firmly planted in the pantheon of Society heroes, and not just because he could manage a budget. A National Geographic press release around this time proclaimed his photographs of previously unseen lands comparable to those of Richard Byrd's portraits of Antarctica. Grosvenor himself was so impressed that he offered Washburn a job at the Society's headquarters in Washington.

Instead, that November Washburn accepted a position as instructor at Hamilton Rice's Institute of Geographical Exploration, one of the chief benefactors of the Crillon expeditions and the place where he was doing much of his Harvard postgraduate work. Institute chief Hamilton Rice had become such a fan that he had dipped into his own pocket in February 1936 to finance Washburn's trip to England to lecture at the Royal Geographical Society about the Crillon expeditions—itself an honor not often bestowed on an American so young.

Rice's good will, however, did not translate into fat paychecks for Washburn the employee. He still had to make ends meet through his income from book royalties and lecturing, and by continuing to live at home with his parents at the Deanery. However, Washburn did gain a small office at the institute, along with an even more important perquisite: Rice's willing commitment to allow him to continue having adventures.

Washburn immediately lined up his next National Geographic assignment. "Dr. Grosvenor asked me at the end of the Yukon Expedition if there was anything else not too big and expensive that I might be able to do. I said, 'I think if you give me $1,000, I could make the first photographic flights over Mount McKinley.'"

Once again, Washburn had a deal. The assignment resulted in three flights in a twin-engine Lockheed Electra over and around the mountain in July 1936. For these missions, one of Washburn's Harvard instructors—pioneer aerial photographer Albert W. Stevens—let him borrow one of the most formidable pieces of equipment in Stevens' photographic arsenal: the 53-pound Fairchild K-6, a giant of a camera that carried rolls of film measuring 120 feet long and 9½ inches wide, yielding enormous 7" x 9" negatives.

The K-6—which Stevens had used during the 1920s to photograph unexplored territory in the Andes and along the Amazon—was a step up from the Fairchild F-8 camera that Washburn had used on his 1934 Crillon expedition and the following year in the Yukon. The K-6's negatives were even larger than the F-8's. Both machines took up a lot of space. To accommodate this kind of bulk, Washburn removed a door in his airplane and sat cross-legged in the opening. A cat's cradle of ropework around the door supported the camera and helped keep him from falling out.

At the end of his first round of McKinley shoots, Washburn showed again that he was as careful an accountant as he was an explorer and photographer. He sent Grosvenor another refund: this time $40. He was rewarded for his prowess in both areas by similar assignments from the Geographic photographing more Alaska

territory from airplanes in 1937 and 1938. Many of his 1936-37 shots wound up in his third NATIONAL GEOGRAPHIC article, "Over the Roof of our Continent," which appeared in the July 1938 issue.

But, as usual, Washburn wasn't content with just looking at snow and ice-covered rocks from the air. He needed to be walking on them—and he soon would be. His photographic activities during the Yukon Expedition led directly to what he calls the single greatest—and possibly most harrowing—adventure of his life.

AN ADVENTURE is what happens when you have a good plan and it starts to fall apart.

I knew even before our plane touched down on the ice of Walsh Glacier late in the afternoon of June 18, 1937, that things were not going to go exactly as we'd envisioned. The skies were dark with low-lying storm clouds, the advance guard of a huge storm that was rolling in from the southeast at a very inconvenient moment. Bob Bates, who had been a key member of the Yukon Expedition, and I were planning to set up the base camp that we would use to scale 17,150-foot Mount Lucania—at the time, America's highest unclimbed mountain. We were supposed to make the climb, return to the base, and be picked up in August for the flight back to the little snow-covered airport at Valdez, 200 miles away.

Our single-engine Fairchild 51 airplane had stainless steel skis as its landing gear. Bob Reeve, our experienced Alaskan bush pilot, glided to a stop about three-quarters of a mile below the spot on the glacier where our supplies were cached under a large tarpaulin. Reeve had deposited them there on three easy flights a couple of months earlier.

I immediately jumped out and made my way through deep, icy slush up to the pile while Bates and Reeve remained with the plane. I was digging out some items we would need right away when I heard the airplane engine start again. Crawling out from under the tarp, I saw the plane taxiing up toward me, with Bates trotting along behind. I had just grabbed a toboggan from under the tarp and started off down the glacier to meet them when suddenly I heard a terrific roar. One wing of the plane shot up into the air at a crazy angle. The other wing dug into the snow. There was more roaring, a sputter, and then the motor stopped. For the next several moments, thoughts of rescue parties and headlines raced through my mind.

We'd already figured that Lucania would be a challenge. It had been pronounced "unclimbable" by Walter Wood, a distinguished glaciologist who himself had failed almost two years earlier. In fact, I had wanted to tackle the job that same year myself but had been persuaded otherwise by a senior member of the American Alpine Club out of deference to Wood, who already had begun laying plans to do it. So instead of climbing Lucania, I put together the National Geographic Yukon Expedition—which just happened to involve a lot of aerial photography of the Mount Lucania neighborhood. I made sure that I got some good pictures of the mountain. Later, after hearing that Wood had quit his attempt a dozen miles east of the top, I used these shots to pick out the most likely route to Lucania's summit from its Alaskan side.

My plan depended on setting up the base camp near a likely landing site that I'd spotted on Walsh Glacier, thus avoiding a long trek just to get to the jumping-off place—a trick I'd

learned from Mounts Fairweather and Crillon. At an altitude of 8,500 feet, the site I'd chosen would require the highest and most remote landing on a glacier ever attempted in North America—and I knew that Bob Reeve was the one to do it.

Two other climbers were supposed to join Bates and me: Russell Dow, a veteran of the 1933 and 1934 Mount Crillon expeditions, and Norman Bright, an acquaintance with extensive climbing experience in the high mountains of the American West. We planned to assemble on the ice and begin establishing progressively higher camps up the side of Lucania. We would make the final dash to the summit from the last camp in the usual manner.

Anyway, that was the plan. With the supplies already in place on the glacier, our intention on June 18 was for Reeve to drop Bates and me at the site, where we would begin setting up the base camp while Reeve returned to Valdez to pick up Dow and Bright. Now our airplane was stuck in seemingly bottomless slush. And things immediately got worse: Before we could even get the plane unloaded and set up a tent, the thunderstorm that we'd seen during our flight in arrived.

The three of us huddled on that glacier for the next five days while the sky unloaded a few million gallons of rainwater on our heads. At least we weren't cold. Unusually warm temperatures crept into the 60s even at night. Very unseasonable weather, Reeve kept saying. But the combination of rain and warmth was taking a toll: It was wrecking the smooth surface of the glacier, exposing multiple crevasses. We never ventured more than a few feet from our tent without being roped together. Who knew how many more cracks were lurking unseen inches below our boots, waiting to swallow us up like poor Monkey, Fanny, and Brownie?

No one who knows anything about Alaska bush pilots would ever question their courage—and this was especially true of Bob Reeve, who was already well known for his skill in making hazardous landings. Nevertheless, Reeve refused to leave the tent the whole five days that it rained, even with a rope. He told us that we could do the climbing and he'd do the flying. "You skin your skunks and I'll skin mine" was his reply when Bates and I invited him to walk with us up the glacier a bit during a lull in the storm.

The deluge finally ended. After digging the airplane out of not one but four hidden but shallow crevasses and changing the pitch of the propeller, Reeve figured he had a fair chance to get the little craft into the air. But well before the attempt was at hand, he informed me, "Assuming I get into the air, I don't intend to fly into this goddamned place again with anybody or anything, not to get the other two guys in, and not even to get you guys out."

Flying back the 200 miles to Valdez with Reeve was clearly out of the question: It would be tricky enough getting the plane off our shortened runway without the combined weights of Bates and myself. As it was, Reeve threw away his tool kit and emergency equipment to improve his chances of becoming airborne before hitting a crevasse. It was obvious that we would have to walk out either back into Alaska or forward into Canada.

It appeared that the most feasible route would be one that would take us across Mount Steele—which had been summited in 1935 by Walter Wood. Although Wood had been the first to stand on the summit, we would be making the first ascent from the west side. After

THE LOST PILOT

IT WAS TO BE the capstone of a career of blue-sky adventure. She would follow the Equator around the globe by air, 24,000 miles across 18 countries. When finished, she intended to write a book about the journey for her publisher-husband, G. P. Putnam, who would have it on bookstore shelves in time for Christmas shoppers. It would be another triumph for 39-year-old Amelia Earhart, the woman that the press had dubbed "America's Sweetheart of the Air."

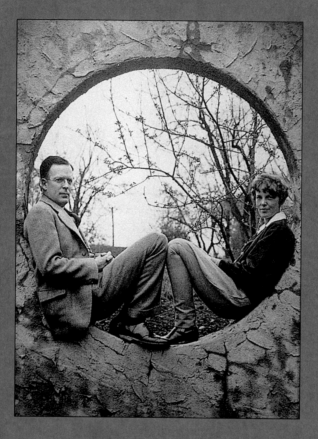

Brad Washburn listened intently as she talked through the details after supper on a January 1937 evening at the Putnam mansion in Rye, New York, several months before the projected takeoff date. Though only 26 years old, he was by then both a pilot and a famously seasoned organizer of major expeditions, well qualified to troubleshoot their plan. They pored over maps and aerial charts that she'd spread out on the living room floor, Washburn and Earhart scuttling around on their hands and knees, tracing each segment, Putnam leaning forward in his easy chair from time to time to offer opinions, both husband and wife working into the conversation their need for an absolutely crack navigator. Maybe Washburn was being interviewed for the job, maybe not. In any case, as he reviewed the project, he became convinced that he wanted no part of it.

He was well acquainted with the airplane Earhart would be using. He'd used the same model for his National Geographic Society-sponsored photographic flights over Mount McKinley months earlier: a sleek silver-skinned, twin-engine Lockheed Eletra 10E.

It was Washburn's flying résumé that had led to this supper, the first substantial contact he and Putnam had had in several years. They had drifted apart after the 1930 publication of *Bradford on Mt. Fairweather*. In the meantime, Putnam had married Earhart—whom he'd met in 1928 while helping search for a young woman to be the first of her gender to cross the Atlantic by air. Earhart was a passenger on that flight: Her main duty was to keep the log. Nonetheless, the feat transformed her from an obscure Boston social worker with a yen for flying into an international celebrity. It did indeed result in a book, plus the full Putnam treatment: A storm of publicity fueled by lectures and other appearances, commercial tie-ins, and prospects for seemingly endless more of the same.

After their marriage in 1931, Putnam had continued to stage-manage the tousled-haired Kansan's aerial adventures for maximum exposure, including her record-making 1932 solo flight across the Atlantic. And now they both wanted to hear what an earlier Putnam publishing protégé had to say about their newest plan.

Washburn spotted trouble almost immediately. The plan called for a refueling stop on Howland Island, a tiny, isolated spit of sand located 2,550 miles east of Papua New Guinea. If Earhart missed it, she would run out of gas in the middle of the Pacific Ocean.

Washburn advised setting up a radio transmitter on Howland. If all other navigational systems failed, Earhart could home in on the signal.

As Washburn remembers the conversation: "I said, 'Amelia, you absolutely have got to have a radio on that island, or you're never going to hit it.'

"I'll never forget that moment. Putnam was sitting there, we were on the floor, and she turned her face up to him and said, 'What do you think about this?' And he said: 'Well, if we wait to set up a radio transmitter,

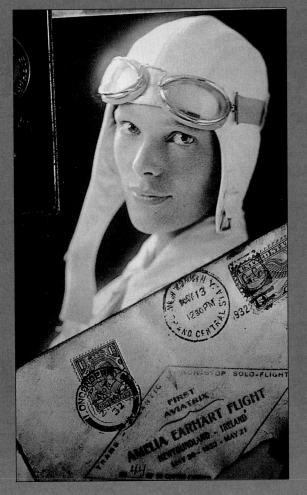

the book won't be out in time for Christmas.'"

Putnam did provide the next best thing: a floating radio. A Coast Guard cutter would move into position off Howland Island at the appropriate time and attempt to establish contact.

Nevertheless, communications would prove to be Earhart's downfall: A problematic antenna system on the Electra, confusion over broadcast frequencies, and possibly Earhart's failure to follow aircraft radio protocol in her own transmissions. All were circumstances that Washburn, the detail- and safety-oriented planner, almost certainly would not have allowed if he'd been along on the flight.

The three parted company that evening.

Five months later, on the July day that Washburn arrived in Fairbanks, Alaska, after his own harrowing escapade on Mount Lucania, the search for Earhart and navigator Fred Noonan was all over the evening paper. Her disappearance was the first news he'd had outside the world of the wild Yukon.

"I thought, 'what a pity.'"

PUBLISHER G. P. Putnam and his famous aviatrix wife, Amelia Earhart (opposite); Earhart (above)

that we would simply follow Wood's route back down the east slope, across the Donjek River, and to safe haven at a Canadian hunting and trading outpost called Burwash Landing on the shore of Kluane Lake. From our rain-soaked camp on Walsh Glacier, it would be a circuitous journey of roughly 110 miles across ice-covered slopes, forest, and Arctic bogs.

Despite our bad luck, however, climbing Lucania still seemed a good possibility. The hike to Mount Steele would take us to a high pass that lay within several hours' walking distance of Lucania's summit. You never know what you might run into in an uncharted wilderness; but after once again poring over a bundle of aerial photographs that I'd taken in 1935, I was convinced that a short detour on our way back to civilization would put us on top of Wood's "unclimbable" mountain.

And why not? We were well supplied with all essentials for Arctic survival: warm clothes, a sturdy Logan tent for shelter, plenty of fuel with which to cook and melt snow for water, and plenty to eat. Food, we thought, would be our least concern—we had 400 pounds of victuals, and, once Reeve departed, only two people left to eat it. Moreover, we knew that Wood had left behind a substantial cache of food at one of his campsites just on the other side of Mount Steele.

With all this food around, Reeve, Bates, and I ate gargantuan amounts while waiting for the bad weather to end. One night for supper we had a whole ham, accompanied by copious amounts of pea soup, corn, and lemonade.

We did have one disappointment in the equipment department. We'd had some footwear custom-made for us, but not all of it had arrived at Walsh Glacier before the weather shut down our aerial shuttle. Bates and I discovered that we had three left-footed boots and only one for the right foot. The rest were in Valdez.

Luckily, we had with us two pairs of off-the-shelf L. L. Bean "Maine hunting shoes"— rubber bottoms and leather tops. They would have to do. We were headed for Lucania.

"There is a bare chance two of us can do it alone," I wrote in a letter to my parents on June 20 for Reeve to forward when he reached Valdez. I didn't want to raise expectations for the summit attempt too high. "If we possibly can, we want to hold the old trip from failure to success. You will hear from me when we reach Burwash Landing. If we can't make Lucania, it will be late in July. If we can make her, it will be earlier [sic] or before the middle of August. We are so mad at this glacier that if we can once get going and get a bit of crust, we'll start doing things in a hurry."

Reeve managed to make a white-knuckle but successful takeoff, and in the days that followed, we pared down to a bare minimum of supplies and climbing equipment in the interest of reducing weight. We packed 50 days of food, our tent, some rope and ice axes, and not much more. We abandoned almost all our valuable photographic and survey apparatus. I even left my treasured Fairchild aerial camera. To further save weight, we packed only one pair of extra socks each, one sleeping bag for both of us, and one inflatable mattress.

Already, Lucania and Steele were making the Yukon Expedition look like kindergarten.

We struck out walking on June 25, using a small ski sledge to haul supplies. Our

MOUNT LUCANIA, a 17,147-foot behemoth in Alaska's St. Elias Mountains, towers above Walsh Glacier.

method was this: We would scout out the trail ahead and mark it at hundred-foot intervals with a standard item of Arctic exploration: thin wooden wands about 30 inches long. Traditionally these are made of trimmed willow branches, but we were using wooden dowels because of their greater stiffness. Then we would haul supplies up in shifts to the site for the next camp. Normally these camps would be spaced five or six miles apart, but with our reduced manpower, we were setting them up at roughly two-mile intervals.

Eighteen days into the trip we established Camp VIII on the 14,000-foot pass that lay directly between Lucania and Steele. Now we had to make the choice: Should we forget Lucania and make tracks for Steele and the safety that lay beyond? Or should we make the detour and make the first ascent of Mount Lucania?

At that point we reckoned we had about ten days more food than we would possibly need for our dash into Canada. We decided to put it to good use.

After a long sleep on July 8, the weather—which had been bad up until then—suddenly broke. We loaded our camp rapidly onto our backs and, leaving a cache of food and gasoline at the pass, headed west. We established a new camp at the very foot of the final mass of Lucania at ten o'clock that night.

The next day, climbing at last with no loads on our backs, we wallowed our way upward through 3,000 vertical feet of snow to the summit. We reached it at 4:45 in the afternoon after nearly eight hours of continuous climbing.

The view alone was worth the effort. With the temperature hovering around zero, scarcely a cloud lay in any direction except to the east over the great lowlands of Canada. Every peak in the St. Elias Range, from Bona 60 miles to the north to Fairweather 225 miles to the south, stood out with crystal clarity. It was hard to believe that Mount Logan was well over 30 miles away: Its immense summit ridge and cliffs stood out in colossal scale.

We had done it. Now, all we had to do was get out alive.

The morning after the climb, we threw away all but a bare minimum of food—enough, we figured, to take us across Mount Steele and then down to Walter Wood's food cache on the other side. We also tossed aside our largest cooking pot and most of our clothes, then cut half the floor out of the tent to save another bit of weight. Finally, we started off.

At noon on July 11 we reached a 16,400-foot shoulder on Mount Steele. Leaving our loads on that spot, we climbed the final gentle slope to Steele's lofty summit. And then, to our astonishment, we discovered a big bundle of trail markers left there by Walter Wood. Once again the weather was ideal: The St. Elias Range was cloudless from end to end except for a picturesque reddish haze over the peaks to the southwest.

After an exultant half-hour rest at the summit of Steele, we returned to our loads at 3 p.m. Throwing away more food, our last spare clothing, our shovel, the tent pole and pegs, and all but three pints of gasoline, we also cut the rest of the bottom out of our tent and even sliced off all of its guy ropes in order to save a few more ounces. One of our last sacrifices was our air mattress. From now on we'd be sleeping on bare ground.

We were well aware of the dangers of traveling so light in exchange for improved speed. Although we were now walking where others had gone before, we knew that any surprises could have grim consequences. Our motto was simple: Anything that Walter Wood could get up, we could get down.

The first surprise occurred within hours. Following Wood's route, descending Wolf Creek Glacier to the site of his highest base camp, we found that the cache of canned food that Wood had reported leaving had all been destroyed by bears. Every single can had been punctured by huge canine teeth and its contents sucked out. It must have been quite a feast. Only a single glass jar of Peter Rabbit peanut butter had escaped unscathed.

We pressed on, camping on the shores of the Donjek River the night of July 13, about 25 miles from Burwash Landing and Kluane Lake, but running perilously low on food. And that's where we encountered our second big surprise. The Donjek was swollen by ice melt from the unusually warm summer temperatures. Crossing this huge river even on horseback (the way in which Walter Wood had crossed both ways two years before) would be completely out of the question for two men with sizable packs. Worst of all, there were no raft-building materials anywhere on our side of the river.

Early in the morning we started hiking up the valley to the end of the Donjek Glacier,

possibly ten miles away. Needless to say, no good map of this area had yet been made. We assumed that the river emerged from the end of the glacier and all that we had to do was to get onto the glacier, cross it, and then re-descend the valley on the other side of the river.

But there was no easy solution to the mess in which we found ourselves. When we reached the glacier, to our horror we discovered that our river didn't emerge from this glacier, but from another one many miles farther up our valley. It roared through a box canyon along the side of our glacier. On the left edge of our glacier we could stand on the ice, look across a torrent of ice water, and see tiny birds flitting about through the trees only 40 feet away from where we stood.

We spent that night swathed in our tent-without-a-pole and crowded into one sleeping bag, all in a steady, frigid rain. Early the next morning, after we'd gotten off the Donjek Glacier, we discovered, thank God, that the river was braided into many channels. We were able to cross it piecemeal. Then came the 20-mile descent of the valley to a point on the east side of the river, perhaps 50 feet from where we'd stood the day before. Luckily, Bob Bates had an old pistol with him, so we managed to eat a squirrel and a rabbit, along with scores of tasty mushrooms that were all about us as we descended through those lovely woods.

On the afternoon of August 19, ten days from the top of Lucania, we were still about 25 miles from Kluane Lake and the little cluster of buildings called Burwash Landing. We were both tired and hungry and sat down for a wee rest. Suddenly we heard the tinkling of bells. We looked in the direction of the sound and soon saw a man's head, and then another. A pack train with a half dozen horses!

They asked us where we'd come from, to which we replied: Valdez, Alaska. They were speechless. And where were we going? "We're going anywhere that you are going!" They were headed for a nearby cabin, whence they were going downstream a few miles the next day to get some horses that had been feeding down there. The next day we rested with them in their camp, and, on the following day, we accompanied them on two of those horses back to Burwash Landing. And so ended the most exciting mountain climb that Bob Bates and I would ever make.

FIRST CRILLON, now Lucania. First ascents in Alaska were becoming a habit for Washburn. The following year, 1938, he added two more: 13,176-foot-high Mount Marcus Baker and then Mount Sanford—at 16,237 feet the highest unclimbed peak in North America until Washburn and Terris Moore climbed it on skis.

Hamilton Rice had been true to his word. In addition to allowing Washburn to climb mountains, he was letting his young instructor continue making photographic flights over the St. Elias Range for the National Geographic Society, including a third trip around Mount McKinley that fall.

Life was dealing generously with Washburn, when tragedy struck in May 1938, just before he set off for Mount Marcus Baker. He and some of his mountain-climbing friends were stuck in Seattle, Washington, unable to sail to Valdez for the climb due to a dock strike. Washburn, who had recently received a pilot's license, offered to

take some of them on a sight-seeing tour in a rented seaplane. They had just finished a 45-minute flight to some mountains just west of Seattle and were coming in for a landing on Lake Union when, at the last moment, Washburn miscalculated his altitude.

Landing an airplane is tricky enough on a dry runway. The pilot's job is to slow the plane gradually, so that it touches the ground just before it stalls. If the plane is too high at this crucial point, it drops precipitously—as anyone who has experienced a bumpy landing aboard a commercial airliner can testify. Water landings are more difficult because, usually, there are no nearby frames of reference, such as trees and buildings, for use in judging altitude.

The water that Washburn landed on that day was perfectly calm, so he didn't even have the benefit of waves to help him assess his height. He stalled the plane too high, and the craft hit the water with violent impact. It immediately turned upside down and began sinking. By frantically kicking at the windshield, Washburn and his friend James Borrow were able to break through and claw their way to the surface. But Borrow's 24-year-old fiancée, along with the 27-year-old wife of Washburn's Yukon Expedition companion Ome Daiber, remained trapped in their seats in the rear of the flooded, inverted plane. Gasping for breath, Washburn and Borrow frantically dived back into the murky water to try to free the women and get them to the surface. Repeated efforts failed, however, and the women perished.

"I was completely devastated," Washburn recalled. Yet despite this accident, Washburn and Daiber remained good friends.

EVENTS ENTIRELY beyond his control were about to turn Washburn's life in a radically new direction. In March 1938, just as he was winding up his spring semester affairs at Harvard and laying final plans for climbing Mounts Baker and Sanford, a horrifying episode took place in Europe. Anti-Semitic mobs went on rampages in Germany and Austria, destroying Jewish institutions in the fearful night of shattered glass and broken dreams that became known as *Kristallnacht*.

The democratic nations of Europe seemed paralyzed in the face of this and other examples of Germany's cruelty, as well as its increasing appetite for land belonging to its neighbors. Suddenly, isolation versus some form of intervention became an active issue in U.S. politics. It seemed that a very large war was inevitable.

Now approaching his 30th birthday, mountaineering wunderkind Brad Washburn was growing a bit long in the tooth to be learning close-order drill. But at a time when signs were pointing toward the importance of air power in the forthcoming conflict, he knew all about the problems faced by crews flying at altitude in unheated airplanes. And he did know a few things about how to survive in the chilly climes of Western Europe's future battlefields.

FIRST SIGHT: After climbing 6,000 feet through fog and snowstorms, Washburn and Bates set up camp at a high pass and were finally rewarded with a full view of Mount Lucania through their tent opening.

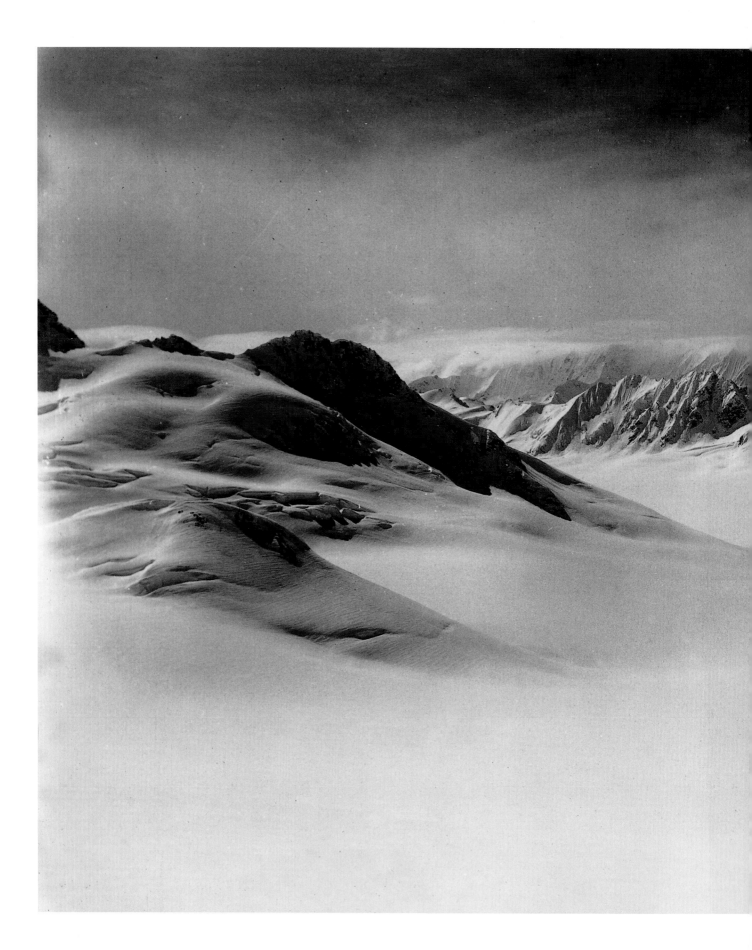

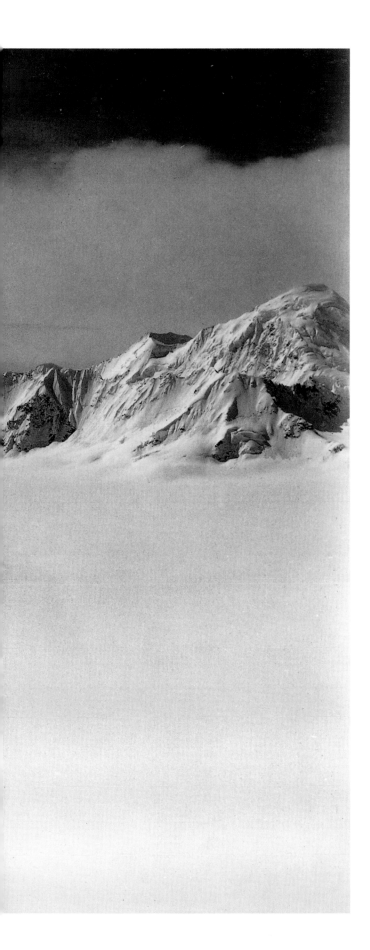

VIEW FROM "MOUND" TRIANGULATION STATION TOWARD
MOUNT SEATTLE, YUKON, 1935

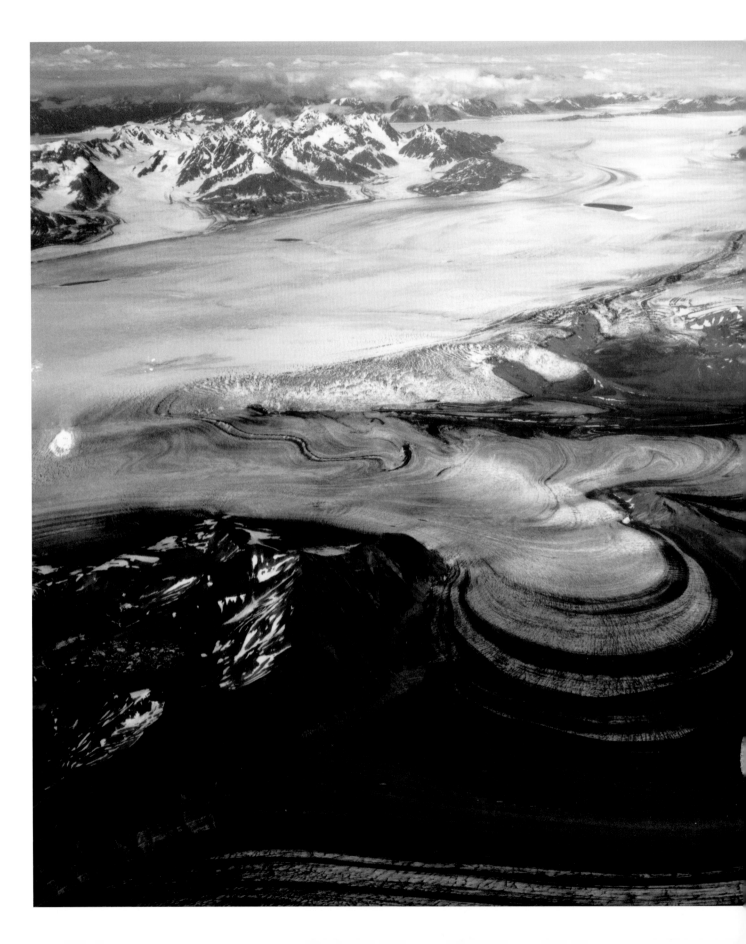

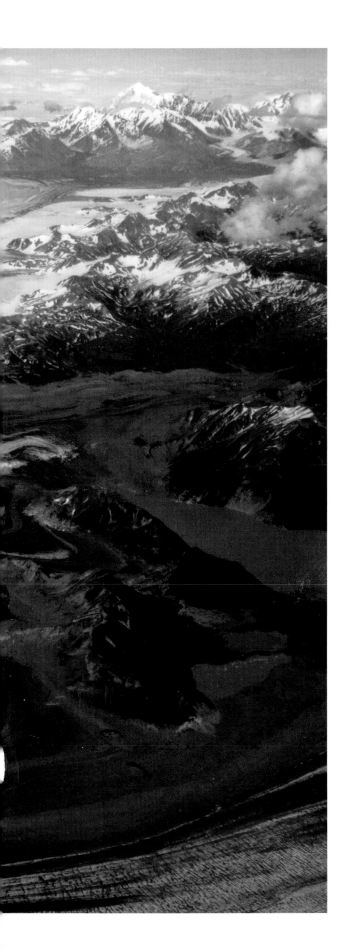

BERING GLACIER, ALASKA, 1938

AERIAL VIEW OF THE TOWN OF VALDEZ, ALASKA, 1937

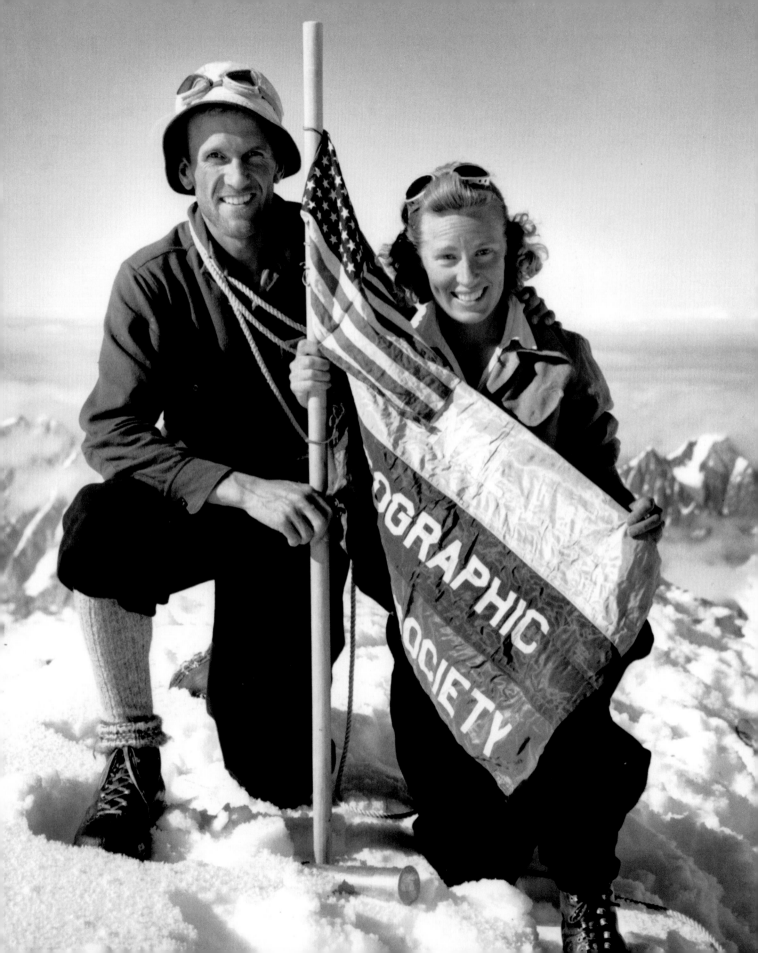

LOVE AND WAR

1941-1945

The mailman had his usual bundle of letters for the head secretary of Harvard University's biology department, plus an unusual request. Would she please go over and talk to a young guy who was leaving the Harvard faculty to take a new job? His name was Bradford Washburn, he'd just been hired to run the New England Museum of Natural History, and he was looking for an assistant.

The 23-year-old secretary, whose name was Barbara Polk, didn't know Washburn, but had read about him in the newspapers. It would have been unusual for anyone associated with Harvard in the early spring of 1939 not to have caught some whiff of the university's famous resident adventurer. She also knew, from long-ago childhood visits, a little about the natural history museum. It was a collection of artifacts from around the region housed in an imposing but somewhat run-down building on Berkeley Street in Boston. Prominent among its holdings were the huge skeleton of a finback whale, which had hung from the ceiling of the main hall ever since the 1870s, and a stuffed moose whose dust-coated fur bore evidence of posthumous insect attacks.

One of the stops on the mailman's route was the place that this man Washburn was leaving, the Institute of Geographical Exploration, located

HIGH COUNTRY HONEYMOON: Brad and Barbara summited their first peak together, Alaska's 10,204-foot Mount Bertha, only three months after their marriage. Decades of teamwork—and collaboration with the National Geographic Society—lay ahead.

down the way from the biology department on the Harvard campus. A few days earlier Washburn had asked Clarkie, as the mailman was called, if he knew anyone along his route who might be interested in working for Washburn at his new job.

Barbara Polk replied with a blue-eyed, dimpled smile that had Clarkie half smitten: "No! I don't want to work in an old museum and definitely don't want to work for a crazy mountain climber!"

But the mailman, who had taken a liking to Washburn and wanted to do him a favor, wouldn't let it go at that. He knew Polk as a friendly and efficient worker, and also had heard her praised by other secretaries along his route. After several days of importuning, including a call from Washburn himself, Polk finally agreed to drop by the museum and tell him in person that she wasn't interested.

She scheduled the interview for late afternoon on a day when she had an evening social engagement. Her date, a biology graduate student, agreed to wait for her in his car, which he double-parked in front of the old building. She spent the next 20 minutes sitting on some boards inside a large, messy room that was undergoing conversion to an auditorium trying to convince this brash young man that she wanted nothing to do with him or his museum. He didn't seem to be listening. He said he needed someone who could handle the museum's books as well. "I don't know anything about money," Polk protested. Washburn countered, "Well, you can learn, can't you?"

Though she found the museum just as depressing as she'd remembered from her visit years before, its new director was nothing like the hoary old explorer she had imagined. She promised that she would give it some thought over the next couple of weeks.

"I was supposed to be thinking about it," she later remembered. "But he called me up every night to see if I was thinking. And I finally said to my father, 'if that guy is so persistent and persuasive, I'm inclined to think that museum will go places. Maybe I'd be smart to take this job.' So I called up and said I'd take it."

As a child, Barbara Teel Polk had always enjoyed the company of boys. She said she found them "more stimulating" than girls. "They did riskier things, and I figured that any boy I met would lead me into adventure."

She was the youngest of three children, one of two daughters of Alvar W. Polk, a Universalist minister's son. The family was solid middle class and rooted in the Universalist denomination's liberal theological and social ethos. Polk had worked his way up from a position as errand boy at the church's publishing house to managing its book department. After she graduated from Girl's Latin School in Boston, Barbara entered Smith College at age 16, having precociously skipped the fifth grade. Some of her father's social consciousness had rubbed off on her. She spent her first summer after finishing Smith teaching arts and crafts to immigrant children

at Dennison House, the same Boston settlement center where Amelia Earhart had been a social worker almost a decade earlier.

Despite her parents' generally progressive views, Barbara had received the kind of upbringing thought proper for a young lady of the day. This entailed lessons in piano and ballet, and the expectation of marrying, raising children, and running a household. The job at the university—which she took after finishing a course at a secretarial school—was seen by her family as a way station along that path. Harvard, with its abundance of eligible male students, graduate students, and young faculty, seemed an especially felicitous place to wait for the expected to happen.

Once, as a child, Barbara had run away from home for a couple of hours after being ordered to stay in her room as a punishment. This kind of rebelliousness was rare, though she did occasionally question the program of adulthood that had been laid out for her. While still in college she asked the dean of Harvard's exclusively male law school, who was a family friend, why she couldn't attend his institution. He replied that a woman lawyer "would take the place of a man who has to make a living."

She accepted this kind of thinking without too much fuss. It was just the way things were. But she also recognized opportunity when it came her way. Here,

perhaps, was a chance for some of that excitement that boys generally enjoyed.

In the meantime, the "crazy mountain climber" had just made a big career decision of his own.

I WAS ON A FLIGHT from Boston to Philadelphia in November 1938 to give a speech about the first ascent of Mount Lucania when I recognized a familiar bald spot on a head a few rows ahead of me. It was an acquaintance: John K. Howard, of the Boston law firm of Gaston, Snow. Not long ago he had been elected president of the New England Museum of Natural History, and he was looking for a new executive director.

I knew all about the museum. In fact, as a favor to "K." Howard, I had allowed it to be a sponsor of the Lucania expedition—even though it couldn't afford to contribute a penny to that undertaking. It was just a way of giving the museum a little recognition that might come in handy for its fund-raising efforts. It had a long and distinguished history as one of the oldest museums of its kind in the country, second only to the one in Charleston, South Carolina. But with its aging collections and unimaginative ways of displaying them, in recent years it hadn't attracted much public attention.

Among Howard's various complaints about the current director—who was serving without any salary—was that the man was only interested in minerals. Howard had an expansive vision for the museum. He wanted to do some new and exciting things. But he was discouraged because already he'd been turned down by two young men who had seemed well-suited for the job of building on his vision.

He asked how I was doing. I shared some real problems about my job at Harvard's Institute of Geographical Exploration, where I was the de facto assistant director as well as an instructor. In my opinion, the Harvard Geology Department had its knives out for the institute. There always had been a sense in the department that neither the institute nor its founder, Hamilton Rice, quite measured up to the university's lofty standards. It was an open secret that Rice had essentially paid for his professorship by endowing the institute. Moreover, the new president of Harvard felt openly that geography was a subject that shouldn't even be taught above the fifth grade.

I was going on about the unfairness of life when all of a sudden John interrupted me by saying, 'You're exactly the fellow I'm looking for!'

Our plane was just descending into Newark, where John was getting off, and we had no time to pursue the matter further. But John obviously already had been giving some thought to offering me the job. He immediately followed up with a telegram, and later, when we were both back in Boston, continued an unrelenting campaign to recruit me.

Between his enthusiasm, and all the political infighting concerning the institute, I finally agreed—on condition that I be allowed to take off at least a month every year for exploration or mountaineering, and that I be able to continue writing and lecturing. That was important, since the salary they were offering was only $3,000. I would also continue part-time lecturing at the institute.

This was all fine with the trustees. I was elected as director in December and went to work on March 1, 1939. I hired Barbara Polk three weeks later. It was the second best decision of my life. The best one was yet to come.

FOR SEVERAL MONTHS nothing much happened in the way of social interaction between boss and secretary. Washburn, with his usual vigor and sense of urgency, threw himself into the work of revitalizing the old museum—and, inevitably, raising money, even though John Howard had sworn that he wouldn't have to bother himself with that end of it. As his new secretary would later recall: "Whenever Brad decided something needed doing, you hardly had a chance to take a deep breath before we were doing it."

Their relationship was formal and businesslike, and for a while stressful for Polk. Washburn had a habit of standing behind her while she typed reports. Everything needed to be done immediately. Crises were unending. But she did learn about keeping books, which she found that she liked. And occasionally she would encounter a larger-than-life character, such as the boisterously profane Robert Abram Bartlett, who had accompanied Robert Peary on several North Pole expeditions, including the final one in 1909. Bartlett, who continued journeying in the Arctic through 1941, once stormed into the museum on some mission demanding to know, "Where the hell is Brad Washburn?"

Polk began receiving her own doses of adventure when Washburn started inviting her to accompany him on flying trips. On the first one he noted pointedly that they were still on the clock. He had to fly a certain number of hours every month, he explained, and with his new job he found it difficult to find the time. With Polk coming along, they could discuss business.

She was an enthusiastic participant in these breaks from the office routine. One of her heroes was Anne Lindbergh, whose life of adventure she envied, and who had received an honorary degree from Smith College the same year that Polk graduated. During one wintertime flight in an open cockpit, with Polk wearing a flying suit, helmet, and goggles, she imagined she was Anne Lindbergh winging across the Orient.

If Washburn had any romantic interest in his new secretary, he was keeping it well hidden. Just before Christmas that year he called her into his office and asked if she would help him address Christmas cards. Her reward for a lengthy session of this was a hearty thanks, dinner at a nearby cafeteria, and "then he let me ride home on the subway."

The following month, January, the two unexpectedly found themselves together miles away from the workplace. Washburn was in Hartford, Connecticut, to give a lecture. Polk was en route to New York to spend the weekend with a young naval officer she'd been dating. She had gotten a ride to Hartford with a museum employee who was running the film projector for Washburn's show. She planned to continue the rest of the way by train. But the next train wouldn't depart for several hours.

The Museum of Natural History

Hoisting the jawbone of a whale out of the museum

At age 28, Washburn became director of the New England Museum of Natural History, housed in an 1864 building in Boston's Back Bay.

A view of the Main Hall from the second-floor mezzanine

The young director hard at work

Then secretary to the director, Barbara Polk does a little dusting up.

A school group lines up for a visit. Eventually, Washburn would turn his museum into one of the world's preeminent children's museums.

Washburn was surprised and delighted when she showed up for his presentation about Mount Lucania. It was the first time she'd seen him lecture, and she was impressed.

As it happened, Washburn was taking the same late train to New York for some meetings. Since Polk hadn't reserved a sleeping berth, he gallantly offered his, saying that he would find another.

They had a number of things in common, including a love of France and things French. Polk had spent her college junior year at the University of Grenoble and the Sorbonne. The latest news from Europe was disturbing. Germany, which had gone to war with the Western democracies the previous September by invading Poland, was storming across the continent.

Polk had some personal knowledge of what the victims were up against. Several years earlier, while still in college, she had spent a two-week Easter vacation with a family in Cologne. The offer of a free trip to Germany had turned out to be part of a program to indoctrinate foreigners with the policies of that country's new strongman, Adolf Hitler. Polk first had been amused, then repelled by what she'd seen, including young men with short swords at their waists and Nazi armbands strutting about in bistros, drinking Rhine wine and arguing loudly with the foreign students about the direction their country was taking. The young men's method of cutting in on a pair of dancers was to walk up, click their heels together, and bark, "Heil Hitler."

Washburn and Polk had talked of many other things, including the first time she had seen the Alps from a train window on her way from Grenoble to Paris. She had been delightfully surprised by their stupendous heights.

One part of her was thoroughly enjoying their time together, but the minister's granddaughter was a bit nervous about the propriety of being seen with her boss so far away from the office, especially in the close proximity of a railroad sleeping car. She was doubly perplexed when it turned out that the other berth Washburn had mentioned earlier happened to be located directly above hers.

After they had tucked themselves in for the night, she was startled to see a hand dropping down from above. The fingers were waving slightly as the train rocked along. An attempt to say good night, she reckoned.

What to do? Their relationship clearly was heading off in a new direction. Maybe he'd been attracted to her all the time. Certainly she had liked him well enough from the beginning. But she was afraid he would get a wrong message if she just grabbed his hand and squeezed. He might think her too aggressive.

All she could do was follow her instinct. She gave his fingers a gentle squeeze and whispered good night.

Drifting off to sleep, neither of them fully realized the extent to which they'd already fallen in love.

Nothing along those lines had been spoken. The truth was clear to others,

though. The next morning, at Washburn's insistence, Polk joined him for breakfast at a New York hotel with adventure radio broadcaster Lowell Thomas, with whom he'd had a lengthy friendship. That evening Thomas reported to his wife that he'd just met Brad Washburn's future wife. He'd seen what they hadn't yet acknowledged to themselves.

Polk met her naval officer in New York, but at weekend's end, she waved good-bye to him on the platform at Pennsylvania Station, and she and Washburn began the five-hour ride back to Boston together.

As they talked again, Polk was reading something new in his eyes, and she found herself responding. The following morning she was eager to get to work at the museum. She blushed when the boss arrived. The next evening he gave her a ride home. She invited him in. As they were sitting on the sofa, he asked, in his usual direct style, if she loved him enough to marry him.

Nothing was said about the kind of life they would lead, the roles each would play. Where would they live? Would Barbara continue working at the museum? Would she go with him on expeditions? Did they want children?

These matters all seemed so remote, so inconsequential. Just as suddenly as the question had been posed, she answered it: Yes.

Washburn's family didn't immediately endorse this plan for their son. His mother had high expectations for the future Mrs. Bradford Washburn. For years Edith Washburn had been conducting a low-key but persistent campaign to steer him toward society debutantes—which Polk wasn't. Washburn had been engaged once before, three years earlier, to an office worker he'd met in Cambridge. His family, especially Edith and brother Sherry, hadn't tried to hide their strong feelings that it wasn't a good match. The pair had finally broken up, and Brad had spent the Lucania expedition getting over her.

This time, though, he was certain of his choice, and he made that fact clear. The family quickly caved in. On April 27, 1940, in the Harvard University Chapel, Bradford Washburn and Barbara Teel Polk were married. It had been just three months since their hand-touching episode aboard the night train to New York.

Among other changes for the Washburns, including Brad's having to hire another secretary, marriage meant vacating the Deanery. The newlyweds found a $75-per-month ground floor apartment at 180 Commonwealth Avenue in Boston, and they immediately set off on a two-week honeymoon of hiking and skiing in the White Mountains. They had barely returned to their new home when news from

Europe intruded: Germany had invaded the Netherlands and Belgium. It reminded Barbara of what she'd seen in Cologne in 1934. Hearing about the Netherlands, she exclaimed, "That's just what those Nazi boys in Germany said they were going to do!"

Upon the couple's return, Washburn began planning seriously for his first mountaineering outing since taking on the museum job: a trip to be made with the help of a dog team up Alaska's Mount Bertha, an unclimbed 10,000-foot peak near Glacier Bay in the neighborhood of Mounts Fairweather and Crillon. He never asked his bride if she wanted to come: He just assumed she did. And, despite some trepidation on her part, he was right. Her only previous mountaineering experience had been a 3,500-foot climb she'd done with a date soon after college. She'd found it hard work and not especially enjoyable. But she was game for giving her new husband's passion a try, and determined to prove that whether she liked it or not, she could do it.

A petite 5 foot 1 and 115 pounds, Barbara was the only woman in the eight-person party, which included four Harvard students, all under age 20. One was the captain of the school's ski team, future *Boston Globe* editor Tom Winship. Another climber was future Alaska Lieutenant Governor Lowell Thomas, Jr., the 16-year-old son of the famous broadcaster.

Barbara enjoyed the company of this bright and lively bunch, but once again found the going hard and occasionally frightening, for example when circumstances called for rappelling—a skill she had to learn on the spot. At one point she began laughing almost hysterically to hide her panic when she found herself dangling in midair, unable to plant her feet squarely against the side of a steep, icy slope.

But she was intrigued by the beauty and remoteness of the area, as well as by the pioneering aspect of what she was doing. At 3:30 on the afternoon of July 30, one of those preternaturally bright highland Alaska days, with Mounts Crillon, La Perouse, and Fairweather poking their heads through a sea of puffy clouds on the horizon, Barbara Washburn became the first woman to summit Mount Bertha. The moment was captured by Tom Winship in a photograph that has since become an icon of their lives together: The newlyweds are kneeling triumphantly in the snow, flags of the United States and the National Geographic Society unfurled in front of Barbara.

When the couple returned from Bertha, Barbara was two months pregnant. Their daughter Dorothy was born March 7, 1941. For the first three months of Dottie's life Barbara devoted herself entirely to her daughter's care. But Washburn announced in April that he wanted to go on another expedition, this one to unclimbed, 13,832-foot Mount Hayes in the Alaska Range about 90 miles south of Fairbanks.

During the Mount Bertha expedition, Barbara steals a moment to write in her diary. Above, her new husband "takes the waters," of Glacier Bay.

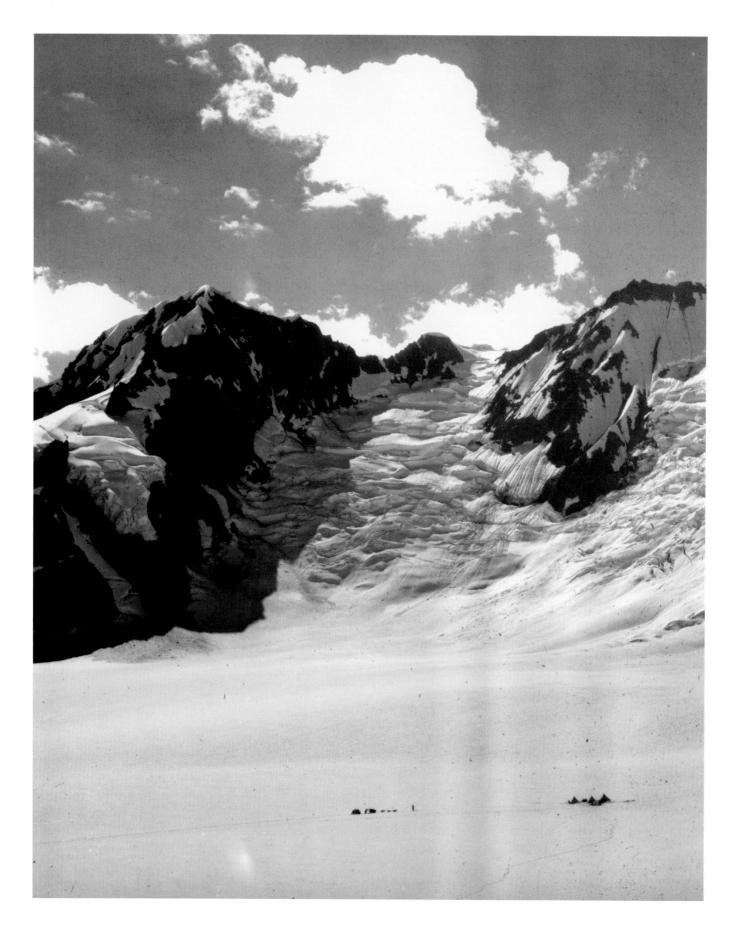

NOW BARBARA WAS TORN. The issue was settled when Washburn's mother and father—the latter having retired from the Episcopal Theological School the previous year—enthusiastically agreed to keep Dottie with them at Rockywold on Squam Lake for the duration of the climb.

Washburn's sudden wish for another Alaska trip was partly inspired by what was going on overseas. By the spring of 1941 it seemed all but certain that the United States would become entangled in the war that was now raging in Europe. Germany's invasion of Poland in September 1939 had triggered a conflagration that quickly spread across the continent and into Russia. France had fallen the following June, and one month later German warplanes had begun pounding England.

One of the reasons Washburn was determined to climb Mount Hayes that summer was that he feared it might be his and Barbara's last opportunity for a long time, not only for the pleasure of adventuring in Alaska, but also for gathering fresh material for his lecture business—which still accounted for half his income.

It was around this same period, as the war in Europe was heating up, that the U.S. Army Air Corps began taking a more than passing interest in Washburn's well-publicized activities. Its commanding general, H. H. "Hap" Arnold, was especially curious about the young climber's experiences air-dropping supplies into his base camps, as he had begun doing during the Crillon expeditions. The general began hearing all about this from Washburn himself after they were introduced by their mutual friend Lowell Thomas. Washburn often came to Washington for National Geographic or other business. He became a frequent dinner guest at the general's home at Fort Myer, located directly across the Potomac River.

When General Arnold heard about Washburn's plans to use airdrops in his forthcoming attempt on Mount Hayes, the general offered the services of one of his Douglas bombers for the job. He also wanted to send along an officer to study Washburn's methods and to observe firsthand his cold-weather clothing and equipment in use.

The Army air crew got off to a rough start. The first time they tried to deliver

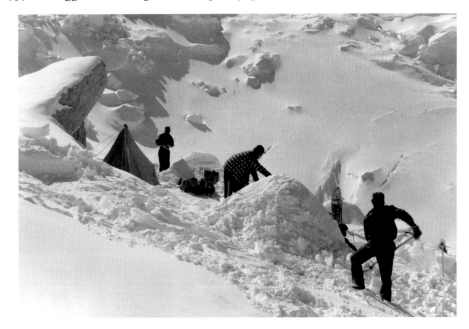

CAMP VII at the base of Mount Bertha gave Barbara her first taste of the mountaineering life. There would be more to come. A year later Brad was back in Alaska, setting up camp (above) to take on Mount Hayes.

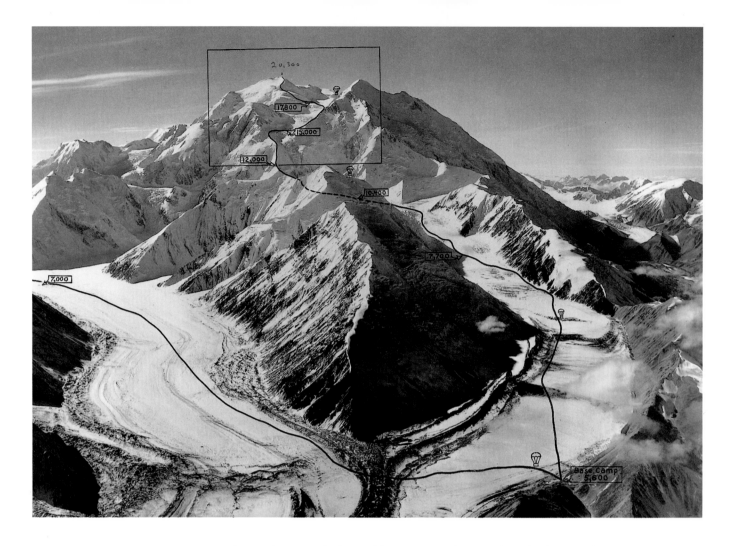

supplies to the site at the base of the mountain that Washburn had chosen for his camp, thick, low-lying clouds forced them to come in so low that the parachute delivering a food box barely had time to open. The box burst on impact and cans of food went flying across the valley. On the next pass, made an hour later after the ceiling had lifted a bit, the parachutes landed perfectly, but a keg containing half the party's fuel supply fell out the plane's door.

Despite these logistical setbacks, the climbing party, which again included Barbara, pressed on. They reached the top of Mount Hayes on the windy afternoon of July 29 with the thermometer reading just 11 degrees. In celebration they tossed rolls of colored paper and confetti into the air.

The climb had been even more grueling than the one the year before up Mount Bertha. Barbara was exuberant over having completed the trek, once again as part of a first-ascent party, but she'd already decided that the best part of these mountaineering experiences was the camaraderie. She liked the humor, the camp songs, the endless discussions of issues ranging from news, politics, and culture of the day to the eternal mysteries of life.

Back in Washington, General Arnold's interest in what Washburn knew about dealing with low temperatures was further whetted by what young Capt. Robin Montgomery had to say in his reports about the experience. The U.S. Army now came to Washburn with a more ambitious proposal for Washburn. In late September, Col. L. O. Grice of the Army Quartermaster Corps invited Washburn and a distinguished group of other Arctic experts to help make a complete reevaluation of the military's cold-weather clothing and equipment. The group eventually included polar explorers Sir Hubert Wilkins and Vilhjalmur Stefansson, and outdoor clothing entrepreneur L. L. Bean.

Their services were urgently needed. The two decades of peace that had followed the end of the Great War hadn't served the military establishment well in terms of preparedness to meet future challenges. Very little effort had gone into advancing technology in any area, including that of cold-weather gear.

The situation was especially critical in the emerging world of aerial combat. During the early years of the war, British bomber crews running 30,000-foot-high flights in their efforts to take the fight back to German airspace encountered temperatures as low as minus 40 degrees Fahrenheit. Horrible cases of frostbite were resulting. Machine gunners fending off attacks from swarms of German fighter planes would thrust aside the huge side doors of their aircraft and blaze away, sometimes casting away their cumbersome gloves and manning weapons with their bare hands when the maneuvering got desperate. According to one report, the British 8th Air Force in the early fighting suffered more injuries from frostbite than all other causes combined.

Washburn was eager to apply whatever he knew to the service of his country. With the patriotic blessings of Barbara and the trustees of the natural history museum, he took an indefinite leave of absence from his day job in April 1942 to join the group of fellow experts. In his words:

WE WERE VERY UNHAPPY with the equipment then available to the various branches of the services. Everyone seemed to be expected to fight in the same old equipment that had been used long ago in World War I. But this war was clearly different. It was not going to be fought in Europe alone, but on a dozen fronts scattered all over the world.

A number of us speedily developed innovative clothing and equipment to meet these new requirements. But the Army refused to actually buy anything until it had been given brutal field tests to prove its adequacy in combat. Hence the U.S. Army Alaskan Test Expedition of 1942, which I joined as the Air Corps' representative. We spent nearly three weeks on the high, frigid slopes of Mount McKinley and actually made its third ascent in the process.

When I got back, I wrote a scathing report about the tents and other survival equipment. I wasn't bashful about letting people know what I thought, and after a number of months with no results, I took my concerns straight to General Arnold. Some changes were made, but on the most pressing issues, it was my word against the entrenched powers. For one reason or another, business continued as usual.

FIELD-TESTING IN 1942: The U.S. Army Alaskan Test Expedition set up base camp at 5,600-foot McGonagle Pass on Muldrow Glacier. Mount McKinley rises high above the glacier's upper forks; team members traversed the south (left) fork several times testing ski equipment.

One afternoon I was invited to have a drink with an old friend by the name of Henry Field, whom I'd first met during one of my lecture trips to Chicago. Field now worked in Washington for the newly formed Office of Strategic Services, a forerunner of the Central Intelligence Agency. He wanted me to meet a friend of his, the prominent Chicago neuro-surgeon Loyal Davis, now serving in the army as a lieutenant colonel and senior military consultant in his field. Davis had recently returned from an official mission to England, where he'd been horrified by something he'd seen: the massive frostbite injuries that were being suffered by Royal Air Force crews on their bombing runs over Germany.

The ghastly frostbite photographs Davis had secured in England, plus my observations, pointed toward a grim future for U.S. combat air crews. But how to get these shocking facts across to the War Department in such a way that something would be done? I told Davis about my frustrations in trying to fix the mess. Davis had encountered similar problems in penetrating the bureaucratic morass.

Now Henry Field jumped into the fray. It happened that he was a good friend of Grace Tully, President Roosevelt's personal secretary. Field called her up and told her the whole sordid story. She not only understood the problem: She offered to pass along our concerns directly to the President.

And here's exactly what happened. Field and I coauthored an unsigned report recommending a top-to-bottom investigation of certain materiel procurements. A couple of days later Field received word from Tully that "the report is on its way."

The document landed on Roosevelt's desk August 30, 1943. The next thing I knew, I was being summoned to Arnold's office. On the way over, I was petrified that he'd found out about my involvement in this egregious circumvention of the chain of command. His executive assistant told me to go right in, despite the fact that Arnold was in the middle of a very important meeting. He handed me my report, saying, "Brad, take a look at this!"

The report bore no mention of my role in its development. However, it dramatically confirmed everything I'd been telling him—of course, since I'd helped write it!

Arnold had two reactions. He was furious at having this bombshell come down to him from higher authority—the highest in fact. But he was also pleased because, he said, he now felt he had the ammunition he felt he needed. Hell broke loose. When it was over, the entire system of air force equipment development and procurement had been overhauled.

I went back to developing and field-testing cold-weather gear for the remainder of the war and had many exciting times in Alaska before it was over. In the end I received the War Department's Exceptional Civilian Service Medal, a generous commendation from Air Force Secretary Lovett, and the following praise in a letter that I received from Hap Arnold: "The long hours, extensive research and personal hardships which you willingly endured were notable contributions toward making our air force personnel the best equipped in the world."

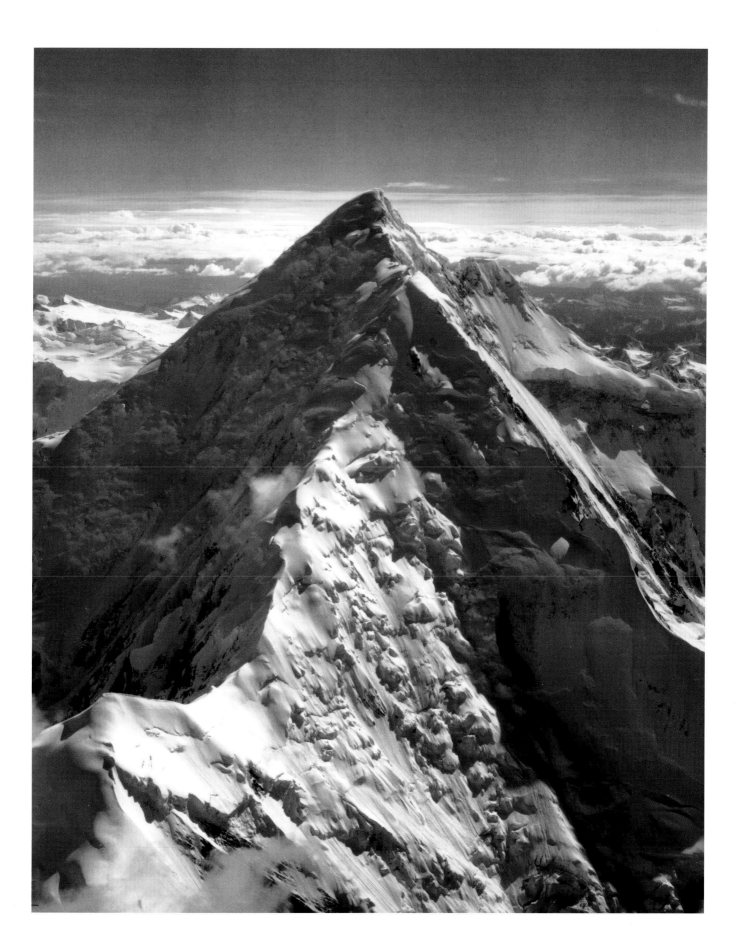

EASTERN SPUR OF MOUNT BERTHA, 1940

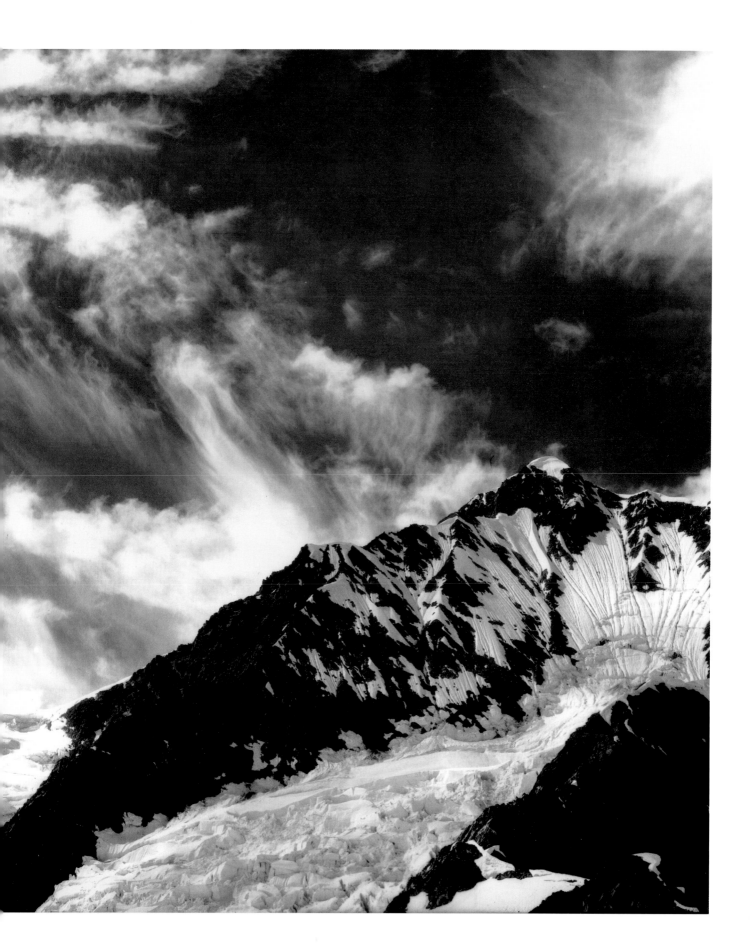

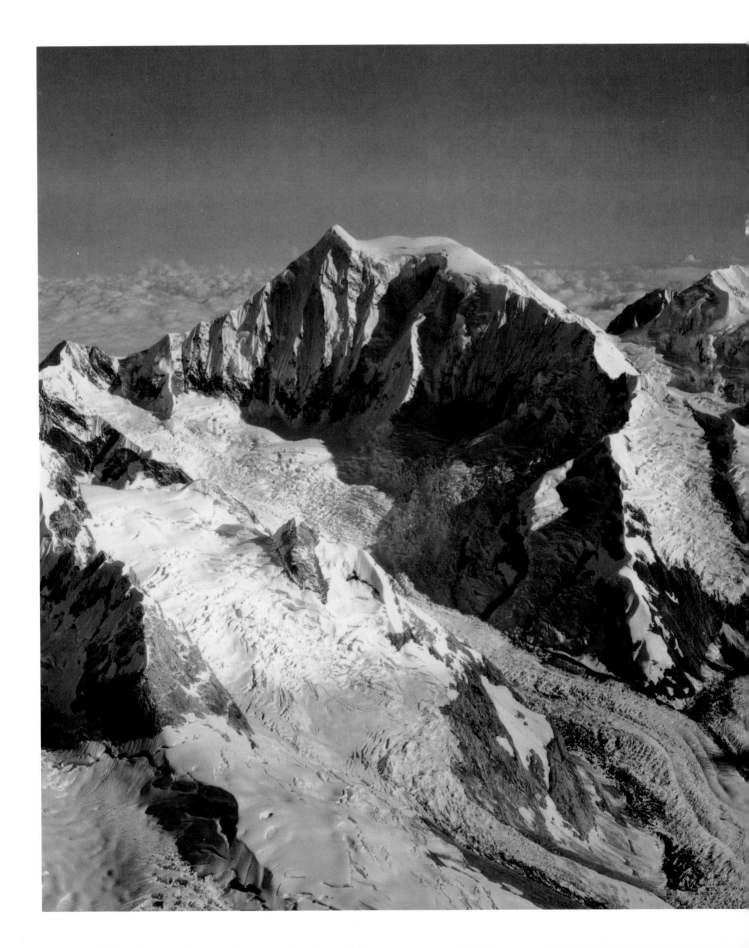

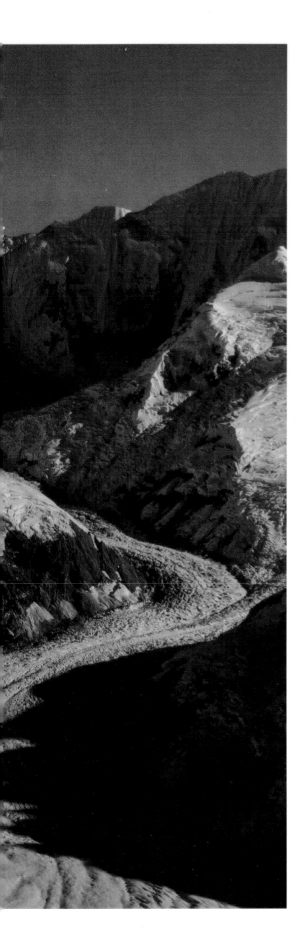

LOOKING SOUTH OVER JOHNS HOPKINS GLACIER,
MOUNT BERTHA, ALASKA, 1940

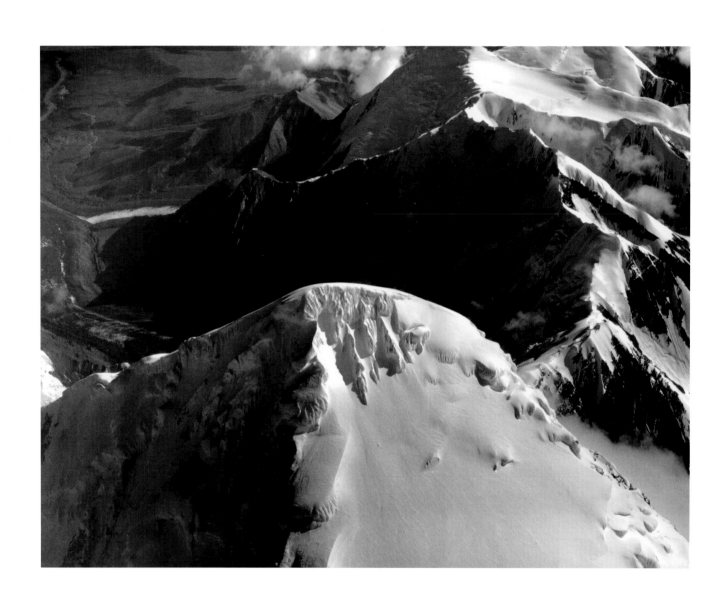

LOOKING DOWN ON THE SUMMIT OF MOUNT HAYES, 1941

SKY CATHEDRAL

1945-1951

Hunched over in the dank refrigerated darkness of an emergency igloo, Washburn stared at the sleeping pill in his hand for a long moment. He was having second thoughts about taking it.

It was a little past ten o'clock on May 21, 1947. A monstrous snowstorm was pummeling Mount McKinley. He'd just gotten off a two-way radio hookup with his wife, Barbara, who was riding out the same storm in a tent with two other climbers at 14,600 feet—1,500 feet below his own position. They were waiting for the weather to lift so that they could resume their journey toward the summit. He'd had to shout: Wind was shaking her tent violently, the fabric popping around her like cannon fire. He recommended that she take a sedative and try to get some sleep, and he assured her that he was about to do the same.

With his flashlight he took another look around the interior of the small dome of hard-packed snow blocks that he and 38-year-old Air Force survival specialist Jim Gale had hastily thrown together that afternoon as the storm was moving in. The darkness was oppressive. The noise was different from what was going on inside in Barbara's tent, but it was at least as nerve-racking. The wind had a deep, throaty sound, like some ancient, enraged thing focusing its energy on trying to get

DWARFED by the Alaska landscape, Barbara Washburn stands at 18,000-foot Denali Pass. She was the mother of three young children in 1947, when she became the first woman to climb Mount McKinley.

into their puny shelter and destroy what it found hiding there. Washburn couldn't get to sleep either.

The storm was worrisome for another reason. It looked as if it might be around for a while. Washburn and Gale had been on a reconnaissance trip when it had moved in, scouting the trail ahead and marking a location for their final camp. They had only a small amount of food and fuel with them. Would it be enough to last until the weather broke? McKinley already had claimed the lives of two of the handful of people who'd climbed it up until then: Allen Carpé, Washburn's old Mount Fairweather rival, and Carpé's climbing partner Theodore Koven. They had perished in 1932, apparently after falling into a crevasse. Carpé's body had never been found.

Washburn put the little tablet into his mouth, worked it down with a cup of hot chocolate, and settled back in his sleeping bag to see what the morning would bring.

IT WAS WASHBURN'S SECOND GO at McKinley. If he and his team succeeded, it would be only the fourth time the continent's highest peak had been summited, and the first time by a woman. Washburn had done it back in 1942 as part of a 17-man expe-

EARL Norris mushes the expedition's dog team up the great Muldrow Glacier that sweeps toward the summit.

dition testing equipment for the U. S. Army and Air Corps. He and seven other members of the elite high-altitude party had gotten to the top without too much difficulty. If the current plan worked out, Washburn would become only the second person to summit twice.

This 1947 expedition was part science and part Hollywood. RKO Radio Pictures had first approached Washburn with an offer to finance a summit attempt on Mount Everest. The movie people were planning to make a film of *The White Tower,* a novel by James Ramsey Ullman about mountaineerng. Although Ullman's story took place in the Alps, RKO wanted to shoot background film in the dramatic Himalaya. Another thought was to raise public awareness of mountaineering through a well-publicized expedition led by one of its best-known practitioners.

Washburn would have loved to oblige. He'd been preoccupied with thoughts of Everest ever since his days at Groton. It was still the holy grail of unclimbed mountains. But he quickly convinced the RKO executives that such an expedition was impractical. Everest was located on the border of Tibet and Nepal, both of which were closed to Westerners. Instead, he offered to climb a mountain he already knew

a good deal about—McKinley—which also happened to be located relatively close to Air Force bases in Anchorage and Fairbanks. RKO would pick up the tab for a large, first-class climbing party, plus a broad scientific agenda that would include rock collecting, surveying, weather observations, and a study of cosmic rays—an activity best carried out at high altitudes. Cosmic rays, mysterious energy waves emanating from space, were of special interest to the U.S. Navy's Office of Naval Research—which conducted basic research for the entire military establishment—because of the potential dangers they posed to high-flying manned aircraft as well as future Earth satellites. The office wound up helping support the expedition.

It would be called "Operation White Tower." The studio agreed to everything, and even paid for the Washburns to hire a nanny to take care of their growing family during the expedition. They had three children by now: 6-year-old Dottie, 4-year-old Edward Hall (Teddy), and 11-month-old Elizabeth Bradford (Betsy).

Barbara had spent most of the war years in Cambridge busying herself with child-raising. With Washburn on the government payroll, they were able to afford to rent a house not far from where Brad's family lived when he was born.

The McKinley trip was Barbara's third major outing, the first since Mount Hayes, and she was handling herself on the slopes like a pro. She had joined the others in playfully questioning the febrile news stories that were being filed along the way by the reporter who was traveling with them, Len Shannon. The climbers considered his breathless dispatches outrageously dramatic. Shannon countered that "Your activities may seem routine to you, but to the public and to me they are as dramatic as going to the moon." A few days later the reporter had himself evacuated, vowing just before being picked up for his flight out: "When I get back to Los Angeles, I'm going into the darkest nightclub I can find, smoke a big, black cigar, and never look at snow again."

The storm that struck on May 21 tested everyone's nerves and endurance.

ON THE DAY BEFORE we got snowed in, Barbara and I had spent our first time entirely alone together on a rope. We were ascending knife-edged Karstens Ridge. She climbed like an old hand. Never once did she step on the rope, and never once did I have to pull her. Traleika Glacier was 4,000 feet below us. She'd learned the trick of not looking down.

The next day, Jim Gale and I accomplished our mission of gaining a foothold at 18,000-foot Denali Pass, and were on our way back down when the storm moved in. Our 16-person party was now divided among three camps. Gale and I were at 16,500 feet, Barbara and two others at 14,600 and the rest were at 11,000. Everyone was well stocked with supplies except Gale and me.

By the evening of the second day we were down to our last half-gallon of gasoline. We could survive without a flame for heat, and could even live for many days without much food. But we needed our stove to melt ice for drinking water. We couldn't go long at all without water.

The news from Barbara's location was grim: She reported that half the camp had been torn apart, some of the valuable cosmic ray equipment had been swept away, and the winds were continuing unabated.

All Gale and I could do was hunker down in our sleeping bags and try to conserve fuel. We had a temporary respite on May 26 when the storm lifted long enough to allow a dash back up to 18,000-foot Denali Pass, where some rations including a small amount of fuel already had been air-dropped. We were able to throw a tent up just before another front moved in. But fuel remained a constant worry.

Finally, after nine punishing days, the weather broke long enough for a resupply drop from the air. Then we began our push to the top. Eight of us made it, including Barbara, and we had a windblown celebration in minus 20-degree weather.

Our party wound up spending an unprecedented 90 days on McKinley, a feat made possible by constant airdrops of supplies. We accomplished a great deal of science, and RKO seemed delighted with its film footage as well as the publicity it received through the steady barrage of news stories we'd been feeding them. However, I drew the line at one shot they'd wanted to get. They wanted to film a life-size dummy of Rita Hayworth dressed in a scanty bathing suit propped up on the summit of Mount McKinley.

That seemed to me, well, a bit over the top.

A sadness came over me as we descended from the summit. I thought this second time might be my last on that great mountain. But for now I had to force my attention away from anything having to do with ice, snow, and mountain climbing. I had to start thinking about building and operating my museum.

A big job lay ahead of me back in Boston. As respectable an institution as the New England Museum of Natural History was, it was in a lamentable state in 1939, when I was hired. Things hadn't improved by the time World War II was over. I returned to a staff of about a dozen people, a $44,000 budget that was frequently in the red, and about 45,000 visitors per year—all admitted free. The grand old building in the Back Bay on Berkeley Street was hopelessly antiquated and structurally unsound, in danger of being condemned by the city. A trip to the museum in those days reminded many of a walk through an attic.

In my determination to turn things around, I had strong allies on the board of trustees. They included an old climbing colleague: Terris Moore, who had summited Mount Fairweather with Allen Carpé in 1931. During the war he'd worked alongside me as part of the military clothing and equipment advisory group. He had been with us when we summited Mount McKinley in the army expedition of 1942.

After visiting a number of leading science museums elsewhere in the country, I laid out a very ambitious program. It called for ditching the old museum building and putting up a brand new one on Boston's Charles River Dam—a site which I'd discovered on an airplane flight. The whole thing, including five acres of overgrown parkland, was owned by the Commonwealth of Massachusetts. Perfect!

I insisted on a new name: the Museum of Science. I wanted to touch on all branches

of science, not just natural history. I especially wanted to captivate and inspire children, as I had my own and knew what worked for them. Too many museums had a look-but-don't-touch policy. At our museum children would be able to pet a porcupine, play in a locomotive, sit in a model of a real spacecraft.

All this would cost money. And, despite "K." Howard's pledge that I wouldn't have to worry about that end of it, this, of course, became my prime preoccupation almost immediately.

I must say I got pretty good at it. In 1997 somebody figured out that during my years at the helm we raised over $200 million in current dollars. In addition to the usual courting of wealthy patrons, we tried to come up with creative ideas. When we were raising money to complete our planetarium, we sold off various heavenly bodies. The sun went for $10,000, the moon for $500. The price of constellations varied according to size. The last time I checked there were still millions of stars left. At a dollar apiece, not a bad bargain.

Some of the biggest piles of greenbacks came in through plain luck, like the time that Barbara happened to be at a New Hampshire cocktail party in 1955 and overheard a lawyer and a banker sitting on a stone wall trying to decide what to do with the fortune of a certain philanthropist. The subsequent gift to the museum went a long way toward the construction of our new central building.

Timing helped. The 1950s was a period of great public interest in science. It was an age of miracles ranging from television to atomic power and its potential for peaceful uses. This fascination with things scientific was apparent in February 1950 when we opened a temporary museum on the Charles River site where the new building was going up. The exhibit hall was all of 21 by 28 feet, part of an old sheet-iron building, not much more than a heated shed that also housed the museum's staff.

Despite its low-tech exterior, long lines formed to view live animal and electricity demonstrations inside, to sit under man-made stars in a miniature traveling planetarium, and to ponder such wonders as a sand pattern pendulum that demonstrated harmonic motion, a Geiger counter that detected radioactive minerals, and a cutaway model of a General Electric axial-flow turbo jet airplane engine. In its single year of existence the temporary museum attracted 80,000 visitors, at admission rates of 25 cents for adults and 10 cents for children. (We liberally handed out free passes to schools and neighborhood houses in low-income areas.)

I had found a new career. My mother, who long had feared that I would become a professional mountain guide, was relieved that I seemed finally to have landed a stable job.

MOUNT MCKINLEY AGAIN. 1951. Another storm. Another igloo.

This time when Washburn and the other climbers woke up in the morning, they found that a tunnel they'd built to link their snow house to a cooking tent was filled with loosely packed snowdrift. It had blown in from a six-foot gap between igloo and tent. And the storm hadn't quit yet. When Washburn and two others dug themselves out, they stepped into a 60 mile-an-hour blizzard.

HELICOPTERS kept the expedition supplied; this one hovers above Mount Brooks.

Washburn was part of a nine-person party on a quest to find the shortest, fastest and maybe safest way up Mount McKinley. Despite his museum-building duties, mountain climbing remained an important part of who Washburn was. And it wasn't at all lost on the museum trustees that his reputation in this area was a powerful attraction, both for visitors and donors. So they had no objections when he proposed returning to Mount McKinley—this would be his fourth trip.

In 1949 he had directed a surveying party for the Office of Naval Research, which was still interested in cosmic ray research. The navy wanted to find a way to the summit that would be faster than the long and difficult Muldrow Glacier route, then the accepted route.

Washburn spotted a more promising approach that year while on a helicopter flight with James Gale. It was on the western side of the mountain. He publicly proposed the new route in an article that appeared in the *American Alpine Journal,* throwing it out as a challenge. A group of mountaineers in Colorado picked up the gauntlet. They came to Washburn seeking his photographs, on which he'd traced

Mount McKinley

Barbara hanging laundry at base camp, Reid Inlet

*Old prospector and his pet raven
at Reid Inlet*

*Keeping pesky mosquitos away, Barbara rests
after conquering McKinley.*

Victory on the north peak of McKinley, June 7, 1947, Brad's 37th birthday

George Browne, Brad, and Barbara collect rock samples at 18,500 feet on McKinley.

Brad in the combined kitchen and radio tent

dotted lines indicating the proposed path. Washburn showed them the photos and asked to go along. The Coloradoans did more than just agree to having him join in: They made him their leader.

His plan was to go almost to the top along a steep ridge called the West Buttress. In architecture, buttresses are distinguishing properties of the world's great medieval cathedrals. The use of this term for mountains, especially monarchs like McKinley, makes a pretty metaphor. McKinley's West Buttress extends roughly five twisting miles, rising in that relatively short distance 7,000 feet. But just reaching the point where the climbing would begin involved crossing miles of buggy lowlands and a long, treacherous glacier. Washburn's scheme called for landing climbers and supplies on the glacier only seven miles away from the place where they would begin the steep part of the climb.

In addition to the Coloradoans, Washburn would be joined by three old friends, all McKinley veterans: Air Force igloo wizard James Gale, Army Capt. William Hackett, and, as expedition pilot, Terris Moore—who in addition to having built a thriving career as a bush pilot since their days on McKinley in 1942 had found employment as the president of the University of Alaska.

Washburn kept an extensive log of the trip:

May 16 – Denver! Finally on the way to Alaska after a month of feverish preparations, fundraising, and planning the final details of the museum's new Hayden Planetarium. Had supper tonight with the members of our party from Denver. To bed at 10:30 p.m....

May 18 – Reached Fairbanks at 6:30 a.m. I've located and sorted all my gear but four pieces that left Boston only two days ago. They should turn up soon. In the meantime, I have a speech to prepare. I'm to receive an honorary doctorate at the University of Alaska, along with Governor Earl Warren.

June 2 – Up at 4 a.m. and off with Terry Moore in his airplane bound for McKinley to do some reconnaissance. We climbed up through a thin layer of ground fog and then headed up the southwest fork of Ruth Glacier. Mount Silverthrone off to the right, covered with a gray plume and very menacing weather. The flight up that gorge south of McKinley was the most dramatic flight I've ever made in Alaska. The fantastic ice and rock slopes of the Rooster Comb, Mounts Huntington and McKinley were impressive and savage beyond description.

June 18 – Henry Buchtel, the leader of the Denver group, and I are now safely camped at our base camp on Kahiltna Glacier, elevation 7,600 feet. We are in our little seven-foot-square Logan tent, supper just finished, ready for bed. The cloud tops are only just above us and we can get glimpses of Mount Foraker, all pink with alpenglow. My, what a good feeling to be here after all these months of hoping and planning.

June 20 – Henry and I trudged up to within a few hundred yards of 10,300-foot Kahiltna Pass, very near where we plan to set up our advance base camp. Back at the main camp, Terry

Multitalented expedition member George Browne watercolors on Muldrow Glacier. His father, Belmore Browne, had been co-leader on the legendary Parker-Browne reconnaissance expedition of McKinley in 1910.

Moore made an unannounced landing in the early evening with Bill Hackett. Then he flew right back to our staging area in Chelatna, Alaska, picked up Jim Gale, and brought him here with all the rest of our equipment. Both landings were made under terrible conditions, with light snow falling. Let's hope for a spell of really good weather.

June 22 — An Air Force C-47 cargo plane appeared at 6:30 a.m. at our 10,000-foot camp and started dropping supplies even before everybody could scramble out of the tent. They made at least a dozen passes, each time tossing out something—43 pieces in all, five of them by parachute, the rest free-fall. We now have more than a ton of stuff, much of it for use in adding to the surveying work we did two years ago. In addition to finding a new route up this mountain, my aim is to produce a beautiful and detailed map of the whole area.

June 30 — At last, we're all here at the Kahiltna Pass camp. The remainder of the party arrived after a five-day pack train trip through the lowlands—lots of miseries from rain and mosquitoes. One of them … fell into a huge crevasse on the way up the glacier. Fortunately he was well-roped and so only went in up to his neck. He summed up the experience like this: "I felt like a roofer who had just fallen through the dome of St. Peter's!"

THE STORIES had been coming out of China for years. Travelers returning from the remote west central region of the country told of a gargantuan mountain range whose main peak might exceed Mount Everest in height. Its name, Amni Machin, means "Father of the Great Yellow River." Joseph Rock, the National Geographic Society's peripatetic Asia correspondent during the 1930s, had glimpsed it from afar; but no explorer had gotten close. The area was inhabited by unfriendly Tibetan nomads led by a warlord queen.

Sightings by U.S. combat pilots flying between India and China during World War II rekindled interest in the mystery. In 1947 *Life* magazine asked Washburn—who knew Rock and had discussed the mountain with him—to lead a party to fly over the area, locate and photograph the peak, and if possible determine its height. Washburn invited three others to join him: a radar expert from the Massachusetts Institute of Technology, a geologist, and a photo lab technician.

To finance the expedition *Life* enlisted Milton Reynolds, a voluble, publicity-conscious ballpoint pen manufacturer from Chicago. Reynolds insisted on joining the expedition in person. He also picked the air crew: William Odom, a 28-year-old thrill-hungry test pilot, and his mechanic T. Carroll ("Tex") Sallee.

The expedition quickly descended into farce. After many travails involving publicity gambits by Reynolds,

repairs to the B-24 bomber he provided, and threats posed by Mao Zedong's Communist insurgency, all hands assembled in Peking in late March, 1948. While taxiing from the brick apron where the airplane had been parked, Odom turned the craft too sharply to get onto the concrete runway. The right wheel sank into deep mud, crumpling a propeller blade. For Washburn, who had become increasingly repulsed by Reynolds' behavior, this was the last straw. Washburn and his team resigned on the spot.

Three days later, repairs effected, Reynolds, Odom, and Sallee departed for Shanghai (above)—stranding the Washburn contingent. Washburn later learned that Reynolds attempted to fly illegally, with no flight plan, from Shanghai directly over Amni Machin to Calcutta. The plane returned to Shanghai without finding the mountain, and the men explained that they had realized in flight that they had no Indian visas. Among other complaints, Chinese authorities said Reynolds had left without paying the expedition's hotel bills. The standoff ended when Reynolds and his crew distracted machine gun-toting Chinese guards by tossing handfuls of gold-plated ballpoint pens onto the runway, and then roared off for Tokyo.

The mystery of Amni Machin was finally solved some 25 years later, when a Chinese expedition revealed the peak to be 20,610 feet high—a whopping 8,425 feet short of Mount Everest.

July 4 – There's nothing like an igloo! We're camped tonight at 13,000 feet, not very far from where the real climbing will begin. We set up an igloo and a cook tent this afternoon, then divided up the party by drawing straws. I'm glad I got the igloo. The wind is building fast—already up to 35 mph in gusts—and snow is falling hard. It's 18 degrees Fahrenheit outside, but 35 in here. Not bad. The fellows in the tent are going to have a wild night of it.

July 5 – Up at 9 a.m. after a comfortable night—inside the igloo, at least. When we dug through the snow blocking the tunnel we stepped out into a fiendish blizzard. The wind's gusting up to 60 mph and it's snowing like hell. We're going over to the tent for breakfast now, and expect to look like snowmen before we get across the six-foot gap between the igloo and the tent.

July 6 – Big blow all last night, but all cozy in the igloo. When I got up at 7:30 a.m., the tunnel was completely blocked and the cook tent half buried. It took us 25 minutes to dig out. The wind died down around 2 p.m. and we re-pitched the tent. My, the weather changes fast here!

July 8 – We've reconnoitered all the way up to 17,200 feet, the very top of the West Buttress of Mount McKinley. All that remains is for us to get up the steep 1,000-foot slope that leads to Denali Pass—the snow-covered saddle that lies between McKinley's north and south peaks. It's right in front of us, temptingly close. After we get to the pass it will be a relatively easy climb to the summit.

This is a spectacular route. Views of nearby peaks and the glacier below are stunning every day, in every conceivable combination of light and shadow. I wonder where we'll be tomorrow night.

July 9 – We are now camped in the 17,000-foot snow basin right below Denali Pass under gorgeous blue skies above a silvery sea of clouds. The pass now seems but a stone's throw away, a pure white collar under the deep blue sky. Our objective is very nearly won: A single clear day now and we'll be in the pass. But we're due for a few chilly nights. We abandoned half our sleeping bags at 13,000 feet to cut weight. It's getting mighty cold already.

The sun has just set behind the western spur of McKinley's north peak. The clouds have disappeared. Lakes and rivers to the northwest are all gold, and a fresh new moon is rising to the west of Mount Foraker. My, what a sight. This is the most beautiful route possible....

July 10 – Last night was wonderfully clear and calm. We decided to take a crack at Denali Pass, and maybe even the summit if the weather holds.

The weather was cool, 20 degrees Fahrenheit, and winds calm as we tackled the steep western slope of the pass. Ridges of snow formed by the wind, called sastrugi, are enormous. How the winds must have howled across that bleak slope.

A flash of bright yellow caught my eye as we arrived in the pass. It was a parachute flapping in the wind. Attached to it was a cache of cosmic ray equipment—stuff that we'd left behind in 1947.

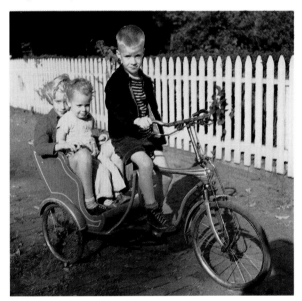

A SHANGHAI pedicab, brought back from China by Washburn, transports his young family through the streets of Cambridge. Teddy, at the wheel, does the peddling for his sisters, Dottie and Betsy.

Success! We concluded the first ascent of McKinley's West Buttress and proved that not only could it be done, it was exactly what we'd predicted: the shortest, safest, and easiest way to climb.

Now we were on familiar ground. All that remained was a dash to the top. Could we make it? There was a big cloud plume hanging over the summit. At the very least, there would be fog up there.

We started off. To our amazement, as we climbed up the ridge, we ran into scores of our old trail markers—little birch dowels we'd stuck in the snow in 1947! All were sheared off almost flush with the icy surface of the snow by the violent winter winds.

At 19,000 feet we entered the fog. The breeze got brisker. We made the next thousand feet in exactly one hour, trying to keep in the lee of the mountain. Jim and Bill were having a bit of hard going with the altitude, the only time I've ever seen Jim tired. Curiously enough, I've never felt better.

At about 19,800 feet I decided to strike off to the right and try a new route, right over the top of the Kahiltna Shoulder. This would avoid a lot of the half-hardened sastrugi through which we'd been floundering on the direct route.

At 4:45 p.m., just as we reached the crest of the shoulder, the weather cleared. We were the first people, I believe, ever to go there. What a view of the top and the wild peaks to the south and southeast!

We were now less than 300 yards from the summit. The bamboo pole that we'd left on top in 1947 was clearly visible! I stopped briefly to take some pictures, then caught up with the others trudging along the last big hump on the ridge. For the next hundred yards I broke trail, reaching the top of the final drift at 5:30.

I'd never really dreamed we'd get to the top today. Now we could see what lay on the other side of the mountain. I was overcome with emotion. The whole amazing panorama to the east opened up to us. All was clear in every direction: Mount Hayes, the Coast Range, Marcus Baker, Lake Minchumina, the hills behind Anchorage, the green lowlands of Clearwater and Wonder Lakes. A hundred thousand square miles of Alaska spread out below us. I thought of what a member of Archdeacon Hudson Stuck's party said after their first ascent on June 7, 1913.... "The view from the top of Mount McKinley is like looking out the windows of heaven."

A bit of orange bunting that we'd tied to the top of our bamboo summit marker four years earlier had slipped down to the snow. But it was still intact, needing only a new knot. We busied ourselves refastening it, reluctant to say good-bye to this wondrous spot.

Twice before I'd left this place thinking I'd never return. In all probability this really will be my last visit. I've just celebrated my 41st birthday. I have a wife and a family, and a very demanding job.

As I headed down off the ridge, tears unexpectedly welled up in my eyes. Jim Gale, as rough-and-tough a guy as you'd ever want to meet, told me … the same thing had happened to him.

MCKINLEY WITH A TRIBUTARY OF CACHE CREEK
IN THE FOREGROUND, ALASKA, 1953

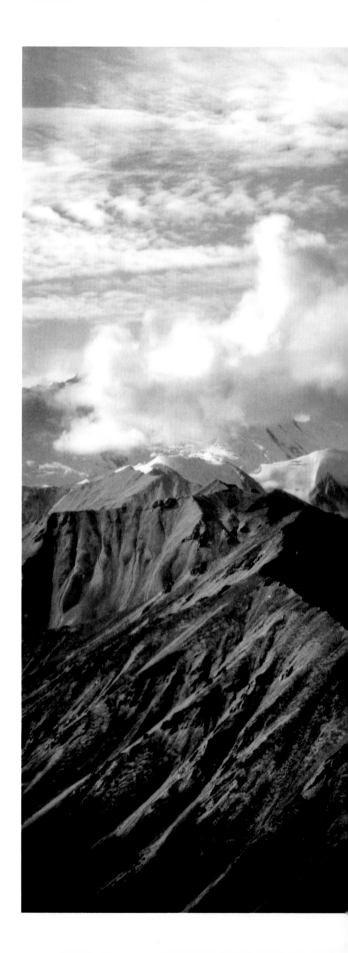

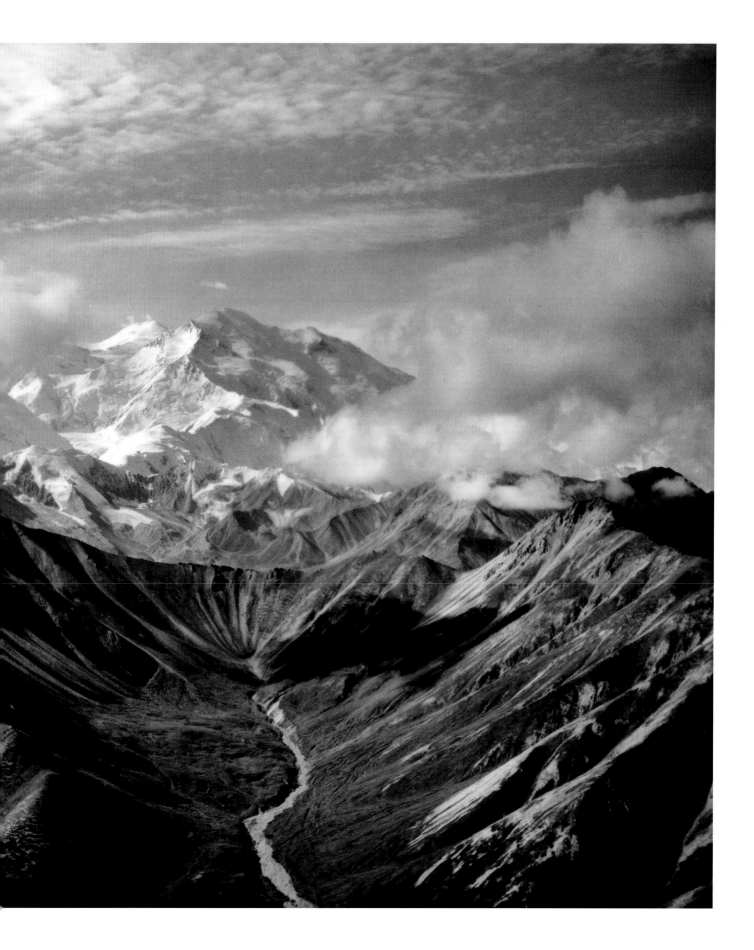

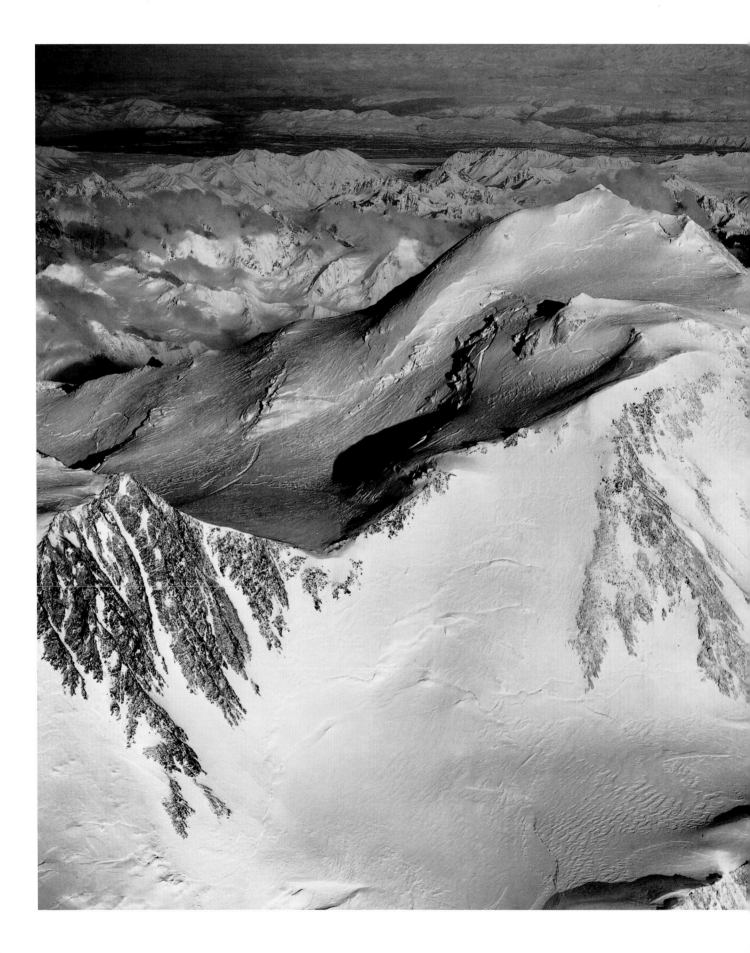

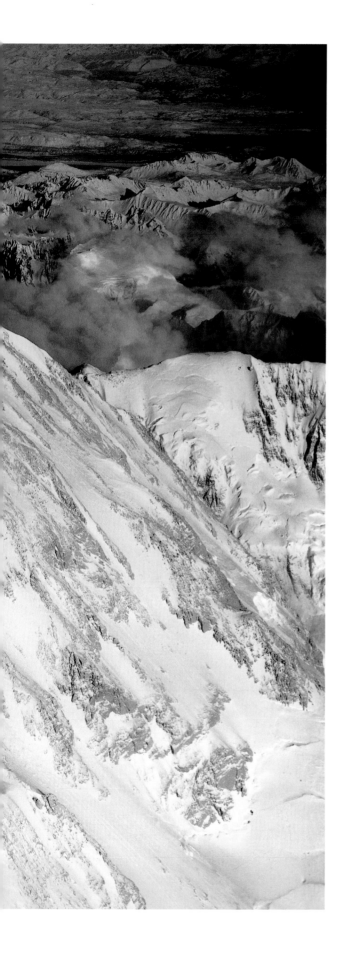

SUMMIT OF MCKINLEY, LATE AFTERNOON, 1951

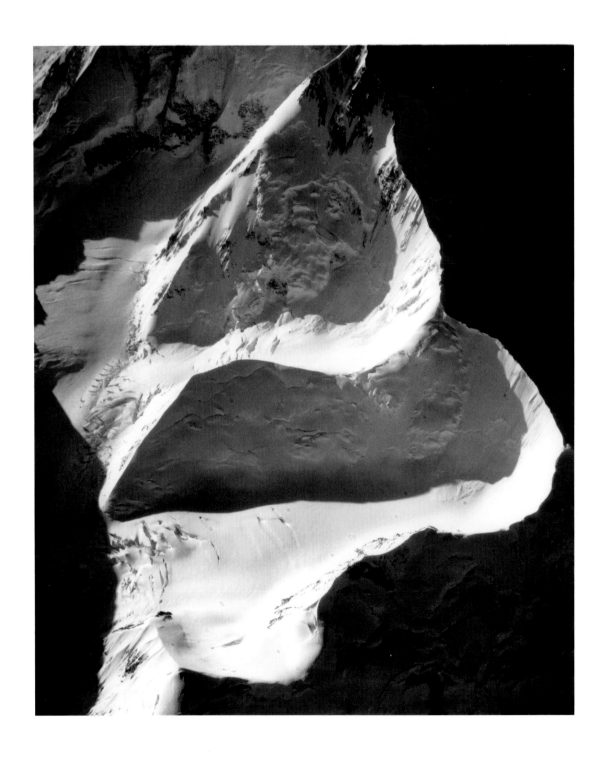

FLATIRON SPUR AND UPPER MULDROW GLACIER BELOW THE NORTH PEAK OF MCKINLEY, 1964

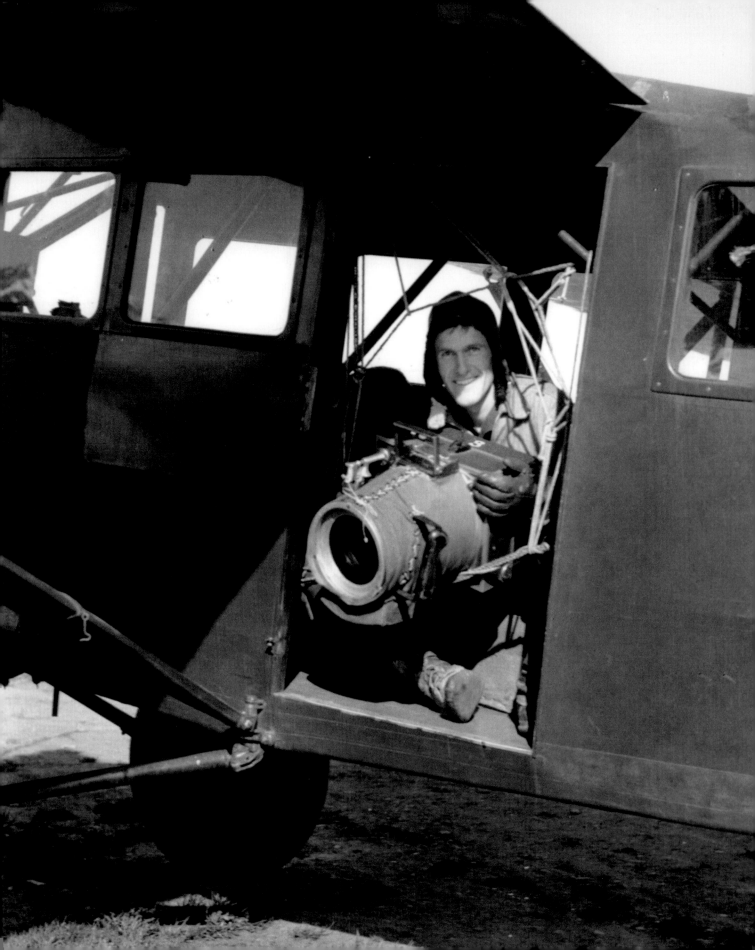

EYES ON HIGH

The Photographs

Washburn's 1951 trip up Mount McKinley had a huge effect on Talkeetna, a small outpost located about halfway between McKinley and Anchorage on the Parks Highway. With the opening of the West Buttress Route, McKinley suddenly became accessible to just about any reasonably fit person with a couple of weeks of vacation time and a good guide. High-adventure seekers began pouring into Talkeetna for flights to the Kahiltna Glacier base-camp site, turning the village of some 600 souls into the Alaskan equivalent of France's Chamonix, the jumping-off place for climbs of Mont Blanc. Before 1951 only 76 people had attempted McKinley. As of the end of 2001 that number had swollen to 24,968—an average of almost 500 per year, including children and persons with a variety of disabilities. However, despite its new appeal, McKinley remained a serious undertaking. Those actually reaching the summit since 1951 numbered 12,830—a success rate of 51 percent. Ninety-one climbers died on McKinley's slopes during the same period, an average of almost two per year.

The West Buttress expedition was notable in the world of mountaineering for another reason. It was the first time that a significant new route had been planned entirely for aerial photography. Now other climbers

Washburn took many of his phenomenal aerial photographs with his cumbersome, large-format Fairchild K-6, often leaning out of open plane doors to get his shot.

began turning to Washburn's pictures, hoping to find new paths up other slopes. Washburn was happy to oblige, and he continued to propose more routes himself, presenting them as "challenges." Each of the nine great new routes climbed on McKinley between 1954 and 1963 was suggested by Washburn.

It was a classic case of two technologies—photography and aviation—coming together to make something new and useful: images of the Earth as seen from the air. Geologists loved to study Washburn's illustrations of how multiple glaciers, the ice mixed with layers of glacial debris to form marble-cake designs, came together in their stately processions toward the sea. At such junctures science not only imitated but also arguably created art.

BRAD and Barbara, still newlyweds, prepare for their first trip to Alaska. In Valdez, Alaska, Washburn and colleague Bob Reeve (opposite) inspect film dried on the makeshift drying rack Washburn designed. It could hold a 125-foot roll of film.

The more pictures he took, the more captivated Washburn became by the abstract beauty of the patterns he was seeing from those heights, especially when isolated from the context of the horizon. His frame would catch a field of snow-covered crevasses—each one large enough to swallow a freight car—that from 2,000 feet looked like hound's teeth; mammoth snowdrifts carved into supple, almost erotic shapes by the wind; psychedelic contrasts of light and dark formed by groups of tundra ponds. With their exaltations of free-flowing natural forms, images such as these harked back to the art nouveau style in decorative arts, which was popular around the time Washburn was born, and to its antecedent, the arts and crafts movement.

Washburn typically scoffed at attempts to draw him out about his increasingly obvious aesthetic purposes. But inevitably, people began noticing that he was up to something other than science. He did admit to having been influenced very early on by the great turn-of-the-century Italian photographer Vittorio Sella, who had accompanied the Duke of Abruzzi on his 1898 first ascent of Mount St. Elias. Washburn paid special attention to Sella's dictum that "big scenery should be photographed with big negatives."

Convinced of this truth, in 1929 Washburn abandoned his beloved 1925 Christmas present, his Kodak Vest Pocket Autographic Special with its 2¼" by 3¼" negatives, and bought his European-made Ica Trix, whose negatives measured a considerably more ample 4" by 6". That was the beginning of a steady upward progression that culminated with his use in the skies over McKinley and elsewhere of the giant Fairchild cameras.

For a while Washburn heeded the counsel of his mother, who insisted that in order to be interesting, photographs should include people. And indeed some of his

most affecting shots show the Lilliputian effects on humans of the enormity of Alaska. But the most technically valuable piece of advice came from the great American scenic photographer Ansel Adams, for many years a close friend of Brad. Adams told him to "expose for shadows, and develop for highlights." In this way, the subtleties of details lying in shadowed areas could be brought out in the printmaking process, while the brilliance of the sun-drenched snow could be retained. This technique gives the photographs of great landscape photographers their luminous, painterly qualities.

Washburn learned by experience and by studying the works of Adams and others that the best times to photograph were in the short intervals around sunrise and sunset, when Alaska's dramatic snow- and icescapes were raked by light. A codicil to this rule: The most dramatic skies appeared just before and after storms. He often used a filter, such as the slightly orange No. 15 Wratten, to enhance cloud detail.

Washburn's first solid clue that his photographs might have some value other than scientific or documentary came when one of his early Alps photographs,

"Sunrise, Aiguille du Midi," won first place in a 1929 Appalachian Mountain Club photographic competition. Later, the appearances of pictures from Mounts Crillon and Lucania in the photo-driven NATIONAL GEOGRAPHIC and *Life* magazine were additional proof that his camera savvy was extraordinary.

But it wasn't until the 1960s that his growing body of work began gaining serious critical acclaim. A handful of his shots found their way into "The Photographer and the American Landscape," a 1963 exhibition in the exalted setting of New York's Museum of Modern Art. Two years later the Kodak Pavilion at the New York World's Fair showed some of his pictures in an exhibit entitled "The World from the Air." Many more exhibitions followed, including a 1976 show called "The Land" at London's Victoria and Albert Museum. His work was shown in the 1983 "History of Mountain Photography" at New York's International Center of Photography, and in 1988 one of his prints was chosen as one of the "Master Photographs" in the center's collection entitled "Photography in the Fine Arts." Recognition of this kind continued into the new century with a 2000 exhibition at Boston's Museum of Fine Arts—"View From Above: The Photographs of Bradford Washburn"—whose exhibition catalogue won, among several other honors, the grand prize at that year's Banff Mountain Book Festival.

One of Washburn's fans in Boston was Clifford S. Ackley, curator of prints, drawings, and photographs at the Boston Museum of Fine Arts. Ackley commented for an exhibition of Washburn's photographs that: "While retaining their historical documentary value, they can nevertheless be appreciated for their surprising, sometimes dizzying, spaces; for the intricate interplay of light and shadow over pristine blankets of snow; for their revelation of natural textures and patterns of startlingly abstract beauty."

Jim Enyeart of New Mexico's College of Santa Fe and former director of the prestigious George Eastman House International Museum of Photography and Film in Rochester, New York, has stated that Washburn's "photographs are like those which Ansel Adams would have made if he'd had a flying carpet." Adams himself observed shortly before his death in 1984 that Washburn's aerial photographs of McKinley not only were the first of their kind but also remained "the finest ever made of the great natural landmark."

While Washburn's images served such useful purposes as furthering the study of rocks and glaciers, at the same time they offered what another individual who appreciated both science and art, Amelia Earhart, would have called "hyacinth for the soul." In addition they were coming in very handy as Washburn pursued yet another one of his many interests, one that was becoming increasingly central to his life as he grew older—the making of maps.

———

TWILIGHT ON MOUNT HUNTINGTON'S WESTERN RIDGE,

ALASKA, 1964

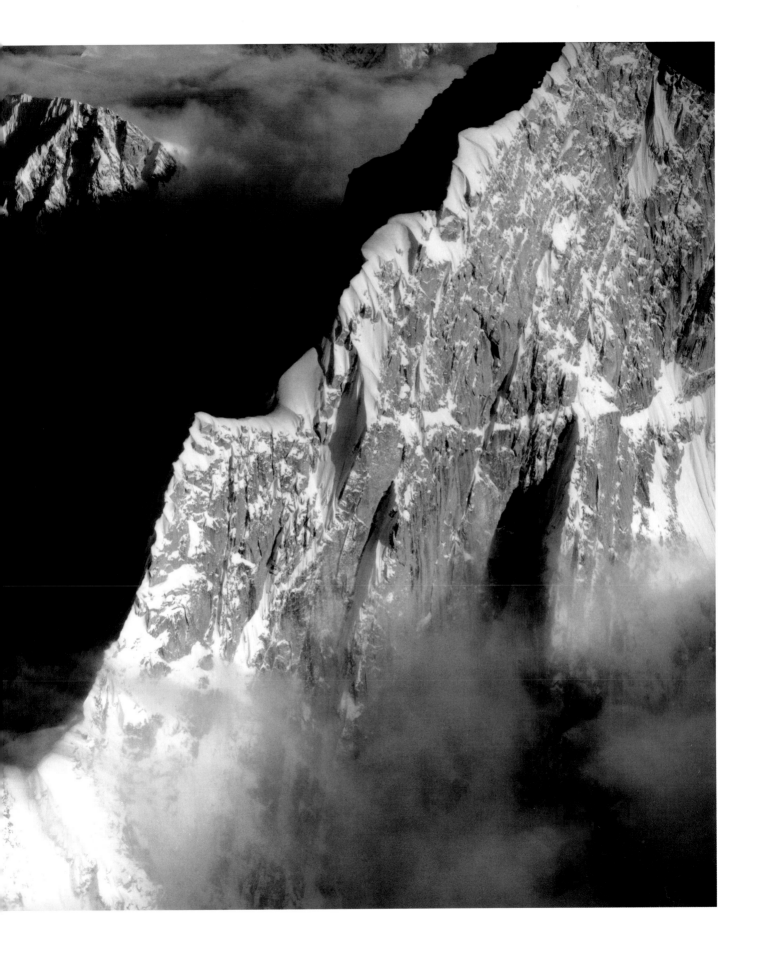

SASTRUGI—WIND-ERODED SNOW—AT THE BASE OF MOUNT SILVERTHRONE, ALASKA, 1945

CREVASSES NEAR SNOUT OF SHERIDAN GLACIER, ALASKA, 1938

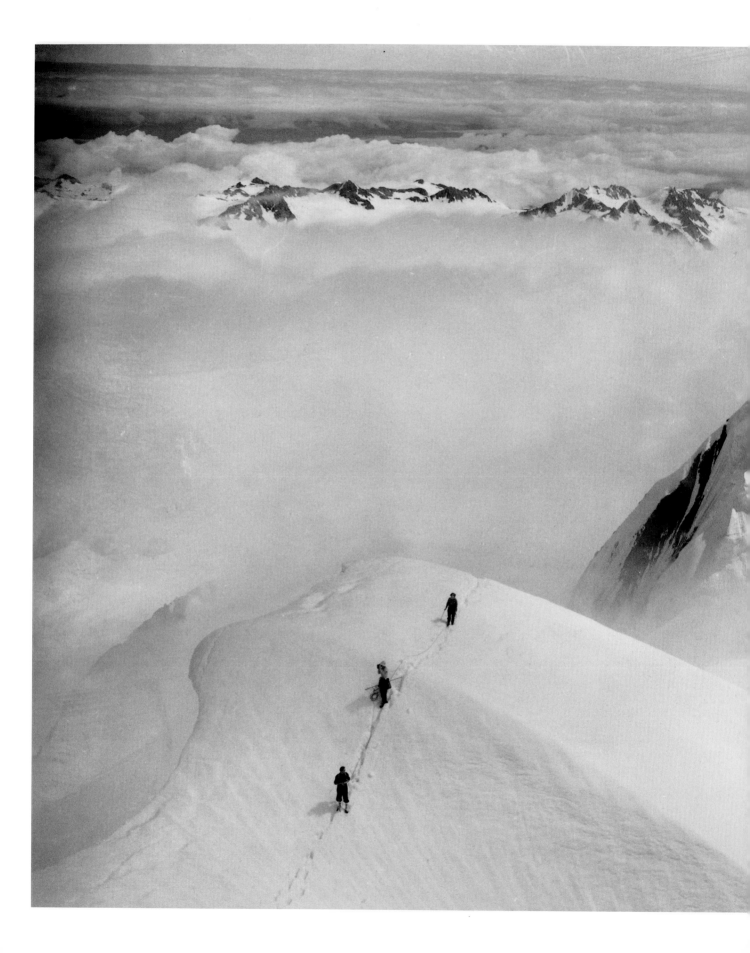

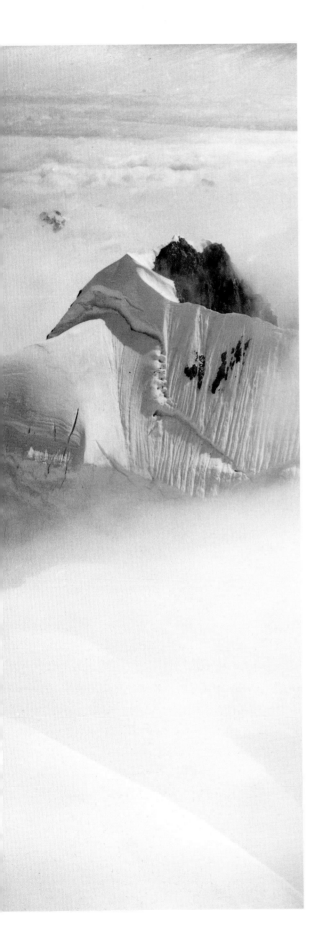

CLIMBERS ON KARSTENS RIDGE, MOUNT MCKINLEY,
ALASKA, 1938

SNOUT OF A MORAINE-COVERED DYING GLACIER,

PETERS DOME, ALASKA, 1949

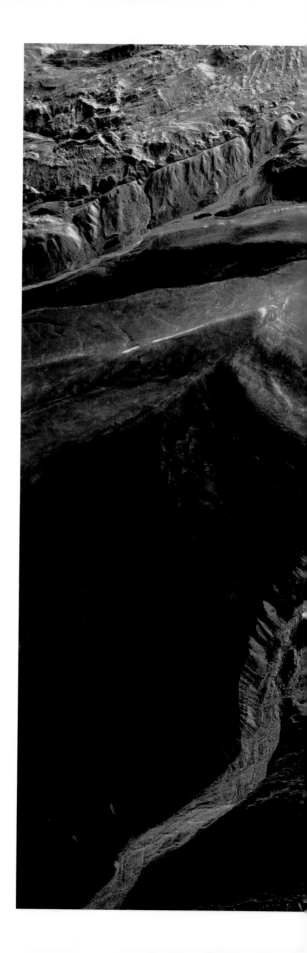

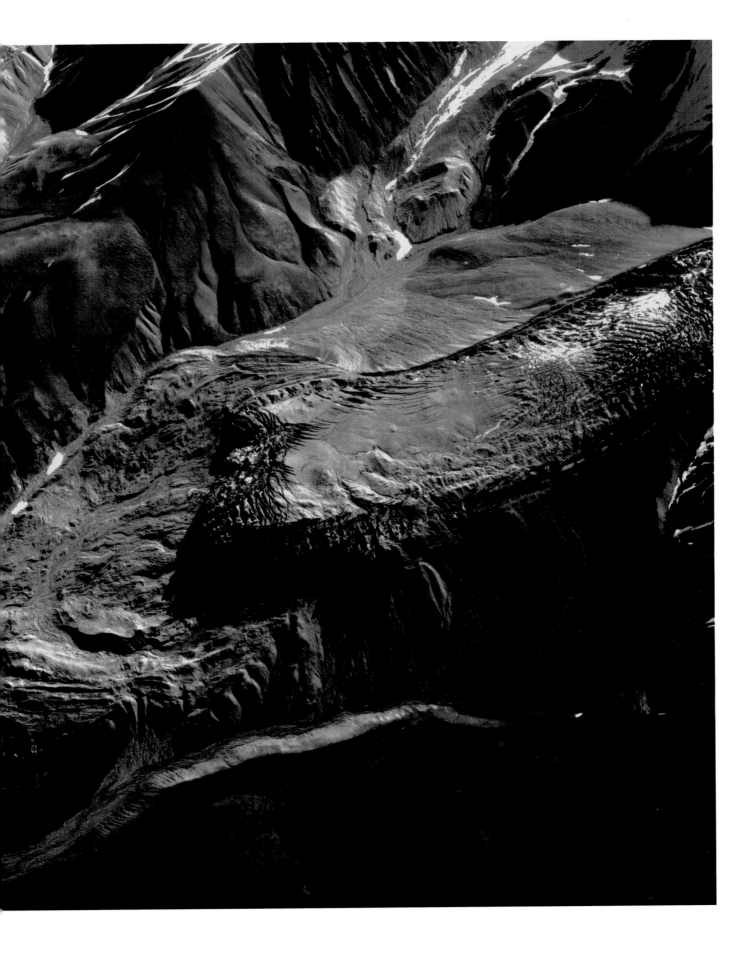

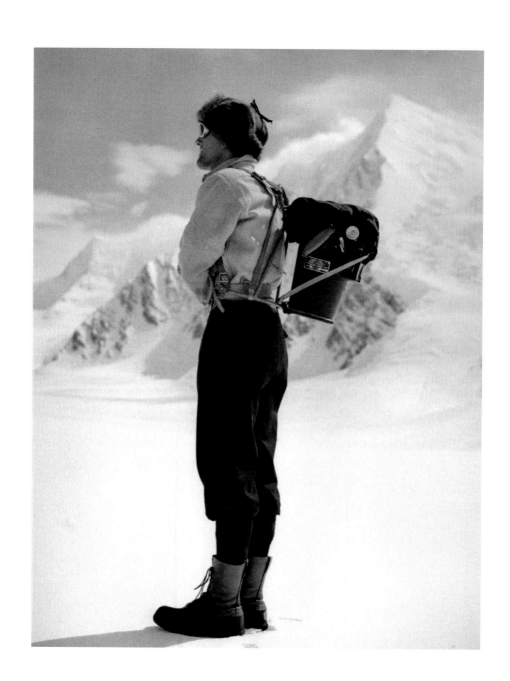

WASHBURN AND HIS FAIRCHILD F-8 AERIAL CAMERA ON MOUNT MARCUS BAKER, ALASKA, 1938

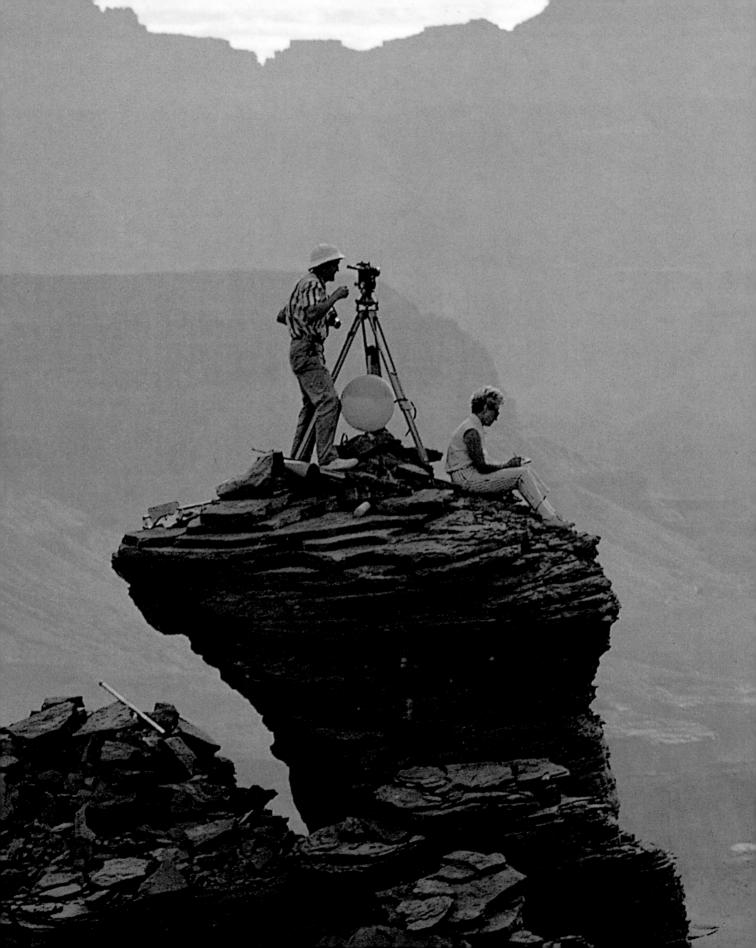

MOUNTAIN MEASURES
1952-1988

It began as a vaguely run-down feeling, as if Barbara hadn't been getting enough sleep. Also a flagging appetite. Nothing too bad, just enough to notice. Maybe it was something she'd eaten.

The Washburns had been taking special care with their diets throughout the four weeks they'd been in Kathmandu. It was 1984, and the capital of Nepal was a paradigm of urban grime and chaos, piles of garbage in the marketplace and stray dogs competing for space in the noisy streets with humans, automobiles, and sacred cows. It was November 10, Barbara's 70th birthday, and some American friends were throwing a party for her. Not a good time to be feeling pokey. Both Washburns were under a great deal of stress, and that alone, she was thinking, could account for a case of malaise. Trying to find other reasons not to be concerned, she began to feel feverish. She took some aspirin and tried to will herself not to get sick.

Especially not now. After more than three years of negotiations with various government and commercial bureaucracies in several countries, Brad had received final permissions and the wherewithal to do what had never been done before: to extensively photograph Mount Everest from the air. He would use these images to draw the most detailed map

GRAND CANYON DAYS:
In the 1970s, the Washburns mapped the heart of Arizona's Grand Canyon for National Geographic. Atop Dana Butte in the middle of the canyon, Brad uses a theodolite while Barbara takes notes.

ever made of that great peak and its surrounding territory. The end result would not just be extremely accurate; it would be a work of art, with subtleties of line, color, and shading that would make it look more like a painting than a map. Washburn would hover over sheets of drawing paper with the aid of a magnifying glass, inking in details—a twist of ridge here, a serac there. In some important ways the work would help recompense for one of the great missed opportunities of his life: actually putting his boots on the tallest mountain of them all.

Bringing this hugely complicated project together had been the equivalent of threading a hundred needles in a snowstorm. But now the funding had been lined up; the photographic gear, film, and a sleek Swedair Learjet secured; a blizzard of Chinese and Nepalese government documents signed; and the human support crew readied. The project was still running into obstacles. The airport manager at Kathmandu turned out to be a back-country tyrant, jealous of his authority and generally hostile toward foreigners. At first he'd refused to allow the Learjet to land, rudely demanding to know why anyone would want to undertake such a costly and useless project. Didn't maps and photographs of Everest already exist? Even before that crisis, just getting camera gear into the country had sparked bureaucratic animosity. When they'd landed and shown the customs official a document exempting their equipment from duties, the officer had informed them that the person who'd signed the document lacked the authority to do so. That person was the king of Nepal.

But at last it seemed that everything had been straightened out. It was only days before they were due to take off in the Lear for their first overflight. Washburn was in a buoyant mood as he began getting ready for the birthday party. He'd dreamed of Everest ever since he'd attended a riveting lecture at Groton in 1926. The speaker was Capt. John Noel, the British army officer who'd filmed the famous 1924 ascent attempt that had resulted in the deaths of George Mallory and Andrew Irvine. Three years later, while a freshman at Harvard, Washburn had met another member of the same expedition: Noel Odell, the last person to have seen Mallory and Irvine alive. These accounts had stirred longings in young Washburn and his New England climbing friends. Someone would be first to the top. Why not one of them? Before World War II Washburn was too young or international politics stood in the way. After the war his attentions were focused on building a museum and raising a family. And now, suddenly, he was 74 years old.

How could so much time have gone by so quickly? He remembered the smallest details of his first time up Mount Washington with Cousin Sherman as if it had happened only last week. He recalled vivid bits about himself and Sherry on Mont Blanc; and scaling the Aiguilles with the young Frenchmen Couttet and Charlet, who'd taught him so much; and building igloos with Jim Gale on McKinley. He also remembered the fine spring day in 1953 when he'd heard Edmund Hillary and Tenzing Norgay had been the first to reach the summit of Everest. Where he was and what he was doing

A DETAILED *topographic map by Swiss mapmaker Edouard Imhof: His technique— seen in this 1932 detail of the Jungfrau group and Aletsch Glacier—influenced Washburn's use of relief-shading and rock-scribing to show contouring.*

were etched into Washburn's memory, just as people in later times would recall the day President Kennedy died or the World Trade Center was bombed. Washburn, driving to work at the museum, was just passing an old city landmark, the Washington Elm, as the car radio announcer declared that Everest had been *conquered.* As if it could be.

Now in his eighth decade of life, Washburn would never go up Everest. Nor would his climbing partner of 44 years. But they would be together high above the mountain as he released the shutter exposing film that would lay the foundation for a big, beautiful map. It all had come down to these final hours of preparation—and this celebration of Barbara's birthday. And so Washburn knew that something seriously was wrong when she spoke to him in a weak voice, saying apologetically that he'd better go on to the party by himself. She wasn't feeling well.

THE ROAD TO EVEREST, like just about everything else, had begun in New Hampshire. That's where he'd made his very first map, the pen-and-ink drawing that accompanied his first book, the trail guide to the Presidential Range of the White Mountains. Making maps had been a key part of every important expedition he'd undertaken thereafter. Mount Fairweather. Crillon. Lucania. The Yukon. In 1935, when he was learning photogrammetry at Harvard, he'd even returned to Squam Lake. A series of aerial photographs he took that summer resulted in the first detailed map of the lake, a task he finished the following year. In 1945 he began an exceptionally ambitious long-term project: a new large-scale map of Mount McKinley. Production of this map became the overriding objective of all his postwar trips to Alaska. Fifteen years of photographic flights and data-gathering culminated in its publication in 1960, with the financial support of the Museum of Science, the Swiss Foundation for Alpine Research, and the American Academy of Arts and Sciences.

Mapmaking traditionally had been a boots-on-the-ground process. The most important part was getting the measurements right, a function that relied on triangulation. Sights were taken through a theodolite, a telescopic instrument used principally for land surveys. Angles were measured, distances calculated. Photogrammetry—which involved taking perfectly vertical photographs from the air—verified these measurements and added detail about the landscape to a

WASHBURN combined photography and cartography to detail some of the world's most impressive landforms. Above, one of his photographs of the Grand Canyon complements his map (opposite), which appeared as a supplement in the July 1978 NATIONAL GEOGRAPHIC.

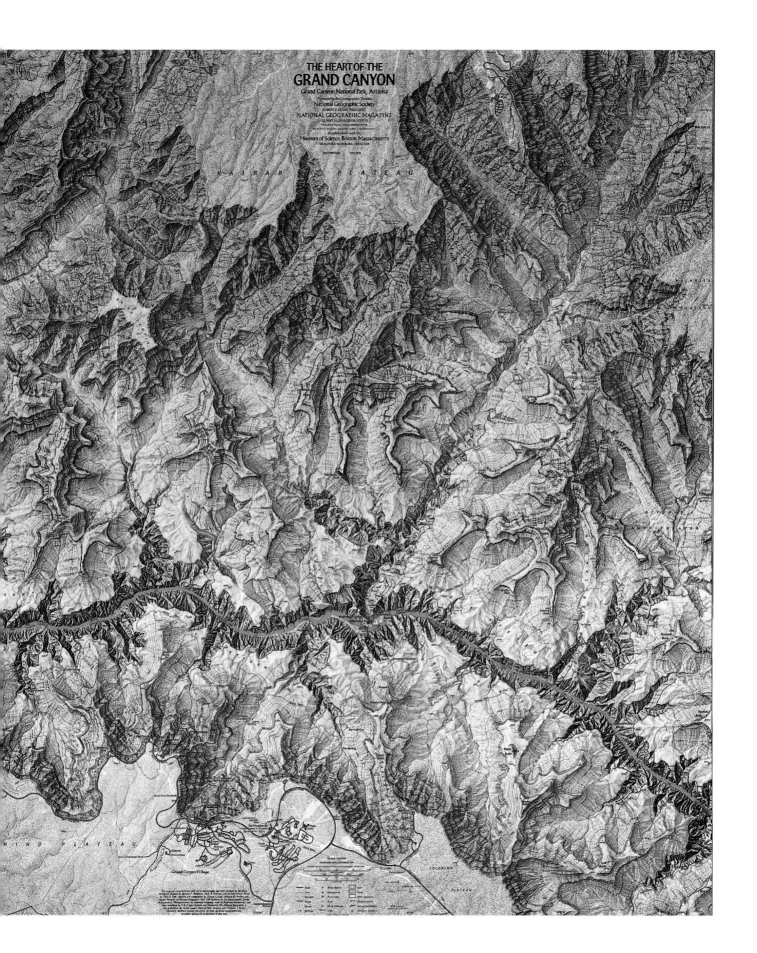

THE HEART OF THE
GRAND CANYON

Grand Canyon National Park, Arizona

Produced by the Cartographic Division

National Geographic Society

ROBERT E. DOYLE, PRESIDENT

NATIONAL GEOGRAPHIC MAGAZINE

GILBERT M. GROSVENOR, EDITOR

In cooperation with the

Museum of Science, Boston, Massachusetts

BRADFORD WASHBURN, DIRECTOR

JULY 1978

degree never before possible. The process, along with the later innovation of laser measuring devices, made it feasible to create maps without ever physically touching the ground. As time passed, Washburn used these tools along with the Global Positioning System (GPS), which could identify the location of any point on Earth with great precision. GPS did this the old-fashioned way, by triangulation, except that measurements and calculations were done electronically with the aid of satellites.

For Washburn, mapmaking represented a way to continue spending time in the wilderness. The premonition that had brought unexpected tears to his eyes as he'd begun his descent of Mount McKinley in 1951 proved correct. He continued going to McKinley and other high and cold places for many years thereafter, but that was his last major expedition undertaken with mountain climbing as a principal goal. When in 1965 he revisited one of the Yukon peaks he'd discovered 30 years earlier, the one he'd described as having "terrible cliffs," it was to map the place that just had been christened Mount Kennedy in honor of the late President. After 1951 Washburn became a cartographic knight in search of a quest, ever on the lookout for worthy prizes. The National Geographic Society published his Kennedy map in 1968—the same year that he completed a new nautical chart of Squam Lake, for the first time mapping the contours of its bottom.

In 1971 his eyes fell on the Grand Canyon—that vast upside-down mountain range he'd first seen in 1916 as a child on his way to California with his ailing father. With a $30,000 grant from the National Geographic—inflation had taken a toll in the three and a half decades since he'd been able to explore 5,000 square miles of the Yukon for $5,000—he set off to trace the great gorge's twists and turns. The undertaking involved a pioneering use of laser beams to make all distance measurements, and extensive use of helicopters, which, unlike fixed-wing aircraft, could land people and gear on the tops of buttes. When it was over, some 300 helicopter flights had been made over a six-year period.

Washburn astonished others involved in the project, including his own wife, with his energy, agility, and physical aggressiveness. Impatient as ever to get going, even in his sixties, he mastered the technique of leaping from helicopters before they'd finished landing. On one occasion he tripped on his way out. Rather than letting the laser equipment he was clutching in his arms fall, he allowed himself to land face-first on a rock. That escapade put him in a hospital with a severely bloodied nose, but didn't dampen his enthusiasm for jumping out of choppers.

Washburn decided to retire from the Museum of Science in 1980 when he turned 70. The museum threw a retirement party shortly before his birthday. Among his gifts were two round-trip tickets to Nepal. His staff had often heard him say that there was something he wanted to do before he died: He wanted to be carried in a sedan chair to a place above Darjeeling where he could cast his eyes on Mount Everest. In

SURVEY DIAGRAM made by Washburn shows the Mount Kennedy-Hubbard massif in the Yukon's St. Elias Mountains. He led a 1965 National Geographic-sponsored expedition to the area.

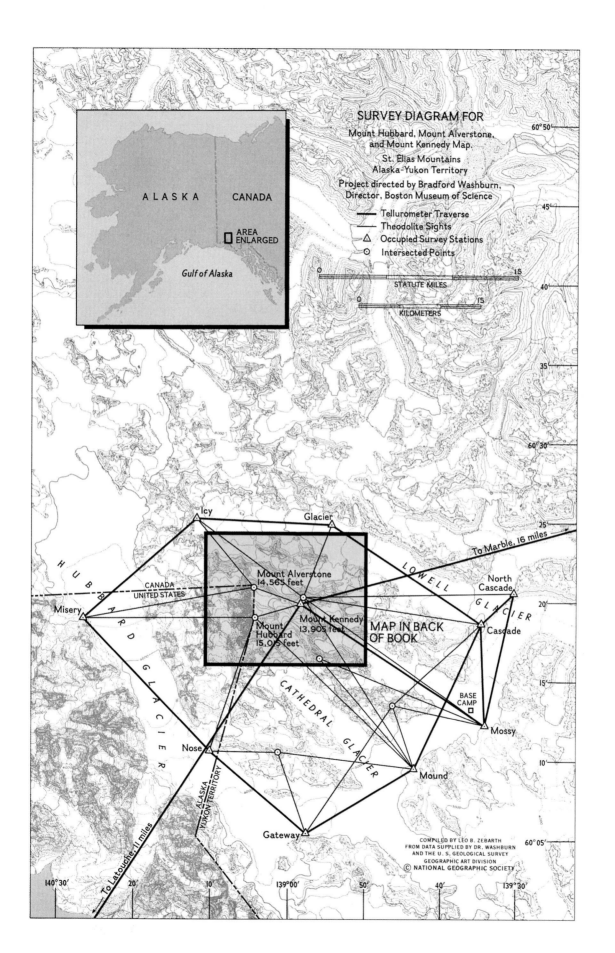

SURVEY DIAGRAM FOR

Mount Hubbard, Mount Alverstone,
and Mount Kennedy Map.

St. Elias Mountains
Alaska-Yukon Territory

Project directed by Bradford Washburn,
Director, Boston Museum of Science

—— Tellurometer Traverse
—— Theodolite Sights
△ Occupied Survey Stations
⊙ Intersected Points

STATUTE MILES

KILOMETERS

ALASKA CANADA

AREA
ENLARGED

Gulf of Alaska

Icy

Glacier

To Marble, 16 miles

HUBBARD

Mount Alverstone
14,565 feet

CANADA
UNITED STATES

LOWELL

North
Cascade

Misery

GLACIER

Mount Kennedy
13,905 feet

Mount
Hubbard
15,015 feet

MAP IN BACK
OF BOOK

Cascade

BASE
CAMP

Mossy

CATHEDRAL

Nose

ALASKA
YUKON TERRITORY

GLACIER

Mound

To Latouche, 11 miles

To Latouche, 11 miles

Gateway

60°05'

COMPILED BY LEO B. ZEBARTH
FROM DATA SUPPLIED BY DR. WASHBURN
AND THE U. S. GEOLOGICAL SURVEY
GEOGRAPHIC ART DIVISION
© NATIONAL GEOGRAPHIC SOCIETY

140°30' 20' 10' 139°00' 50' 40' 139°30'

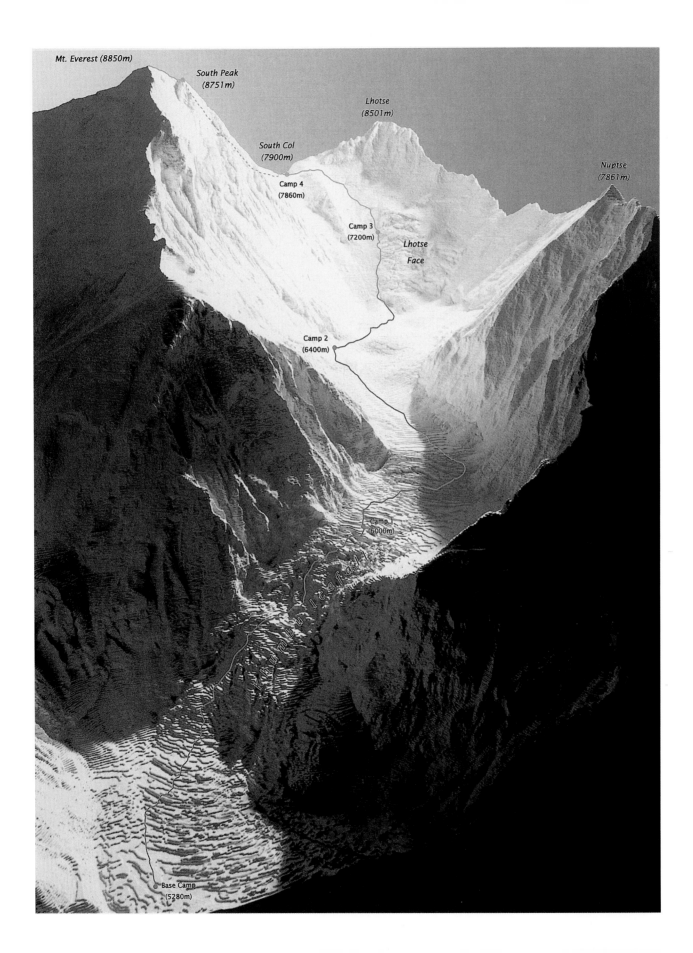

addition to bestowing the tickets, the staff had a makeshift sedan chair carry the Washburns out of the banquet hall with appropriate tongue-in-cheek pomp and revelry. But anyone who thought that Washburn really would be satisfied with sitting in a chair like a mogul, passively viewing the place of his youthful dreams while courtiers banged cymbals and lit incense—well, they just didn't know their man.

It didn't take long for me to realize that I had to make a map of Mount Everest. I got in touch with my old climbing friend and Harvard classmate Bob Bates, who was now director of the Peace Corps in Nepal. Bob knew the king very well: He had been an official chaperone when the future monarch attended Harvard incognito. I had also met the crown prince when he'd visited the Museum of Science some years ago. Now, with Bob acting as intermediary, I wrote describing my idea for a map and requested permission to fly over. The king sent an encouraging reply.

That was the beginning of a long and frustrating sequence of events. The undertaking would also require permission from China, since the region lies on the border of Nepal and Tibet. We were in the depths of the Cold War, and relations between the United States and China were strained and fraught with suspicion. But a bit of luck intervened. I received an invitation to lecture at the Institute of Glaciology in Lanzhou, China. The trip gave me a chance to lobby officials of both countries in person.

Surprisingly, China proved easier to deal with than Nepal. Beijing rather speedily granted my request for an overflight of Everest. The Nepalese, despite the king's approval of the concept, threw up bureaucratic obstacles. We returned to Boston, where I continued going into the Museum of Science every day as its director emeritus, and worked on seemingly endless drafts of the agreement that would allow my project to go forward. The national planning council finally signed off on the fifteenth draft in February 1984—more than three years after the king had originally said yes.

Recognizing the importance of this undertaking, the National Geographic's Committee for Research and Exploration, a panel of eminent scientists in various fields throughout the country, issued an extraordinarily generous $75,000 grant for aerial photographs. We left Boston October 12. Arriving in Kathmandu, we encountered another series of bureaucratic and logistical hurdles, but at last it seemed everything was coming together. The Learjet with the mapping equipment was finishing flight-testing in Switzerland. Key members of the aerial mapping team, including Werner Altherr from Swissair Photo-Surveys, were on their way. Everything was falling into place.

And that's when the love of my life got into her staring contest with death.

Though Barbara nearly had died of bronchial pneumonia when she was four and had experienced the whole inventory of childhood diseases, she'd developed robust health as an adult. She hadn't set foot in a hospital since the birth of our last child in 1946. So I was very concerned when she announced that she wasn't feeling well enough to attend her 70th birthday party. I became increasingly alarmed as I watched her temperature climb to 104 degrees. At that point

Though Washburn never climbed Everest himself, his detailed photographs and maps of the mighty mountain have helped countless other climbers. His National Geographic-sponsored survey of the area also resulted in a new—and higher—Everest height: 29,035 feet.

I sent out an urgent call for a doctor. He arrived on a motorcycle, took several vials of blood, and roared off for a nearby clinic to have them analyzed. The samples revealed an elevated white blood cell count. This was very bad news, because it could have indicated some kind of cancer.

An American doctor at a nearby clinic treated her for several tropical diseases. But nothing worked. After more tests, including an extensive series of X-rays made with old equipment and no lead shield to protect her from radiation, our Nepalese doctor advised going to a medical facility in Bangkok that had more sophisticated medical gear.

We left on the next flight for Thailand and arrived in the middle of the night. The next day they began a series of tests that would have served well in the Spanish Inquisition. First she had her throat frozen and a long tube pushed down into her lungs. Next she had to lie on her stomach while a large needle was pushed into her back for a bone marrow test. After several days of this the doctor drew me aside to break the news. He said that Barbara was dying of lymphoma, a form of cancer that affects the lymph nodes. If I didn't want her to die in a foreign land, I should take her back to Boston immediately: She would be dead within a week.

I said nothing to Barbara of this. I just told her that we were going home. In the meantime I called up the National Geographic, which I'd been keeping posted on this turn of events, and let them know that I was going to have to abandon the mission. I was needed more by my wife than by Mount Everest. They understood and quickly formed a fallback plan. They would send one of their best people to Kathmandu to take over while I looked after Barbara. The project would go on.

The person they chose was 52-year-old Barry Bishop—a person I happened to know very well. I'd first met him in Alaska on the Mount McKinley West Buttress expedition in 1951. Barry had been part of Henry Buchtel's contingent from Denver. He was now the executive secretary—essentially the operating director—of the Society's Committee for Research and Exploration, which had approved my grant.

Pleased to know that the project was in good hands, I turned all of my attention to getting Barbara back to Boston as quickly and comfortably as possible. We left in an ambulance for the Bangkok airport, which was mobbed with Christmas season travelers. It was now mid-December, about four weeks after Barbara had become ill. It seemed that everybody was trying to get somewhere else all at once.

The next Swissair flight out to Zurich was completely booked. The person at the desk told us they couldn't throw someone off the airplane, but that he would do something almost as naughty: He would move us up to the head of the waiting list.

I took Barbara in a wheelchair out to where the airplane was boarding on the tarmac. It was the middle of the night. Barbara's lungs were clogged with fluid, she had a bad cough, and her temperature remained high. I was praying that two of the more than 200 people with reservations wouldn't show up. Finally the departure time arrived and there were exactly two vacant seats left. The flight attendant and two passengers arranged it so Barbara and I could sit together.

Barbara was heavily sedated. She spent most of the flight dozing while I kept a close eye on her. My heart was breaking as I thought about the love we'd shared for so many years. So many adventures we'd had together, so often we'd traveled near and far, beginning with that

WASHBURN *began envisioning a detailed map of Everest when he turned 70. Using the latest technology, including stereophotography helped along by the space shuttle* Columbia, *his team mapped 350 square miles of the Everest region, creating the most detailed map ever made of the world's highest mountain.*

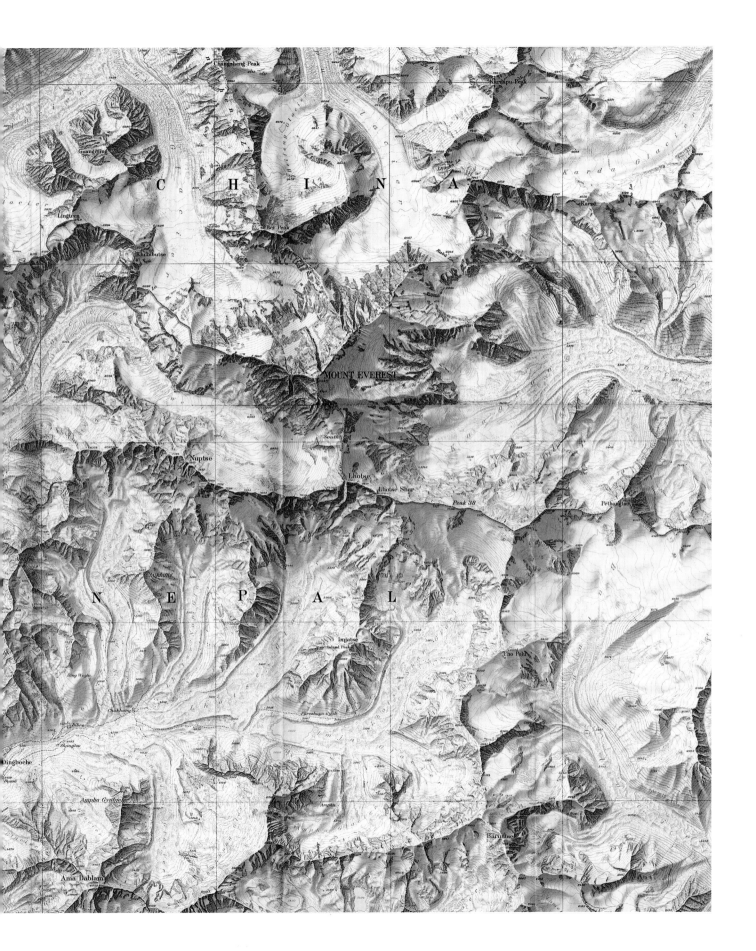

enchanted night on the train from Hartford to New York, the night I'd lost my heart.

By this time she'd figured out that everyone thought she was going to die, and she'd begun to believe it herself. I found out later that she was going over her mental list of widowed friends, trying to figure out who would be the best one to take her place by my side. Far from making a fuss, though, she was putting on a brave show. At one point she came awake while the attendant was passing around snacks. Sitting bolt upright, her disarming dimpled smile lighting up the cabin, she demanded to have some too.

We landed in Zurich in the middle of a blizzard. Werner Altherr, the Swissair vice president who was handling the technical aspects of the Everest project, met us at the gate. He'd arranged an airport VIP suite for us to await our flight to Boston. While we waited, Werner and I went over flight maps and some final details of what was to be done as soon as Barry Bishop arrived in Kathmandu. But I found it hard to concentrate on anything beyond what was happening to Barbara.

When we finally arrived in Boston, our daughter Betsy was waiting at the airport with an ambulance to rush Barbara to Massachusetts General Hospital, where the staff immediately launched a whole new series of tests. The next day the experts told me that in their opinion the crucial test that had been performed in Bangkok, the one on which doctors had based their diagnosis of lymphoma, had been flawed. Barbara didn't have lymphoma. But they didn't know what she did have, and her health was steadily deteriorating. They were convinced she was only days away from death if they didn't come up with an answer.

It was a urine test that solved the mystery. A doctor by the name of Allan Sandler analyzed the sample and identified the real problem. Barbara had a rare autoimmune disease called Wegener's granulomatosis. Once fatal, this disease was now treatable with large doses of Prednisone and Cytoxan, drugs used to fight the growth and spread of cancer cells.

Four years would go by before she would fully recover. But at least we knew what the trouble was. I wasn't going to lose her—although Sandler said that if we hadn't rushed home so a correct diagnosis could be made, she almost certainly would have suffered permanent organ damage or died in Bangkok.

On Christmas Eve the hospital sent her home, and we spent our first night alone together since leaving Kathmandu. The telephone startled us awake early the next morning. I looked over at the clock and said, "Who in the hell is calling us at 7 o'clock on Christmas morning?"

In my grogginess I dropped the receiver, then started talking into the earpiece. Finally I recognized the voice of Werner Altherr. He was calling from Zurich. He said: "Merry Christmas from the team in Kathmandu. I am holding in my hand.... the pictures from our flights over Everest. They are perfect. We send our love."

By this time Barbara had figured out who I was talking to and was getting impatient to know what was going on.

I simply handed her the phone. All I could do was grin.

———➤———

WASHBURN AND A COLLEAGUE SURVEYING ON TOP OF
MCKINLEY'S 12,000-FOOT KAHILTNA DOME, ALASKA, 1951

CLOSE TO HOME, BRAD AND BARBARA WORK ON THEIR MAP
OF NEW HAMPSHIRE'S PRESIDENTIAL RANGE.

Epilogue

At the Top

Boston's Museum of Science is one of the few places in the world where people have been able to walk in off the street and within five minutes be using a wood plug to stuff dead rats down the throat of a boa constrictor. Or watching chickens hatch. Or designing an earthquake-proof building, and then testing it on a shaking device. The museum is exactly the opposite of what most people think of when they hear the word "museum," with its connotations of dusty collections. This museum has a carnival atmosphere: It is bright colors, flashing lights and motion, voices that speak to the visitor, and invitations to touch things and play with them.

One can wander through the labyrinth of rooms and open spaces on each of four exhibit floors and repeatedly be surprised by what's just around the corner. This effect was Washburn's strategy from the time he resumed management of the Museum of Science in 1945, after returning from wartime service. He wanted to mix things up, to display the collections in a manner different from that of an ordinary museum. The mix of technological wizardry and show business has prompted other museum directors to call Washburn's creation the finest science museum in the country. Its success can be measured by attendance—1.6 million people in 2001—and an income of $32.8 million, the funds coming almost entirely from private donations and admissions. A force of 650 volunteers supplements a professional staff of 250-300.

"The Museum of Science is my greatest achievement," Washburn said as we entered a freight elevator to go up to his office. All morning I had been following him around the museum, where everyone—including guards, cafeteria staff, and visiting dignitaries—affectionately called him "Brad." As we threaded through the museum's crowded exhibits, Washburn absently half-whistled a little tune, as if he couldn't let a moment pass without doing something. It was a quick, in-and-out sound, taking breaths and exhaling as he worked through an elaborate melody, like someone playing a harmonica. Seeing that it was a habit that came upon him at odd moments when he was strolling about or pawing through documents or photographs, I wondered what kind of music might be going through the mind of such a person.

I'd imagined that Washburn's office would look like an explorer's den—Eskimo harpoons, caribou blankets, indigenous soapstone carvings. Instead, his oblong lair near a corner of the building had a stark, almost transient look. The most visually exciting part of it was a large window that overlooked the Charles River.

Then I understood. This wasn't a place for reflections on past glories. I was in the working office of a scientist-engineer-cartographer. Like his life, his office was minimally cluttered with only current projects, everything organized for action and meant to be used. No grip-and-grin photos, no certificates and trophies—though Washburn has collected plenty of those, among them honorary doctorates, director-ships, board affiliations and trusteeships, and lifetime achievement awards from the likes of the Massachusetts Audubon Society, the Rhodes Scholarships Selection Committee, the American Association for the Advancement of Science, the U.S. National Commission for UNESCO, the American Geographical Society, the National Armed Forces Museum, the U.S. National Parks Advisory Council, the Boy Scouts of America, WGBH Public Television Educational Foundation, Phi Beta Kappa, and the Chinese Association for Scientific Expeditions. These various plaques and other objects of honor are in storage, mostly in the large collections of Washburnania held by the Universities of Boston and Alaska.

Before me, in the flesh, was a short-statured, fit-looking man dressed in a well-laundered candy-striped shirt, gray trousers, and thoroughly worn-in walking shoes. I was talking to a person whose life had virtually spanned the 20th century; who as a teenager had earned the respect of some of the finest mountaineers in Europe for his exploits in their own snowcapped backyard; who had gone on to explore some of the last uncharted wildernesses on Earth; who had climbed "unclimbable" Mount Lucania; who had pioneered the use of aircraft and two-way radio communications in expeditions, who had applied technologies ranging from photography to laser beams and satellites to mapmaking; whose knowledge of and experiences in the Alaskan highlands—especially McKinley—had earned him the title, "Dean of American Mountaineering."

As Washburn sat there that late fall afternoon answering questions and telling stories, the shadows lengthening over the river, it became apparent that he still liked to travel. He mentioned that the following spring he and Barbara were hoping to go with a tour group to the North Pole. Such trips are available to anyone willing to pay the stiff tab for flights and accommodations in Resolute Bay, the remote high Arctic staging area for polar jaunts. In the Washburns' case, the tour company was offering free passage in exchange for a running commentary about his Arctic adventures. As usual, Washburn didn't intend to go just to see the sights. He was thinking up some experiments to run while they were on the ice. Maybe he'd measure the drift of the Arctic ice pack or take a few depth soundings. His appetite for scientific adventure seemed undiminished, but it remained to be seen whether the trip would come off. The attack on New York's World Trade Center had occurred only two months earlier, and travel companies were scaling back. By the time I returned six

months later, the North Pole trip indeed had been called off. And, 22 years after he'd formally retired, Washburn had given up his office at the museum.

It was now spring. A few flowers were popping out around the Washburn residence—a two-bedroom cottage with slate blue siding, part of a large retirement community in Lexington, about ten miles west of Boston. One of the bedrooms served as his office. The living room was just large enough for a sofa, a few tables, and two Victorian-era parlor chairs that I recognized from old photographs of his parent's home—the Deanery—at the Episcopal seminary in Cambridge. Washburn was in his midget-size kitchen opening a can of hash for our lunch. Barbara had left to join some friends. As he was heating up the food, I noticed that he was whistling again.

"By the way," I said, "What's that tune?"

"What tune?"

"The one you're whistling."

Pause. "No idea."

While he continued fussing with the electric stove, I looked at some mural-size prints of Alaska mountains and glaciers that hung from the living room walls. Occupying a place of honor on a table in the foyer was the only trophy I saw: a heavy crystal globe about a third the size of a soccer ball with a map of the world etched into its surface. It was the National Geographic's Centennial Award, which had been given to both Washburns during a 1988 ceremony marking the Society's hundredth anniversary. Among the other honorees were Edmund Hillary, Jacques-Yves Cousteau, Mary and Richard Leakey, Jane Goodall, and astronaut John Glenn.

The Glenn connection reminded me of something Washburn had said when I'd interviewed him for the *Radio Expeditions Geographic Century* series in 1999. He'd told me how on the day in 1962 that Glenn had first roared into Earth orbit inside the space capsule *Friendship VII,* Washburn's father, who'd been so supportive of his youthful interest in high places, had been terminally ill with cancer. Washburn recalled: "We rigged him up in a chair in front of the TV, and he saw the whole performance. And he turned to me at the end of that experience and said, 'When I was a youngster'—he was born 1869—'we had gas lights in our house. We had no television. We had no radio, no automobiles, no airplanes, and none of these satellites. What on Earth is gonna happen in the next hundred years?'"

As we sat at his kitchen counter eating canned hash, I remembered someone telling me that for the past couple of decades the old explorer seemed convinced that he would live as long as his father—92 years and four months—but possibly not much longer. Washburn was now just two months shy of his 92nd birthday.

I reminded him of the story he'd told me for the radio show, the question his father had posed. What will happen next?

"Yeah," he said. He'd been thinking about that a lot himself lately.

—————

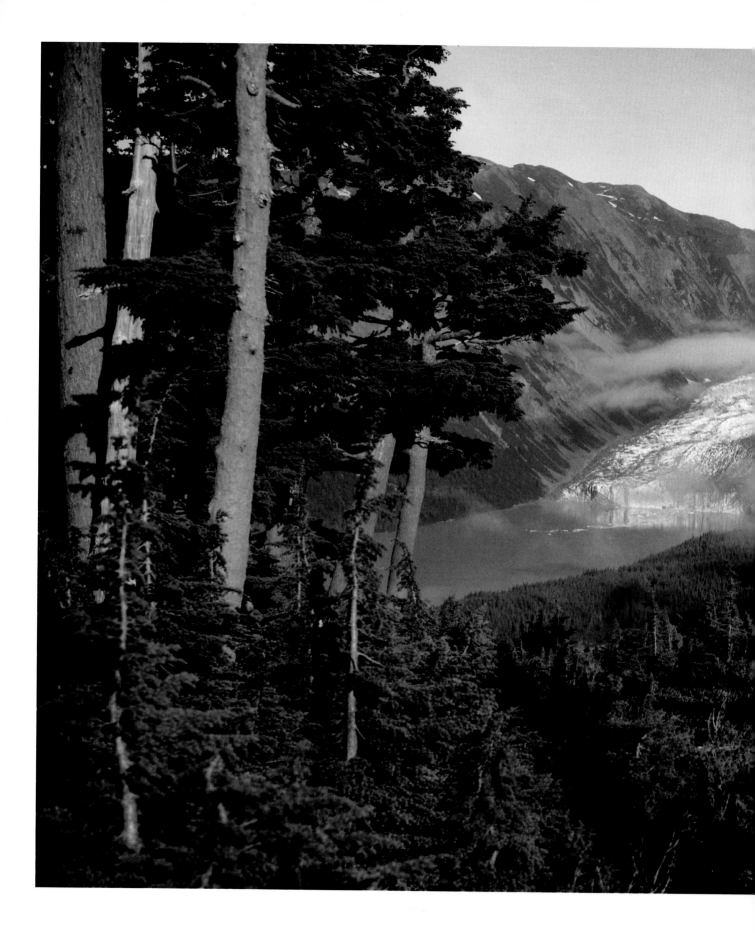

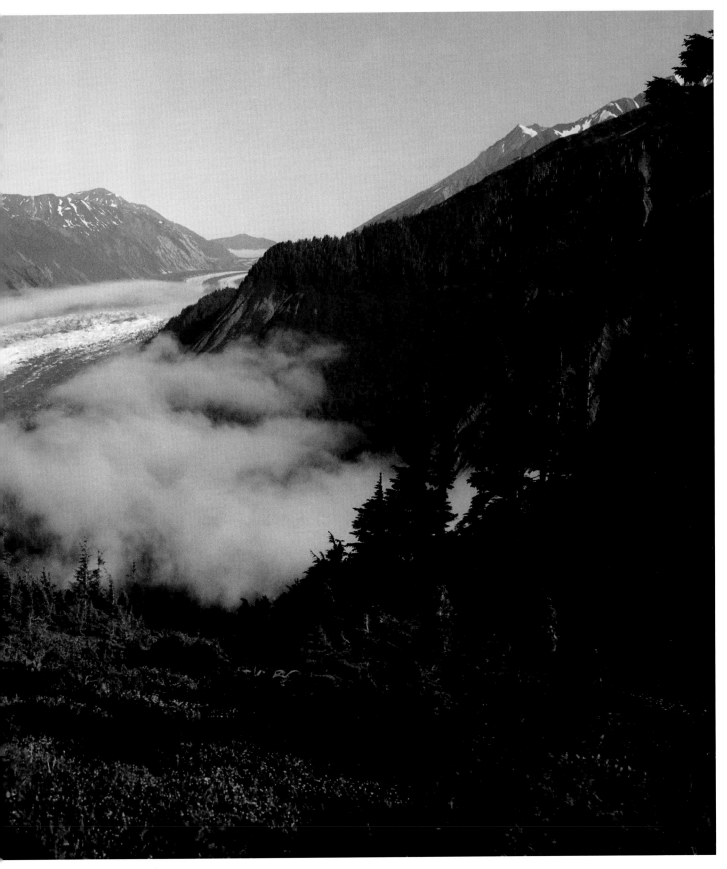

END OF CRILLON GLACIER AND CRILLON LAKE, ALASKA, 1932

Index

Illustrations Credits

Bradford Washburn courtesy Panopticon Gallery, Waltham, Massachusetts; www.panopt.com: Cover neg. 4481, p. 1 neg. 57-5491, 2-3 neg. 57-241, 6-7 neg. 4080, 8 neg. 57-4806, 28-9 neg. 6402, 30-1 neg. 2478, 32 neg. 7688, 40 neg. 2488, 44 (up rt) neg. 57-126, 44 (lo rt) neg. 57-103, 45 (lo rt) neg. 57-130, 55 neg. 57-48, 56-7 neg. 4097, 58 neg. 57-171, 59 neg. 57-131, 60-1 neg. 3731, 62 neg. 4061, 64 neg. 57-397, 67 neg. 2743, 68 neg. 57-679, 72 neg. 83-45, 76 neg. 3553, 85 neg. 57-4019, 86 neg. 57-2675, 93 neg. 57-86143, 96 neg. 57-68426, 102-3 neg. 57-2301, 113 neg. 5703, 117 neg. 57-2238, 120-1 neg. 1015, 122 neg. 1169, 124 neg. 57-3947, 136 neg. 2539, 137 neg. 57-5263, 138 neg. 3221, 140 neg. 2928, 142-3 neg. 2560, 114-5 neg. 2672, 146 neg. 2792, 148 neg. 57-5357, 150-1 neg. 57-5126, 155 neg. 3169, 156 (up) neg. 57-5093, 156 (lo le) neg. 4019, 156 (lo rt) neg. 57-5460, 157 (up) neg. 57-5414, 157 (lo le) neg. 57-5356, 157 (lo rt) neg. 57-5310, 159 neg. 57-5218, 160 neg. 57-5630, 163 neg. 4826, 164-5 neg. 3515, 166-7 neg. 4795, 168 neg. 5160, 170 neg. 57-2091, 175 neg. 57-3684, 176-7 neg. 5010, 178 neg. 57-4865, 179 neg. 2102, 180-1 neg. 57-3919, 182-3 neg. 57-2519, 184 neg. 57-2996, 190 neg. 6121, 200-01 neg. 5859, 208-9 neg. 57-1339

Courtesy Bradford Washburn Collection: 12, 18, 20 (up all), lower right, 21 (lo all), 24, 27, 34, 37, 38-9 (both), 44 (up le & lo le), 45 (top & lo le), 50, 52, 82 (lo), 104-5 (all), 117, 127, 133, 134, 135, 161, 172, 173, 189, 193, 202, 207; 47 photo by Georges Tairraz, 74 photo by Harold Orne, 199 photo by David Ochsner

Bradford Washburn/National Geographic Collection: 69, 80, 82 (up both), 83 (all), 84, 89, 90-1, 92, 94, 98, 99, 108, 118-9, 85

Boston University: 15, 20 (lo le), 21 (up both)

Museum of Science, Boston: 130-1 (all), 194, 205

National Geographic Maps: 191, 197

Charles O'Rear: 186

Sarah Leen: 110, 111

Acknowledgments

I would like to thank the following people for their help on this book. Karen Kostyal, for her guiding hand; Pat Durkin, who critiqued rough drafts of the manuscript; Howard Gotlieb, head of Boston University Library's Special Collections, archivist Sean D. Noel, and archival assistant J. C. Johnson; Michael Sfraga of the University of Alaska, whose Ph.D. dissertation on Washburn was an invaluable source of information and insights; Mark Sandrof and Tony Decaneas of Panopticon Gallery for their endless support and assistance on this project, and their exemplary handling of the Washburn collection; Renee Braden and Cathy Hunter, for help with the National Geographic Records Library; Blue Magruder of the Earthwatch Institute headquarters in Boston, who put me up—and put up with me—in her house in Cambridge; and Karen Sligh, who patiently transcribed roughly 15 hours of taped interviews. —DONALD SMITH

Additional Reading

Coombs, Colby, and Bradford Washburn. *Denali's West Buttress: A Climber's Guide to Mount McKinley's Classic Route.* American Alpine Club, 1997.

Davidson, Art. *Minus 148 Degrees: The First Winter Ascent of Mount McKinley.* The Mountaineers Books, 1999.

Decaneas, Anthony (ed.). *Bradford Washburn Mountain Photography.* The Mountaineers Books, 1999.

Graydon, Don, and Kurt Hanson (eds.). *Mountaineering: The Freedom of the Hills.* The Mountaineers Books, 1997.

Roberts, David. *Great Exploration Hoaxes.* Modern Library, 2001.

Washburn, Bradford. *The Dishonorable Dr. Cook: Debunking the Notorious Mount McKinley Hoax.* The Mountaineers Books, 2001.

Washburn, Bradford, and David Roberts. *Mount McKinley: The Conquest of Denali.* Harry N. Abrams, Inc. 1991.

Washburn, Bradford (photographer), and Lew Freedman (ed.). *Exploring the Unknown: Historic Diaries of Bradford Washburn's Alaska/Yukon Expeditions.* Epicenter Press, 1999.

Washburn, Barbara, with Lew Freedman. *The Accidental Adventurer: Memoirs of the First Woman to Climb Mount McKinley.* Epicenter Press, 1999.

Waterman, Jonathan. *In the Shadow of Denali: Life and Death on Alaska's Mt. McKinley.* The Lyons Press, 1998.

Published by the national Geographic Society

John M. Fahey, Jr., *President and Chief Executive Officer*

Gilbert M. Grosvenor, *Chairman of the Board*

Nina D. Hoffman, *Executive Vice President*

Prepared by the Book Division

Kevin Mulroy, *Vice President and Editor-in-Chief*

Charles Kogod, *Illustrations Director*

Marianne R. Koszorus, *Design Director*

Staff for this Book

K. M. Kostyal, *Editor*

Toni Eugene, Jane Sunderland, *Text Editors*

Marilyn Mofford Gibbons, *Illustrations Editor*

Cinda Rose, *Art Director*

Winfield Swanson, *Researcher*

R. Gary Colbert, *Production Director/Production Project Manager*

Sharon Kocsis Berry, *Illustrations Assistant*

Michele Callaghan, *Consulting Editor*

Manufacturing and Quality Control

Christopher A. Liedel, *Chief Financial Officer*

Phillip L. Schlosser, *Managing Director*

John T. Dunn, *Technical Director*

Vincent Ryan, *Manager*

Clifton M. Brown, *Manager*

One of the world's largest nonprofit scientific and educational organizations, the National Geographic Society was founded in 1888 "for the increase and diffusion of geographic knowledge." Fulfilling this mission, the Society educates and inspires millions every day through its magazines, books, television programs, videos, maps and atlases, research grants, the National Geographic Bee, teacher workshops, and innovative classroom materials. The Society is supported through membership dues, charitable gifts, and income from the sale of its educational products. This support is vital to National Geographic's mission to increase global understanding and promote conservation of our planet through exploration, research, and education.

For more information, please call 1-800-NGS LINE (647-5463) or write to the following address:

National Geographic Society
1145 17th Street N.W.
Washington, D.C. 20036-4688 U.S.A.

Visit the Society's Web site at
www.nationalgeographic.com.

Excerpts from *Among the Alps with Bradford, Bradford on Mt. Washington,* and *Bradford on Mt. Fairweather* used by permission of G. P. Putnam's Sons, a division of Penguin Putnam Inc.

Excerpts describing the Mount Lucania expedition are from the 1938 article "The Ascent of Mount Lucania" by Bradford Washburn, *The American Alpine Journal* 3(2):119-126. Used by permission *The American Alpine Journal.*

Printed in U.S.A.

Library of Congress Cataloging-in-Publication Data
Washburn, Bradford, 1910-
 On high: the adventures of legendary mountaineer, photographer, and scientist Brad Washburn/Brad Washburn with Donald Smith.
 p. cm.
 Includes bibliographical references and index.
 ISBN 0-7922-6911-X (hard)
 1. Washburn, Bradford, 1910-2. Mountaineers--United States--Biobraphy. 3. Photographers--United States--Biography. 4. Natural history museum directors--Massachusetts--Boston--Biography. 5. Photography of mountains. 6. Boston Museum of Science. I. Smih, Donald, 1941-II Title.

GV199.92.@W35 A3 2002
796.52'2'092--dc21 2002032140